ICONS

16th Century Paintings

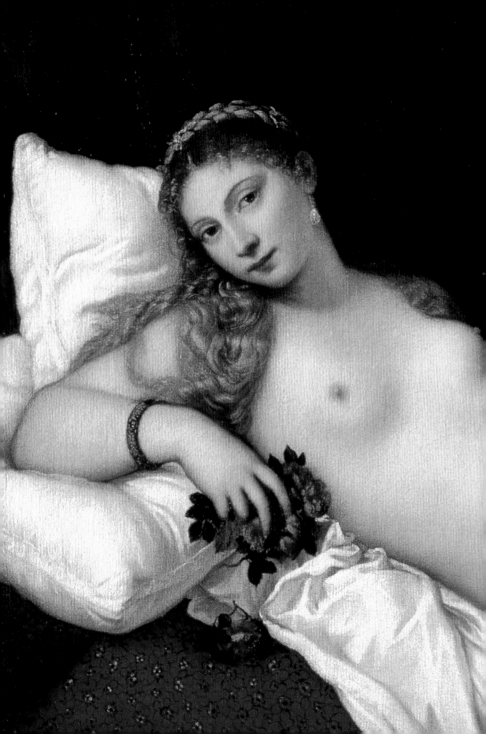

16th Century Paintings

Rose-Marie and Rainer Hagen

TASCHEN

KÖLN LONDON MADRID NEW YORK PARIS TOKYO

© 2001 TASCHEN GmbH
Hohenzollernring 53, D–50672 Köln
www.taschen.com

Cover design: Angelika Taschen, Claudia Frey, Cologne
Design: Catinka Keul, Cologne
English translation: Iain Galbraith, Wiesbaden;
Karen Williams, Whitley Chapel
Editorial coordination: Kathrin Murr, Cologne
Production: Horst Neuzner, Cologne

Printed in Italy
ISBN 3–8228–5558–8

Contents

8 **The Sinner and the Eccentric**
Hieronymus Bosch: The Ship of Fools,
between 1480 and 1516

18 **Strange quartet**
Hans Baldung Grien: The Three Stages
of Life, with Death, c. 1510

28 **Composure in the face
of misfortune**
Raphael: The Fire in the Borgo, 1514–17

38 **The femme fatale charms
the devout viewer**
Niklaus Manuel: The Execution
of John the Baptist, c. 1517

48 **The battle to end all battles**
Albrecht Altdorfer: The Battle of Issus,
1529

58 **Careers in the king's service**
Hans Holbein the Younger: The Ambas-
sadors, 1533

68 **From the canopy of Heaven
to a four-poster bed**
Titian: Venus of Urbino, c. 1538

78 **The utopia of common
huntmanship**
Lucas Cranach the Younger:
The Stag Hunt, 1544

88 **The third voyeur stood before
the canvas**
Tintoretto: Susanna and the Elders,
c. 1555

98 **The Lord sits at the table of lords**
Paolo Caliari (Veronese): The Marriage
at Cana, 1562/63

108 **The Antwerp building boom**
Pieter Bruegel the Elder: The Tower
of Babel, 1563

118 **For Tiber, read Seine**
Antoine Caron: The Massacre by
the Triumvirate, 1566

128 **The barn is full – time for a wedding!**
Pieter Bruegel the Elder:
Peasant Wedding Feast, c. 1567

138 **Aspirations to immortality**
Jacopo Tintoretto: The Origin of the
Milky Way, c. 1580

148 **Two saints bury the munificent donor**
El Greco: The Burial of Count Orgaz,
1586

158 **A woman thwarts Spain's pride**
George Gower: Armada Portrait of
Elizabeth I, c. 1590

168 **The princess in the hospital**
Adam Elsheimer: St Elizabeth Tending
the Sick, c. 1597

178 **Tyrannicide by tender hand**
Caravaggio: Judith and Holofernes,
c. 1599

Preface

The present volume brings together some of the most important paintings of the 16th century. They offer insights into long-gone worlds, into the sphere of the rich and powerful and into the daily lives of peasants and craftsmen. They uncover the stories and myths which preoccupied them, and their religious and material desires. Thus Raphael speaks in a vast fresco of the political miracles which the people hoped for from the Pope; Holbein portrays the lavishness of the diplomatic lifestyle; Hans Baldung Grien shows the misery of growing old; the Swiss artist Niklaus Manuel celebrates Confederate mercenaries; Pieter Bruegel the Elder gives us a wedding feast in a barn; El Greco demonstrates, in *The Burial of Count Orgaz*, that the kingdom of heaven is just as real as the earthly realm. No less rooted in the earthly sphere were the highly personal motives which lay behind the commissioning of these masterpieces of European art.

The authors discuss each picture not just as a work of art, but as a document of its day. The present volume represents a selection of articles originally published under the title of "What Great Paintings Say" in *art* magazine.

The Sinner and the Eccentric

In 1399 the City of Frankfurt ordered a madman who had run naked through the streets to be removed from the city and deposited further down the river Main. In 1406 some fishermen were instructed to carry a lunatic from Frankfurt to Mainz in the night. In 1418 the citizens of Frankfurt had a madwoman transported by ship to Aschaffenburg. In 1427 a blacksmith's lad who had lost his wits was taken down the Main and then along the Rhine to the Kreuznach area.[1]

Such deportations are known to have occurred in other European cities, as well. Sometimes the unfortunates were taken away by boat, although the majority were sent off overland, attached to goods transports. Those expelled were not just the unsound in mind, but also beggars, journeymen, discharged soldiers, cripples, and the sick. At the close of the Middle Ages, the number of people thus moving from one place to the next with no permanent home was large – in some areas it represented up to 30% of the population. The walls and gates which surrounded medieval cities protected them not just from their enemies, but also against these bands of vagabonds. Should individuals nevertheless manage to find their way in, after a few days they were sent on their way or indeed ejected by force. Only in the case of people who were clearly insane was a boatman or ferryman instructed to remove them. He would take

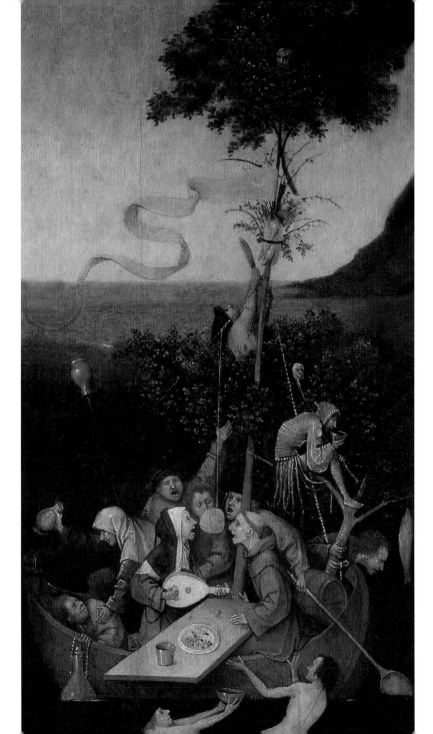

them back to their hometown, or simply abandon them somewhere. The main thing was, they didn't come back.

A clear distinction was made between a town's own lunatics and those from elsewhere. Those from local families were not driven out. They would be at most imprisoned if they assaulted another citizen. They would then be put in the "fool's chest" or the "madhouse", usually small huts rather than solid buildings, where they were cared for by a lowly employee of the town. They were confined there, but not treated. No cure was expected, barring a miracle. The same was true of other serious diseases – patients and their relatives pinned their hopes more on God and the saints than on medicine.

There were two reasons for this: the lowly state of the doctor's art and the dominant role of religion. The kingdom of heaven was ever present in the Middle Ages. People's lives were defined by God. To get close to HIM was the goal of all. True life only began in His presence; this earthly vale of sorrows was seen as a place of transition, only important insofar as people could qualify here for admission to heaven.

This intensely felt, ever-present power of God also determined people's relationships with each other. They were all on the same path, all pilgrims on the road to salvation. In the face of this common goal, the differences between them as individuals assumed less importance. Even the differences between the insane and the not insane. They lived side by side. Families kept their sick members at home. The insane were integrated in society. Only when they had no family or when their relatives could no longer control them were they sent to the madhouse.

The insane were not simply suffered, however; they also served a religious function, by offering a means for the healthy to do good. Alms, endowments and other acts of charity were all good deeds that would increase one's chances of going to heaven.

In Bosch's day, this attitude was changing. He lived at the end of the Middle Ages and the start of the Renaissance, during which the Christian world picture would slowly lose its coherence and power. Bosch painted *The Ship of Fools* sometime between 1480 and 1516 – the precise date is unknown. In 1517 Luther nailed his theses to the door of the church in Wittenberg. He, like other protagonists of the Reformation, doubted the value of good deeds as a ticket to heaven. The insane, together with the cripples and beggars to whom one could also demonstrate one's brotherly love, thus lost their religious worth. From being necessary, they now

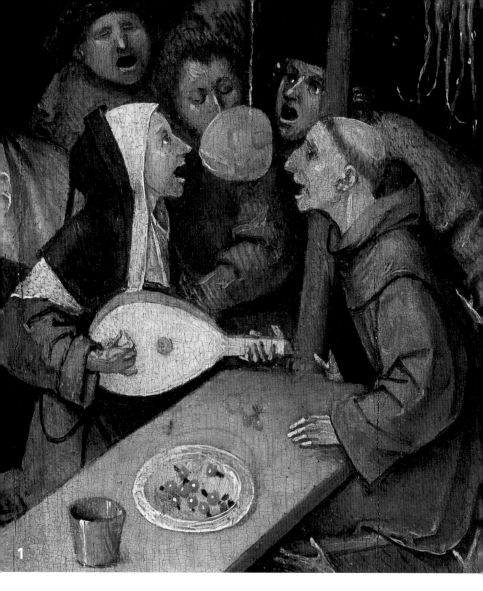

became undesirable. They began to be cast out.

The number of prisons grew, and workhouses were introduced, where the mentally ill were shut up alongside thieves, beggars and those unwilling to work.

Although there is no proof that the insane were indeed packed off

**Fornication
on board**

in boatloads, it would be easy to interpret Bosch's *Ship of Fools* as symbolizing the widespread process of segregation that started in his day. But that would be to view the picture solely through modern eyes. It is unlikely that Bosch's contemporaries would have interpreted the painting in such a way; they would have seen it in quite a different light.

In the middle of the boat sit a Franciscan monk and a nun. The nun is playing the lute, and both are singing or trying to catch with their mouths the pancake hanging from a string and being swung by the man with the outstretched hand. On the table between the monk and the nun lie some small fruits, which look like cherries. More of these fruits can be seen on a plate, beside which stands a cup, perhaps containing dice.

Bosch's contemporaries were used to looking for a meaning in such arrangements of people and objects. In this case their thoughts might have run thus: monks and nuns are supposed to live separately – if they are seated together, they are acting improperly. The lute, the white instrument with the round hole, recalls a vagina, and hence playing the lute means fornication. (In the symbolism of the time, the bagpipes represented the male pendant to the lute.) The childish game with the pancake signifies gluttony, the large number of jugs and barrels drunkenness, and the cup possibly the disreputable game of dice. The people on the boat do not know what is right and proper. They are fools. Not for nothing is one of them even dressed in a fool's costume.

The image of a ship laden with fools would have been thoroughly familiar to Bosch's contemporaries; they would have encountered it, for example, in carnival processions in which boats filled with fools were pulled on wheels through the streets. In several Netherlandish towns and cities there were festival associations by the name of "Blauwe Scuut". People who wanted to drink and be merry would gather together in these "blue ships". Viewers of the present painting may also have read a book entitled *Das Narrenschiff* (The Ship of Fools), a bestseller published in Basle in 1494 and translated into several languages. Written by Sebastian Brant, it describes more than 100 different types of fool and foolish behaviour. Thus "A fool is someone who counts on getting someone else's inheritance…", or "A fool is someone who scorns God and rails against Him day and night…".[2] All these characters get into a boat headed for the Land of Fools.

But a fool in those days was somewhat different from a fool today. In the Middle Ages, the term meant more than it does in today's

language. It was applied not just to someone who flaunted God's commandments and the rules of social coexistence, but also to the mentally ill. We must bear this in mind if we are to understand how Bosch's painting would have been received in its own day. Of course it was appreciated even in the Middle Ages that there were differences between the two categories of fool. But these differences were not taken very seriously. At the end of the day, it boiled down to the same thing: both were unable to recognize the straight and narrow path to God. All fools were sinners. It was simply that the insane among them were given a better chance of forgiveness.

The artists of the Middle Ages employed a language of symbols which they drew upon in the composition of their paintings and which the viewer subsequently used to "decipher" them. A number of reference books were even compiled, explaining the significance of the individual symbols, and these books continue to serve as vital sources of information for us today. They demonstrate, among other things, how many different meanings one image could carry. A ship, for example, might symbolize the City, the Church, faith or life itself. Bosch's ship full of fools could thus be interpreted as an allegory of life or the Church. Criticism of representatives of the Church was widespread in the late Middle Ages. The two interpretations are not mutually exclusive, however.

Like the ship, water could signify a number of different things. On the one hand, it was associated with purification, renewal and baptism. On the other hand, it could mean danger, a threat or sin. Naked figures in the water are almost always

Deeper meanings of water

3

something which couldn't be grasped or fathomed. Humankind is at the mercy of both forces. In the Netherlandish town of Meulebeck, on the other hand, the mentally ill were led across the bridge of a river: passing over the water was supposed to bring healing.

On the pennant fluttering from the mast, Bosch has depicted a crescent moon. This was the symbol of the Turks, who were threatening Europe. In painting, however, the crescent moon was also used to identify the mentally ill: the fools as lunatics under the flag of the enemy of Christendom.

Trees appear in two guises in Bosch's picture, and they occupy a large area of the panel. One serves as a rudder, the other as a mast. The rudder-tree is lashed to the stern. A fish hangs from a dead branch on the right, while on the left – on a branch bursting into a leafy bush – sits the fool. It is a very unbalanced helm, difficult to move; it lacks the most fundamental qualities that a good rudder needs.

In the bush stands a man, who is reaching upwards to cut down a roast goose from the mast. His action recalls games associated with maypoles, which were commonly erected in the Netherlands in Bosch's day. Items would be tied to the maypole, which young people would then compete to cut down.

A mast without a sail

sinners in the metaphorical imagery of medieval times.

Water was also frequently associated with madness. Perhaps because water, like madness, was

The leafy crown of the mast does not grow out of the main trunk, but consists of branches that have been tied on. Only the inner section with the gleaming highlights was executed by Bosch; the rest was added later by a different hand.

The mast is unsuitable for setting sail, the rudder unsuitable for steering. Both features are useless, and the giant cooking spoons will be of little help, either, in propelling the boat forwards. Yet the passengers are intoxicated and in high spirits, and fail to see that they cannot steer their ship. They will never reach the Land of Fools.

In the pictorial symbolism of the Middle Ages, and in the imagery of other cultures, too, the tree (like water, ships and rocks) is of great significance. For the Germanic peoples, the tree was the great ash Yggdrasil, which held heaven and earth together. The Buddhists have a tree of enlightenment, the fig tree. In the Judaeo-Christian Paradise stands the Tree of Knowledge.

The Christian Tree of Knowledge forms the background against which the mast of this ship of fools assumes its particular meaning. It bears no apples, but only a goose tied to its trunk. The man who is cutting the goose down is not thereby transformed; he does not, like Adam, suddenly acquire a thirst for knowledge, but will get no more than a full stomach.

Bosch portrays a reversal of the mysterious process allegorized in the Bible as the Fall and Expulsion from Paradise – a very realistic, materialistic reversal: the displacement of spirit by gluttony.

The fact that the crown of the tree does not grow out of the trunk, but rather is added on, fits both the image of the maypole and the symbolism of the composition as a whole. The tree of fools is dead; it bears not a single leaf or fruit. Although the bush beneath it has foliage, its only fruit is a dead fish. It is also deformed.

Above, in the rapidly wilting crown topping the mast, sits or hangs something which the present condition of the painting no longer allows us to identify with certainty: it may be a skull, or it may be an owl. The owl represents the bird of wisdom and of death. While wisdom on this boat is surely no more than a distant memory, death, on the other hand, is near. This ship of fools will founder and sink.

In Sebastian Brant's *Narrenschiff*, all the characters are constantly moving. They are ceaselessly engaged in some senseless activity or another, as if standing still were dangerous. Bosch's passengers, too, all appear emotionally or drunkenly animated – with one exception: the figure in the fool's costume. He sits apart from the rest, turns his back on them, sips quietly from a

The birth of the eccentric

bowl. One might think he was meditating. Fool's costumes were very popular in Bosch's day, and were worn by professional jesters at court and in carnivals and processions. There were even carnivals devoted solely to fools. The fool's costume included bells, which were supposed to jingle constantly - something they would only do so if the wearer kept moving. In his hand the fool held either a mirror – symbol of narcissistic vanity – or, as in Bosch's panel, a fool's sceptre. This sceptre usually bore a carved jester's face and was understood as a phallic symbol. The fool himself sometimes wore a coxcomb on his cap; the comb and the sceptre represent uncontrolled sensuality. The asses' ears indicate stupidity. Even the fact that the cap fits tightly on the fool's head, almost like a second skin, has a symbolic significance: the fool's costume can't simply be slipped off like other garments, but sticks fast to the wearer. With its symbols of stupidity and lust, the costume is an aspect of human nature: man is not just spirit, but also animal.

This concept of the fool held an extraordinary fascination for the people of the late Middle Ages and early Renaissance era. They thought in metaphors. The fool symbolized the human condition: such is man, a hemaphrodite belonging partly to the world of spirit and partly to the sphere of instinctual urges.

By their very nature, however, symbols are never clearly defined. They permit different interpretations, and as they pass down through the generations, so they are assigned new meanings. Fundamentally, every person was a fool. At a not quite so fundamental level, fools were those who acted wrongly – like the passengers in Sebastian Brant's *Narrenschiff*. Such fools stray from the straight and narrow path and fail to get to heaven. At the start of the Renaissance era this vision of divine redemption, this goal of all human endeavour, lost its cogency. The Christian world picture faded. People began to rely more on their own experience than on Biblical authorities. The earthly vale of sorrows metamorphosed into an attractive landscape. The people within it discovered their individuality. They sought a new metaphor for their new outlook on life, and alighted once again upon the fool. He was reinterpreted: no longer a sinner, but an eccentric, someone who is different from the rest, who flaunts his individuality. Around 1500 – a point in time which saw the publication of a great many books about fools – there appeared in German literature a character who epitomizes this new type of fool: Till Eulenspiegel. He lives not wrongly, but differently. Instead of being slower-witted, he is cleverer than the townsfolk, farmers and thieves. He hood-

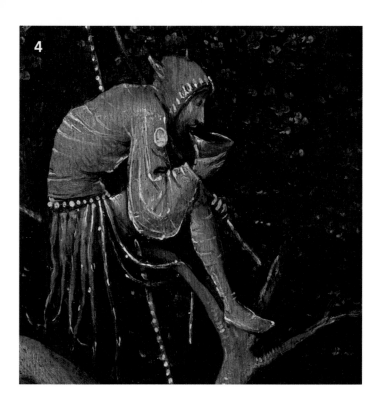

winks them, teaches them lessons
the hard way, and then makes his
getaway. He belongs to the va-
grants, the homeless who drift
across Europe. Amongst the ruling
classes, the Renaissance prince be-
came an idol of individualism,
obeying only his own will. Lower
down the social scale, in certain re-
gions this role of idol was taken
over by Till Eulenspiegel: the fool
as hero.

The person in the fool's costume
in Bosch's painting falls into the
Eulenspiegel category. He doesn't
join in with the rest, he thinks for

himself, an eccentric. All the other
passengers represent the old type of
fool: they are behaving badly, they
are sinning, instead of steering
their ship of life towards the king-
dom of heaven. Bosch thus brings
together in one panel two different
interpretations of the fool, one be-
longing to the Middle Ages and the
other to the early Renaissance. His
Ship of Fools thereby documents the
transition from the old era to the
new.

Hans Baldung Grien: The Three Stages of Life, with Death, c. 1510

Strange quartet

In 1510 the artist Hans Baldung, alias Grien, completed a painting enigmatic enough to ensure that its theme has remained the object of speculation ever since. Who is the young woman, so engrossed in her own reflection: a goddess, the allegory of Vanity, a whore? The other figures are equally obscure. All that can be said for sure of this Renaissance work is that it retains no trace of that Christian notion of salvation which so dominated the art of the Middle Ages. The painting (48 x 33 cm) is in the Kunsthistorisches Museum, Vienna.

Of the four naked figures in the gloomy landscape, it is the young woman who draws our attention. A pale, attractive figure, she stands out starkly against the browns and darker hues of the other figures. To her right, a torn creature holds an hourglass over the young woman's head; a hag enters from the left, a child kneels at the comely blonde's feet.

The work belongs to the Kunsthistorisches Museum, Vienna, in whose catalogue of 1896 the old

woman is described as Vice, the young woman as Vanity and the child as Amor. In the catalogue of 1938 the painting is entitled *Allegory of Transience*, and 20 years later: *Death and The Three Ages of Woman. Allegory of the Vanity of all Worldly Things.* The laconic title in a catalogue of works exhibited at the Baldung exhibition of 1959 reads: *Beauty and Death.*

Dispute has not been confined to the subject of the painting; the authorship, too, remained obscure for many years. Initially ascribed to Lucas Cranach and Albrecht Altdorfer, the painting was eventually attributed to the hand of Hans Baldung Grien. Little is known of the artist's life: he was born c. 1485, probably in Schwäbisch Gmünd. From 1503 to 1507 he was appren-

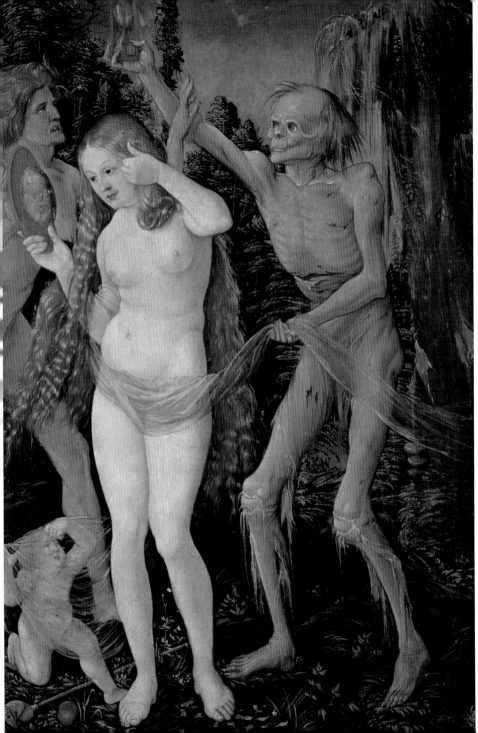

1

First steps

They not only served the practical purpose of ordering diverse phenomena, but were considered things in themselves, pillars of the world order. Numbers possessed a mythical aura that can be retraced to antiquity and, in particular, to the work of Pythagoras. Though number symbolism had never quite sunk into oblivion during the Middle Ages, it nonetheless experienced a revival with the rediscovery of antiquity.

Three and four are the numbers most strongly felt in Baldung's picture: the three stages of life, and, as a fourth stage, Death. Both numbers were highly significant. Four were the points of the compass, four the elements and the humours; there were four periods of the day and four seasons. The times of day and seasons, too, were frequently associated with periods in life: spring and morning were childhood, night and winter the final years of a person's life, or death.

As a universal number, three was even more significant than four. The Holy Trinity, after all, was at the heart of Christian theology. In antiquity, the number three – the beginning, middle and end – stood for the totality. Aristotle had used the number three in his ethics: a bad action derives from an "excess" or a "deficiency", whereas the "just action" lies in the "mean". The Greek philosopher also applied the number three to the stages of a per-

ticed to Albrecht Dürer's Nuremberg workshop. He painted the high altar at Freiburg Cathedral, but lived mainly in Strasbourg, where he died in 1545.

Despite the puzzle presented by the theme, it is nonetheless possible to reconstruct contemporary ideas associated with the four figures, while throwing light on the historical background of the ideas themselves. Numbers, for example, held a peculiar significance at the time.

Hans Baldung

son's life: youth had too much strength, courage, anger and desire; old age had too little of these. Only persons in their prime possessed these qualities in due proportion.

Much thought during Classical antiquity was devoted to the division of life into three, or four (or even seven, or ten), stages, but these ideas did not find their way into the visual arts. The portrayal of the different stages of a human life in medieval art, in paintings commissioned by the church, is exceptional, for such distinctions were considered irrelevant in the face of that still greater division between life before and life after death. It was not until approximately 1500, when worldly patrons began to influence artistic themes, that the ages of Man were more frequently painted. Hans Baldung made them the theme of his own work on several occasions.

It is difficult to judge whether the child at the young woman's feet is a boy or a girl; contours barely visible behind the veil suggest a boy. The hobby-horse, probably considered a boy's toy at the time, tends to confirm the suspicion. Conversely, however, if the painting is intended to portray "the three stages", why give childhood a different sex from that of maturity and old age?

Perhaps the gender of a child was of little importance to contemporary spectators. The difference was, in any case, rarely emphasized. During the first years of their lives, boys and girls wore the same clothes: long frocks or smocks, and snug caps in winter.

At the same time, less interest was shown in children altogether than is the case in today's nuclear family: bonding between parents and children did not occur with quite the same intensity. Too many children were born, and too many died. Only a fraction of those born actually survived; it was better, therefore, safer, not to get too close. Perhaps such emotional reserve partly also explains why artists paid relatively little attention to children. They perceived the adult body more accurately than that of a child. This is certainly true of Hans Baldung Grien. Children who are not old enough to find their balance do not kneel with one leg stretched out in the manner shown in the painting. At least, the position would be extremely unusual.

The image of the child was determined not only by feelings and social relations, but by a whole superstructure of theological theory. This included the tenet, prevalent since antiquity, that children were intrinsically innocent. However, everyday relations with children made very little of the belief in a child's innocence. Children were treated as imperfect adults. Their special status existed only in theory, characteristically illustrated

by a motif in the Bible story of the Garden of Eden: the bite taken from the forbidden apple, and Man's consequent loss of innocence. Baldung cites the theme in the shape of the round object on the ground: this could simply be a child's ball, but it could equally be an apple lying within the child's reach. The child is likely to pick it up before long.

To an educated spectator, the hobby-horse, too, was more than a toy that happened – by accident, as it were – to be lying on the ground. Cognoscenti would have linked it, through one of Aesop's fables, to the theme of the different stages of life. For the Greek writer attributes an animal to each of the three stages: the dog, the ox and the horse. The dog, a morose creature, friendly only to those who look after it, stands for old age; the ox, a reliable worker, who provides nourishment for old and young alike, represents life's prime; the horse personifies childhood, since, in this fable at least, horses are unruly creatures, lacking in self-discipline.

The star of the painting is the damsel. The other figures seem present solely to make her stand out more starkly. Baldung achieves this effect by arrangement and colour: the young woman is furthest to the fore, the only figure whose body is not, at least partially, obscured by one of the others. At the same time,

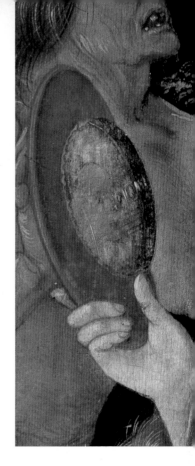

her skin is significantly brighter, indeed nearly white.

In his use of colour, Baldung follows a convention here. His teacher Albrecht Dürer, as well as his contemporaries Albrecht Altdorfer and Lucas Cranach, usually painted the bodies of women somewhat paler than those of men, and young bodies lighter than older ones. But in so doing, they showed moderation, were less given to extremes. Since, even in those days, male skin was

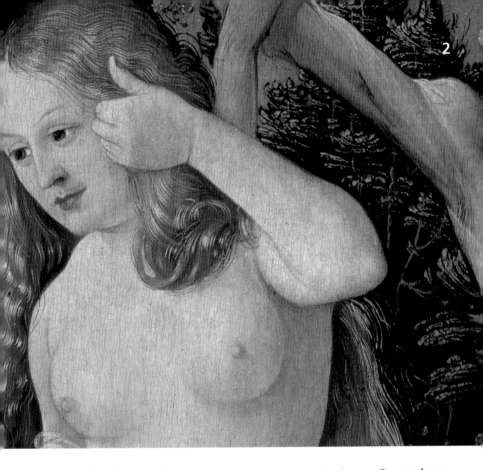

probably no darker than that of
women, and young skin no paler
than old, artists must have been in-
fluenced by something other than
Nature. Perhaps pallor was intend-
ed to indicate a certain delicacy. It
is more likely, however, that they
were painting an ideal aspired to by
women themselves. Pale skin was
the fashion, at least in circles that
could afford it: at court, or among
the wealthy urban middle class.

The special status granted to the

young woman may mean that she
is intended to represent a special
person: the goddess Venus, for
example. The child, in that case,
would be Amor. However, contem-
porary spectators of the painting,
exposed to pictures of Venus and
Amor more often than we, would
have noticed immediately that
something was wrong. Amor, for
one thing, has no bow and arrow,
his traditional attributes; secondly,
since Venus is immortal, the hour-

**Beauty keeps
her secret**

The Three Stages of Life, with Death, c. 1510

glass held over her head is entirely superfluous.

If not a goddess, perhaps the young woman was intended as the allegory of Vanity. There is much in the painting to suggest this. The young woman, apparently absorbed in her own reflection, brushes back her lovely, long hair with her left hand, while, in her right, she holds a mirror, the symbol of Vanity. The mirror is convex; flat mirrors were difficult to fabricate, and therefore inordinately expensive. If the

The body becomes a burden

3

young woman is Vanity, then the older woman is a procuress: supporting the mirror with one hand, she probably beckoned with the other, making sure the young woman did not lack admirers for very long. Death, too, has its place in this picture: anyone setting out to paint the vanity of beauty would probably also have its ephemerality in mind. This was doctrinaire Christian morality, for which the flesh, an obstacle to the spirit's journey to God, was evil. Outside the church, too, people were constantly forced to confront death and the ephemerality of life. The average life expectancy was thirty, almost half our own. Many died in their prime, especially women in childbirth. Hans Baldung Grien painted at least three women who had come under the shadow of Death.

In contrast to the three paintings mentioned, however, Death in the present picture seems merely to be imparting a polite reminder to the young lady that life eventually comes to a close. The hourglass has not yet run out: Beauty has time enough to regard herself in a mirror. But is she really the allegory of Vanity? The child would certainly be out of place in such an allegory. Baldung's composition does not comply with any of the many iconographical patterns of his time. Something is always left unexplained.

Greek and Roman authors, writing of the different periods of life and death, had men in mind. They talked of young men and old, not of girls and old women. Men, during antiquity, were considered the true representatives of mankind, a notion which has survived the centuries and, even today, continues to find its way into people's minds.

Painting has often differed in this respect, not least that of Baldung himself. Three of his paintings show Death and a maiden. A panel in Leipzig shows the *Seven Stages of Life*, another, in the French town of Rennes, the *Three Stages of Death*: in both Baldung paints nude women. Only once does Baldung show Death and a man: the man is fully clothed, his dress that of a mercenary. Baldung's preference for women may derive from a more general preference for painting the female nude. But there may also be reasons less personal: women's bodies alter more visibly than men's, making it easier for the artist to illustrate the different stages of her life. Furthermore, beauty is considered more significant in woman than in man – more attention is therefore accorded to the passing of her charms.

Baldung's work belongs to a period in the history of art called the Renaissance, an era in which the human body is said to have been discovered anew. But that is only half the story. The body that was discovered, celebrated and painted over and over again was restricted to a single stage of human development: young adulthood, which, like the pale-skinned woman in the painting, was full of youthful energy. The other periods, age and childhood, were neglected. There are very few individual portraits of children, or paintings of nudes who are visibly past their prime.

If painted at all, then it was not for their intrinsic qualities, but for purposes of vicarious illustration. Children, for example, were a part of the traditonal inventory of allegories: as putti, angels or Amor. The bodies of old women, on the other hand, were generally linked to something revolting or contemptible: witches, for example, or the Fates. One such work is Dürer's famous illustration of parsimony, showing a bare-breasted old hag with narrow eyes in her wrinkled face, with more gaps between her teeth than teeth in her mouth, and a sack of gold in her lap.

The old woman in Baldung's painting may be intended as a bawd. In contrast to the younger woman, she is portrayed to her disadvantage, for her bodily proportions are incorrect. The arm with which she wards off Death is too long. Baldung frequently distorted proportions in this way.

The lack of respect and devotion granted older women at the

Dancing to death

time, with the exception, perhaps, of portraits like Dürer's charcoal drawing of his mother, together with a pronounced tendency to portray the older female nude as ugly, probably derive from a peculiarly male perspective. The young woman, the object of male desire, was given a certain appeal; sexual inclination determined aesthetics. Conversely, an older woman's body was seen as worn out, its erotic properties dissolved. The male reaction to this was one of disillusionment, perhaps even disappointment. This decided how he painted.

The artist has crowded three figures into the left of the painting, leaving the right to Death. The proportional harmony and figural balance sought by Dürer is lacking here. Instead, the chief effect is one of movement: created, for example, by the old woman striding forcefully towards Death, or by the veil. The latter begins with the child, flows over the young woman's upper arm, is picked up by Death, finally drifting out of the painting on the right.

It has been suggested that the pale nude's veil is the badge of a whore, for in cities like Strasbourg at that time, prostitutes were obliged to wear veils. But then the Virgin was also frequently painted wearing a veil, as were Eve and

Venus. It is therefore unlikely that Baldung's contemporaries would have linked the delicate fabric of the veil with the idea of fornication.

The veil is nonetheless an important feature. Firstly, it fulfils a practical and traditional function in covering the pubic region; secondly, it creates a link between the child, the young woman and Death. The older woman, warding off Death with one hand and supporting the mirror with her other, completes the group.

All four are inter-connected. The cycle of figures thus suggests the motion of a dance: a roundel. Dancers often joined by holding a piece of cloth rather than each others' hands.

Bearing this in mind, it is possible that the contemporary spectator of this painting would not have thought only of Venus and Amor, Vanity and the bawd, the ages of Woman, beauty and ephemerality, but also of the widespread image of the *danse macabre*, the dance of death. It was an image often seen carved on the walls of graveyards and churches: a skeleton, usually playing an instrument, leads representatives of each of the social strata, from the peasant to the emperor to the pope, into the Hereafter. The message these pictures conveyed was that Death cancelled worldly distinctions; only God's judgement counted.

This religious and moral exhortation was evidently compounded by the widely held belief in ghosts. Death was not the only figure to haunt the living; there were also the "undead". People in those days spoke of revived corpses, dead persons taken before their time, the victims of murder, suicide, accident or war, who, deprived of last rites, roved the surface of the earth like a "tormented army".

One of Baldung's contemporaries, the doctor and philosopher Paracelsus, referred to these revived corpses as "mummies". The term aptly describes Hans Baldung Grien's figure of Death: no naked skeleton, but a dried-out corpse, whose finger and toe-nails continue to grow, whose parched skin hangs down in tatters like the dry bark of the nearby tree. But even a superstitious belief in zombies cannot fully account for the four figures in the painting. There is, at any rate, one thing that all these explanations have in common: the painting contains no reference to the Christian notion of salvation, not a trace of that doctrine of Divine Supremacy that was acknowledged and celebrated so frequently in medieval painting.

A papal miracle – painted to reinforce papal authority. The latter, undermined by a deep crisis in the Church, needed propaganda to support it. In the year Raphael completed his fresco, the Reformation began in Germany with Luther's 95 Theses pinned to the door of the palace church at Wittenberg. The base of the fresco, in the former Vatican dining room, measures 6.97 metres.

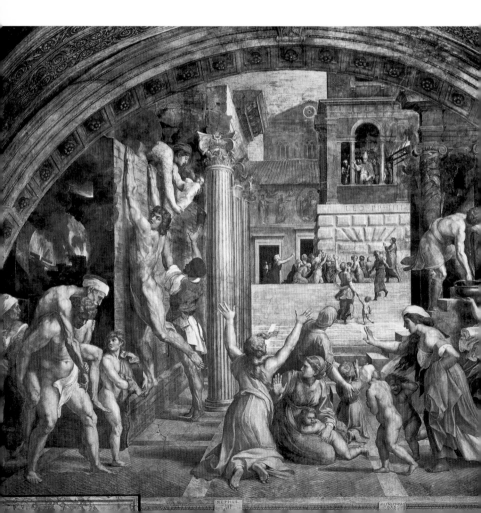

Composure in the face of misfortune

Pope Leo X was much given to sensuous pleasure. During long banquets, he would close his eyes and hum along to the music. When he opened them, and his gaze rested on the walls of his dining chamber, he could enjoy frescos by Raffaello Sanzio of Urbino, the most popular and well-paid painter in Rome.

Raphael's frescos show scenes from the lives of previous popes called Leo. A fire was said to have broken out near St. Peter's, in the Borgo San Pietro, during the time of Pope Leo IV (847–855). The fire raged until the local population sought the pope's help. The Holy Father made the sign of the cross, whereupon the fire immediately went out: a papal miracle.

Little is seen of the dangerous fire in Raphael's monumental fresco (base: 6.97 metres; top arched by domed ceiling). One or two figures are shown fighting it with vessels of water; others, barely dressed, try to escape. The arms and faces of the figures in the backgound are raised in supplication to the pope. He alone can save them from catastrophe. He alone can command the hostile elements.

The image was undoubtedly appreciated by the patron of the fresco. Weakened by internal disruption, Italy was in desperate need of a pope who could perform miracles and protect it against the French, Spanish and Imperial armies struggling for European hegemony.

Leo X wished to be remembered as a pope of peace. The motif of a legend from the life of a previous Leo served his cause very well. He showed great interest in the progress of the fresco. "The pope summons us every day," reported Raphael, who started work on the papal dining chamber in 1514, "and discusses the work with us a little".[1]

The three other walls also show topical papal feats. The dining chamber was the first room painted

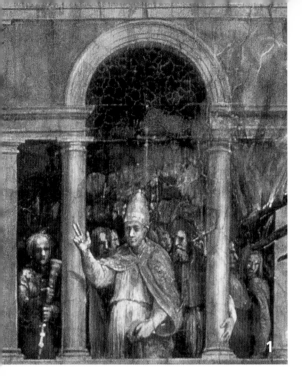

tants for completion of the Vatican frescos. *The Fire in the Borgo* was the last fresco to be executed by his own hand. The dining chamber was completed in 1517. The appartments "owed their distinctive beauty to unique works of art," wrote Leo's secretary, and to the fact that they were "almost always full of cardinals".[2]

Pope Leo IV appears at the window of a loggia, surrounded by attendants. His features are those of Raphael's patron, Leo X. At his first Easter procession, Leo is said to have almost collapsed under the weight of his golden ceremonial gowns and tiara. A weakly man, he was no longer in the best of health at the age of 37, when the painting was executed. His health had influenced his election. Many cardinals had hopes of succeeding him; none of them had wished a "strong pope".

Leo's predecessor on St. Peter's throne, Julius II, had been known as "il papa terribile": "the terrible pope". His portrait, too, can be found in Raphael's Vatican frescos.

During his ten years of office, Julius had been at war almost continually. He had taken the field himself, swearing like a trooper, commanding battles, besieging towns. He saw himself not only as the head of the Christian Church, but as a worldly ruler.

With his battle-cry "Fuori i barbari" ("Out with the barbarians"),

An Epicurean on St. Peter's throne

by Raphael for Leo X. Raphael had also enjoyed the great respect of Leo's predecessor, Julius II, pope from 1503 to 1513.

The artist was born in Urbino in 1483. In 1508 he began work for Julius in Rome. His cartoons for frescos in three new Vatican appartments, known as "stanze", had pleased Julius so much that he ordered all work by other artists to be removed from these rooms. Only Raphael was to paint them.

When Julius died, only two of the rooms were finished. The new Pope Leo X gave Raphael so much work that the young artist was increasingly forced to rely on assis-

Julius had attempted to drive the great foreign powers from Italian soil, constantly forging new alliances in the process. Italy was divided, its towns and princedoms at war with each other. Julius wanted to unite them under papal leadership – a dream, shared by many patriots, which he took with him to the grave. His successor had other interests, and the system of electing popes made it difficult to realise long-term political goals.

Leo X was more interested in family politics than war or empire-building. He had been born in 1475 as Giovanni de' Medici, the second son of Lorenzo the Magnificent, the uncrowned ruler of Florence. It was decided when Giovanni was very young that he should crown the family fortunes with papal dignity. Given a tonsure at the age of 7, he received a cardinal's hat at 14. "God has conferred the pontificate upon us," Leo is known to have said after his election, "we therefore intend to enjoy it!"[3]

The glory of the Holy See under the highly educated humanist and Epicurean Leo X knew few limits. Furthermore, the enthusiastic patronage of the arts begun by Julius continued under Leo. However, since he had practically no background in financial management, he exhausted – according to the French historian Paul Larivaille – the "treasuries of three popes" during his own period of office: the

wealth accumulated by Julius, his own income, and that of his successor.

Despite his desire to be a man of peace, he could not avoid involvement in the struggle between the leading European powers. With his diplomatic intrigues and timid tactical opportunism, he could do little to match leaders like Francis I of France, or Charles V, Spanish and Holy Roman Emperor.

Like other popes, Leo X was unrestrained in his nepotism, surrounding himself with relatives and close friends from Florence. This was essential for his own protection. Rome was a dangerous place, especially after the death of a pope. While the cardinals met in conclave, there were regular riots in the city. The people marched through the streets, plundered the palaces of the dead pope and cardinals, and set them on fire.

Raphael's fresco shows a part of the old city of Rome that was demolished during the 16th century: the original facade of St. Peter's with its Romanesque window arches and mosaics on a golden ground. The basilica had been subject to building work for some time. The church, begun by Emperor Constantine in A. D. 324 over the grave of the apostle Peter, was no longer safe, and its simplicity no longer appealed to High Renaissance taste.

2

The master builders of Rome

Renovations began under Julius, the "terrible pope". In fact, Julius merely wished to build a grand monument to himself in St. Peter's. But when Michelangelo's monument proved too large, Julius decided to extend the church to accommodate it. While plans were being drawn up, however, Julius concluded that only the total reconstruction of Christendom's most important church constituted an adequate monument to his period of office. It was to be a building which could compete in size and magnificence with the "Holy Wisdom" (Hagia Sophia) in Constantinople.

Julius entrusted the architect Bramante with the plans and, on 18 April 1506, ceremoniously laid the foundation stone under St. Veronica's choir-pillar, behind the old façade. The façade itself was left standing, while parts of the basilica were pulled down and renewed.

It was in this half-demolished church in 1513 that Pope Leo X was forced to celebrate his first Easter. He had Bramante continue the building works, appointing Raphael Master Builder of St. Peter's in 1514 after Bramante's death, because, as he said, "We have no greater wish than that this temple be completed in the most splendid manner, and as quickly as possible".[4] The new St. Peter's cathedral was completed in 1626 – 19 popes later.

It was not unusual for painters to engage in architectural work. To meet the Renaissance ideal of "universal man", the artist had to be an "all-rounder". He only had to deliver the plans, after all; the rest was taken care of by experts with the necessary practical experience. "What place … in the world could be more dignified than Rome, and what work confer more dignity than St. Peter's",[5] wrote Raphael to his uncle. His interest in architecture is reflected in *The Fire in the Borgo*. Architectonic features are not merely intended to be decorative. Here, space is used to great effect, and with evident understanding of perspective. The building,

with its mighty square stones and loggia on the church facade, probably reflects plans that Raphael had already drawn up for a Borgo Palace.

The "universal" artist Raphael also designed villas for bankers and palaces for cardinals; he participated in the architectural reconstruction of Rome as a leading city, then fully underway. It was during Raphael's lifetime that the Holy City overtook Florence as a centre of art.

The immense sums of money needed for these works were procured by means of "spiritual" transactions by the popes themselves, not least by Julius and Leo. They sold ecclesiastical offices to the highest bidders, and papal indulgences for every sin in the book. "Thus the material construction of St. Peter's was responsible, to a large extent, for its spiritual deconstruction", as one Catholic historian at the Council of Trent (1545–1563) put it, "for in order to collect the millions swallowed by that colossal work, Julius II's successor was forced to engage in practices which provoked Luther's heresy, which, in turn, has made the Church poorer by an even larger number of millions of souls".[3] In 1517, the year the papal master builder Raphael completed his fresco, Luther had pinned his 95 Theses to a church door in distant Wittenberg.

St. Peter's, the Vatican and other palaces were built largely from the ruins of antiquity. This had been a well-tried method ever since the feudal lords Orsini and Colonna had used the remains of the Colosseum to build fortified towers for themselves and their families. The popes of the Middle Ages had held heathen monuments in disdain. Their humanist successors in the late 15th century, on the other hand, liked to think of themselves as Caesar's heirs, collecting antique medals and sculptures (Julius II, for example, is known to have paid huge sums for the statue of Laocoon, found in the vineyards in 1506). But even these popes exploited ancient remains when it suited them.

During Raphael's lifetime, it gradually dawned on the Romans that something had been lost, irrecoverably, with these buildings. On 27 August 1515, Leo X made the master builder of St. Peter's "praefect over all marble and masonry unearthed from this day forth in Rome and within a compass of ten miles".[6] Anyone finding "marble or other stones" was now obliged to inform Raphael immediately. No "inscribed stones" were to be cut or broken without his permission.

Following their registration, the majority of these "inscribed stones" probably became part of the stonework of St. Peter's. There was little

the artist could do to alter this practice, despite regrets to the contrary, expressed in a letter to the pope in 1518. In the previous twelve years, he wrote, he had "witnessed the destruction of the triumphal arch of the Diocletian thermal springs, the temple of Ceres in the forum and Constantine's basilica …" He found it "… extraordinarily painful to have to behold the cadaver, as it were, of such a venerable and noble town".[7]

The Classical heritage

But Raphael not only tried to preserve ancient Rome; he attempted to reconstruct a picture of it from texts and excavations. In the year Raphael complained so bitterly to the pope, highest honours were conferred upon him for his contributions to archaeology. According to an epigram dating from 1519, he had "sought and found Rome in Rome". "Great is the man who seeks, but he who finds is a god!"[8] While excavating the Latium marshes, Raphael fell ill with swamp fever. He died in 1520.

The painter and architect was greatly celebrated in his own lifetime. Raphael's personality came as close to the ideals of his time as his art. He was modest, well-mannered, widely read and exceptionally charming. His extraordinary career was aided by the fact that the two other major artists of his time did not compete with him: after finishing the ceiling of the Sistine Chapel in 1512, Michelangelo returned to his work as a sculptor; Leonardo da Vinci left for France in 1516.

Success brought him riches. From 1513, Raphael lived in a palace of his own in the Borgo, with a large studio on the ground floor where his assistants did much of the work. Raphael knew how to delegate and organise. He was also an excellent businessman: "… our lord, His Holiness, gives me 300 golden ducats for the building work at St. Peter's which I am to receive as long as I live … Moreover, I am paid for my work as I see fit …"[6]

He received many different honours, almost, indeed, becoming a cardinal. In this, low birth and lack of religious qualification would have proved no hindrance. In 1517, Leo appointed 31 cardinals at a time, inviting all of them afterwards to celebrate the event with him at a huge banquet in the Vatican, under Raphael's frescos.

Raphael's *Fire in the Borgo* is not only a monument to the basilica, it also depicts ancient columns of dark, Africano marble with Ionic capitals, and white columns with Corinthian capitals. There had been columns like these in the basilica at Constantinople. Raphael planned to use them again in the new church. He painted them with cracks and fractures: like the remains of a bygone age.

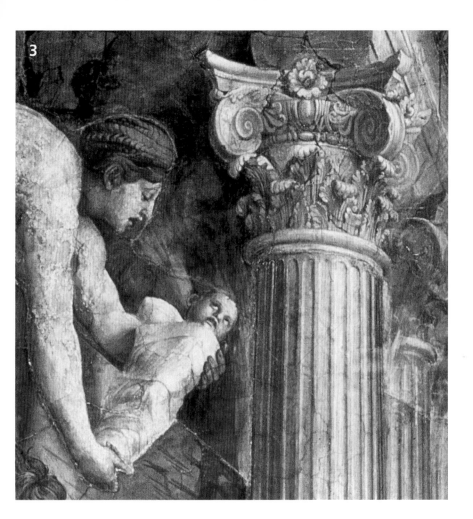

Gaping in amazement, a beautiful woman, bearing water to extinguish the fire, pauses in mid-stride to marvel at the pope's miracle. Her whole bearing expresses nobility, a posture frozen in wonder. The wind plays with her timeless, antique robe to reveal a strong, fully-formed figure. Raphael painted her "with voluptuous brush",[9] according to one of his contemporaries. In a letter to Count Castiglione of Urbino, the artist himself regretted that there were "so few beautiful women available" in Rome as models.[10]

"We lack nothing but women at court",[3] complained Cardinal Bib-

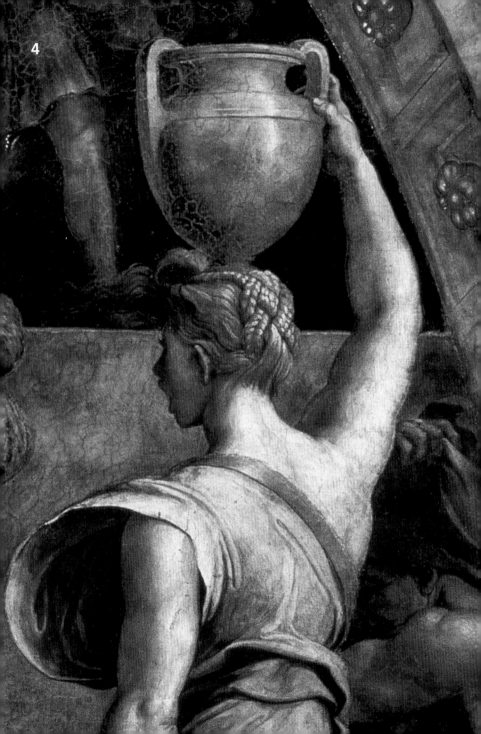

biena. Women in paintings undoubtedly had a special significance at the Vatican. Women were no longer admitted to papal banquets as they had been under one of Julius II's predecessors, the Borgia pope Alexander VI. It would have been thought unseemly for the concubines of the prelates to enter the Vatican.

Raphael, too, is reputed to have kept a mysterious mistress at his palace; he ensured a financially secure future for her through a passage contained in his will. Besides graceful, "sweet" Madonnas, he also painted – like Michelangelo – strong heroines who were capable of maintaining a thoroughly dignified air – and an elaborate coiffure! – while fighting a fire. These women were fully consistent with contemporary taste for what came to be known as the "maniera grande".

The "Grand Manner" was thought by leading humanists at the Holy See to be an appropriate form of homage to the Classical ideals of proportion and harmony. Self-composure was of paramount importance, even during a disaster. It was not only the water-bearer's physical beauty that attracted the admiration of the painting's spectators, but her equanimity, her poise. An open mouth was permissable; distorted facial features were not. Nothing was to be allowed to disturb the spectator's aesthetic pleasure.

The most eloquent contemporary expression of the rules of refined behaviour was Count Castiglione's book *The Courtier*. As its title suggests, the manners it codified applied only to behaviour at court, among the nobility, who were thus able to distinguish themselves clearly from the lower classes. To an aristocratic sensibility, refined manners were a form of real, visible beauty.

These ideals were propagated at a time when Italy, and Rome especially, was threatened by one catastrophe after another: whole streets would be engulfed by flames during fighting between the rival Colonna and Orsini families; the Tiber burst its banks and flooded the lower-lying areas of the city; earthquakes shook the buildings, and after the death of a pope, the mob ruled. While the people prayed fervently to the golden Archangel Michael high up on the Castel Sant'Angelo, the ruling class would strive to maintain its sense of equanimity – not always successfully, however: on the night before Raphael died on 6 April 1520, an earthquake is said to have made Pope Leo flee in panic from the very Vatican appartments where Raphael's frescos pay such impressive homage to the ideal of composure.

In the Grand Manner

Niklaus Manuel: The Execution of John the Baptist, c. 1517

The femme fatale charms the devout viewer

John the Baptist was put in prison for being too popular. He proclaimed the coming of the Messiah, called for repentance and baptized the faithful in the river Jordan. So many people flocked to hear the famous preacher in Galilee that the Roman authorities began to fear he would incite a riot (and exhort the people to stop paying their taxes). Thus reported the Jewish historian Flavius Josephus in the 1st century AD. The Roman governor, King Herod Antipas, had John "clapped in chains, taken to the fortress of Machaerus … and executed".

In Niklaus Manuel's painting, the sword with which John has just been beheaded is lying in a pool of blood on the ground. The body of the ascetic is being quickly whisked away on a bier. The person carrying the front of the stretcher has already disappeared through the arch; only his boot is still visible. The executioner holds out the bloody head of John the Baptist by the beard,

about to sweep it onto a silver tray. Ready to receive this gruesome offering, three women are staring fixedly at the empty platter. The two younger women are called Herodias and Salome, and it is they – so the Bible has it – who have John the Baptist on their conscience.

For if there were political motives for John the Baptist's death, there were also more personal ones. As Mark and Matthew both relate in their gospels, the preacher against vice and moral corruption had been bold enough to openly accuse Herod and his wife of adultery. Herodias had originally been married to Herod's brother Philip, before deserting him for Herod. Insulted and enraged, Herodias "wanted John killed in revenge, but without Herod's approval she was powerless". (Mark 6:19) For Herod knew that John "was a good and holy man", and rather than considering having him executed, "kept

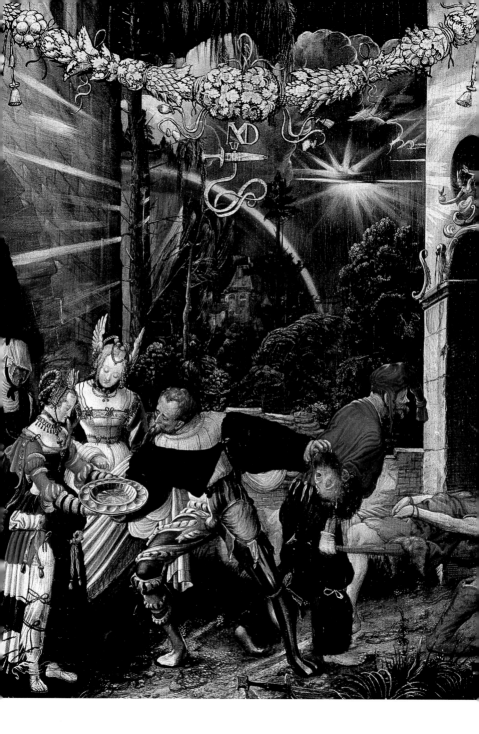

him under his protection" and "liked to listen to him".

His vengeful wife therefore instructed her daughter Salome, Herod's step-daughter, to ask – at a moment when Herod could not refuse her anything – for the head of the Baptist. "I want the head of John the Baptist, right now, on a tray!", demanded the obedient Salome. Herod "was very sorry", but because he had sworn to give the girl anything she asked for, "he sent an executioner to the prison to cut off John's head and bring it to him. The soldier beheaded John in the prison, brought his head on a tray, and gave it to the girl, who took it to her mother." (Mark 6:27–28)

The Evangelists do not say exactly where this transfer took place. The painter sets the scene on an open-air terrace looking out onto a dramatic landscape with a castle, rugged cliffs and windswept fir trees. Dark clouds are banked up in the nocturnal skies overhead, and – an apocalyptic phenomenon – a rainbow and a star are visible at the same time.

The work is first mentioned in an inventory of paintings in 1586, where it is referred to as "The Execution of John with Lightning and Thunder". In 1662 it was purchased by Basle, where it hangs in the Kunstmuseum today. Painted in varnished tempera on spruce, it measures just 34 x 26 cm. In the inventory it was described as "the work of Manüel Tütsch of Berne". This Niklaus Manuel, sometimes known as Niklaus Deutsch, was born in Berne in 1484, and lived an unusual life as a painter, mercenary and statesman – at a time of unusual upheaval for his country.

Bernese mercenaries, like mercenaries from other parts of the Swiss Confederation, headed south in the service of the king, pope or emperor employing them, and from 1494 onwards fought for over 30 years in the Italian campaigns. Returning to their provincial, medieval home town, which

Salome wears the clothes of a prostitute

lay off the major trade routes, they brought with them foreign ideas, customs – and a great deal of money. French gold crowns and Italian ducats flowed for entertainments, luxuries and the arts.

Niklaus Manuel also made a good living. In 1517 he received 400 pounds for a large commission: the decoration of the choir of Berne cathedral. The present, "small *Execution*" probably dates from around this time. An earlier version of the same subject, the "large *Execution*", still hangs in Berne today. John the Baptist was extremely popular – as evidenced not simply by the numerous altars dedicated to him, but also by the so-called "John trays" displayed in many chapels, on which lay naturalistic models of the head of the Baptist, still dripping with "blood".

Many Swiss made the pilgrimage to Amiens cathedral in France, which boasted amongst its relics the "genuine" head of the saint (as, incidentally, did Paris, Venice and several other cities). Pilgrims prayed to John the Baptist for a cure for every possible ill, and in particular – and appropriately – for headaches and an addiction to dancing.

Niklaus Manuel's Salome does not seem very distressed by the execution. Her appearance as she looks at her tray is rather that of an upright, dutiful daughter of a Bernese dignitary out shopping in the market.

Only the infamous slit in her tucked dress, revealing a small area of white flesh beneath a see-through petticoat, hints at the charms of the biblical Lolita who seduced her step-father. While the king was dining with his guests, so Mark relates in his Gospel, "the daughter of Herodias herself came in and performed a dance that greatly pleased them all". The king then promised Salome, "I will give you whatever you ask, up to half of my kingdom!"

More the Evangelists do not say; they do not even call the "girl" by her name. As "the daughter of Herodias", she remains an anonymous instrument in the hands of her mother. The historians, too, know little more than that she married a King Aristobul, was depicted on a gold coin and was called Salome. Yet this secondary player in the martyrdom of St John is omitted from none of the altars dedicated to him, and for almost 2000 years has ranked amongst the favourite subjects of painters, writers and composers.

It is Salome's dance which, for artists, holds the greatest appeal of all. It adorns the 11th-century Bernward column in Hildesheim and the bronze doors of the church of San Zeno in Verona (around 1100), whereby Salome's art (she is dancing on her hands!) strikes us as more acrobatic than alluring. People in the past must have thought

2

**A Confeder-
ate soldier
wielded the
sword**

otherwise: in as early as the 5th cen-
tury, the church fathers condemned
Salome's depravity and denounced
dancing in general as the ultimate
in wantonness and vice.

It was with similar words that
the preachers of Niklaus Manuel's
day thundered their warnings
against the evils of dancing from
the pulpit of Berne cathedral. If we
are to believe the many prohibition
orders from this period, the pleas-
ure-addicted citizens of Berne
danced day and night in their
homes, in the streets, in the town
hall, and especially under the arch-
es of the Franciscan monastery. The

preachers blamed the decline in
Berne's once so strict morals on the
mercenaries, for "war and money
are a school for every vice".

This was the reason for the strict
dress code in force in Berne up to
the end of the 15th century, which
decreed how each class had to clothe
itself. After the lucrative Italian
campaign of 1516, however, the
wearing of "gold, velvet and silk"
became widespread "to a degree
never before seen", complained the
Bernese historian Anshelm. Niklaus
Manuel's Salome is wearing "Ital-
ian" sandals, puffed sleeves and a
laced dress in the very latest fash-

ion. Her costume is thereby almost identical to that of a prostitute whom Niklaus Manuel portrayed around this same period. The prostitute is dancing towards her death in the arms of a skeleton. Salome, too, did not escape death: she was dancing on the ice one day, so legend has it, when it cracked "as soon as she put her accursed feet" on it. She sank beneath the surface and the ice closed around her, leaving only her head sticking out – as if decapitated.

The executioner offers another example of extravagant Confederate fashion: over a finely-pleated snow-white shirt, he wears an asymmetrically-cut short velvet jacket and particularly elaborate multicoloured hose – one leg lavishly decorated with a notched trim, the other patterned with a vertical stripe and featuring a gaping hole which reveals the silk lining beneath. This type of "holiness" guaranteed not only freedom of movement, but also signalled – then as now (as in the case of jeans) – non-conformism and provocation.

Provocative, too, is the elegant, dancing pose in which the executioner is captured, like a lunging fencer. Agility, combined with a powerful, accurate strike, were the trademarks of Confederate mercenaries, "invincible giants" who did not wear armour. The artistic prototype created by Niklaus Manuel

continues to adorn the stained-glass windows of Swiss churches: with legs astride and a flag in his strong fist, he recalls past military might.

These soldiers, who emigrated briefly from their homeland to seek their fortune in the service of foreign masters, liked to pride themselves on their chivalrous virtues. They sought single combat and despised cannon as "dishonourable". To the German humanist Jakob Wimpheling, however, they remained "obstreperous, sullen and arrogant wild men", taught from their youth onwards only to reach for their weapons. They sold themselves to those offering the best pay and observed no discipline. These "honest Confederate soldiers" plunged into the fray or left the battlefield depending on their mood. When they failed to get paid after the capture of Novara in 1522, they took out their anger on the town, plundering, burning, raping and murdering with the utmost brutality.

The king of France, the Pope and the German emperor all vied for their services, each bribing them away from the others. The Confederates' central geographical position meant that a contingent of 30,000 soldiers could be deployed in Italy, France or Germany within two weeks. With success: in 1512/13 the Swiss drove the French out of Upper Italy, installed Sforza as the Duke of Milan and conquered Do-

modossola, Locarno, Lugano and the Valtellina. They were at the height of their power. In 1516 they switched allegiance and subsequently fought on the side of the French.

The Bernese troops who marched to Italy between February and May 1516 also included the 32-year-old Niklaus Manuel, serving as "army secretary" to Albrecht von Stein, commander of the Bernese force. Like so many of his contemporaries, he left his wife, child and job – an altarpiece for the town of Grandson – in the hope of easily-earned money, adventure and foreign climes. He is supposed to have returned home with a rich booty.

Because they had gone to war without the official permission of the Bernese authorities, however, the painter and his colleagues first had to hide out in the Franciscan monastery for a few days. In anticipation of a mild sentence, they spent their time there eating and drinking merrily.

In 1522 Niklaus Manuel contracted himself out anew. The historian Anshelm reports that the painter injured his hand during the plunder of Novara. He was also on the field when the Confederates suffered a devastating defeat in the battle of Bicocca. Over 4000 Swiss soldiers lost their lives, including Albrecht von Stein. Niklaus remembered them in his *Song of Bicocca*, his first work of poetry known

to us, in which he insults the victorious enemy in the coarsest terms. In his Berne *Dance of Death*, he portrays himself, the painter at work, as the last figure in the roundelay. Spruced up in exactly the same elaborate costume as John the Baptist's executioner, he is quite the proud Confederate soldier.

Salome was not the only one to meet an unfortunate end. According to some people, so the *Golden Legend* relates, when Herodias "had the head [of John the Baptist] in her hands and taunted it gleefully, by God's will the head breathed in her face and she expired". Other legends have her as a witch, swooping through the skies at full moon on Midsummer Eve and pitilessly chasing the head of the Baptist like a ball. The Romantic poet Heinrich Heine met her – and fell under her spell, like many artists before and since. "Why did you look at me so tenderly, Herodias?" For Herod's beautiful wife is a biblical example of a *femme fatale*, a woman who brings about a man's undoing. Perhaps Niklaus Manuel's Herodias possesses magical powers; her exquisite headdress suggestively includes the wings of an owl, the messenger of death. Above all, she is strong-willed: with her slender index finger, Herodias instructs the executioner precisely where he is to put the severed head – possibly in mocking imitation of the gesture

with which John the Baptist, in many paintings, points to Christ, whose coming he has been preaching.

It is not surprising that some artists should have confused Salome and Herodias, since both embody the allegedly dangerous aspects of the female sex. Thus John is the victim both of the hatred, thirst for vengeance and unscrupulousness of the adultress Herodias, and equally, of the erotic arts of seduction practised by the wanton dancer Salome. In Niklaus Manuel's painting, the two are joined by an ugly old woman, completing the popular group of the "three ages of man". She might be the old nurse who helped concoct the murderous intrigue, or even Satan in person. In some of the popular "St John plays" performed in the 15th and 16th centuries, the devil visits Herodias in the shape of an old woman, in order to goad her on against the Baptist.

This threatening trio embodies the power of women. Even Niklaus Manuel must have been scared stiff of them. In his sketchbooks, attractive female figures are almost always armed – with a "lasso", or a sword or dagger. He associated women, beauty and eroticism with blood and death and thereby shared the gruesome leanings of his day. From the 13th century onwards, John's execution was clearly the most popular episode in the Baptist's life

as far as artists were concerned. The number of portrayals of such execution scenes doubled every hundred years or so, reaching its high point in the 16th century. At the same time, the number of protagonists was reduced, and the format of the painting shrank accordingly. Niklaus Manuel's almost miniature-like work can hardly have been painted for a church; the Bible served merely as the pretext for a private devotional image whose

The fearsome power of women

4

Signed with a dagger

purpose was simultaneously to satisfy the piousness, sadism and lust of an – unknown – Bernese art lover.

Behind the clouds filling the sky of this "Execution with Lightning and Thunder", a star is shining. The *Golden Legend* relates that "a star … came to rest over the spot where John the Baptist's head was buried". Mysterious natural phenomena such as comets and eclipses were believed to accompany significant events and were viewed as portents of disaster. In times of uncertainty and fear, they were seen with par-

ticular frequency. When the Swiss suffered a serious defeat at Marignano in 1515, two blood-red stripes – reported the historian Anshelm – could be seen running all the way to Berne in the skies over the Confederation. They were signs of further calamity.

Bicocca was followed in 1525 by the equally catastrophic battle of Pavia, where the fleet-footed Swiss soldiers fell beneath the fire of the cannons they so despised. With increasing frequency, too, Swiss soldiers found themselves facing each other on opposite sides of the battlefield. Civil war threatened. The

mercenary profession had plunged the country into serious political and social crisis.

In his poem *The Dream* of 1522, Niklaus Manuel describes how, during sleepless nights, he worries about his homeland and yearns for peace and a new order. Another important celestial sign was the rainbow. Ever since it appeared to Noah, announcing the end of the Flood, it had been seen as a symbol of peace and salvation. It signalled hope for a fairer world and was clearly connected with John the Baptist, who foretold the salvation of the world through Christ. It was from a pulpit decked with a rainbow banner that the preacher and revolutionary Thomas Müntzer (c. 1490–1525) called for a radical shake-up of existing conditions. And it was beneath rainbow pennants that the rebellious peasants marched into the battle of Frankenhausen.

Meanwhile, in Berne cathedral, Berchthold Haller had started preaching in a slightly more moderate vein, in an attempt to "tame the wild bears with the teachings of Christ". He looked for salvation from the political confusion in passages from the Bible, and in a reformation of the Church and morals, for "the mercenary soldier is an inhuman … sinful thing". The small, influential groups who supported him soon took on Niklaus Manuel, as an agitator and propagandist of the Reformation. The painter wrote polemical pamphlets, denounced the corruption of the clergy – which he had experienced at first hand in Italy – and fought, this time with his pen, for a new order. The former soldier became a politician, and from 1523 to 1528 was bailiff of Erlach, not far from Berne. He had little time left over for painting.

It is possible that the "small *Execution*" was painted at the start of Niklaus Manuel's period in Erlach. However, it is usually dated to 1517, however, on the basis of the Swiss dagger – halfway between a dagger and a sword – which appears in the centre of the painting under the artist's gold monogram. Over the course of the years, its blade grew broader and shorter and was decorated with a ribbon. Manuel used this weapon, typical of Confederate mercenaries, to sign both his paintings and his pamphlets. The fact that his signature occupies such a prominent position in the upper half of the picture suggests more than just a healthy self-confidence. Perhaps the artist painted the panel for his own use. Perhaps it hung in the chambers of Niklaus Manuel the statesman, who in 1529, as a member of the privy council – the executive in post-Reformation Berne – passed strict laws against service in foreign armies, the carrying of weapons, eye-catching dress, vice, adultery and dancing.

Albrecht Altdorfer: The Battle of Issus, 1529
The battle to end all battles

The Wittelsbach Duke Wilhelm IV was hardly one of the more important rulers of his day. He governed Bavaria from 1508 to 1550, during the Reformation, but his strategy of shifting alliances with the powerful Habsburgs, French king and Protestant rulers brought him little advantage; he even made a vain attempt to become German king. On the other hand, he did achieve two things with lasting effect: Wilhelm

ensured that Bavaria remained a Catholic land, and he commissioned one of the most important German paintings, Albrecht Altdorfer's *The Battle of Issus*.

The painter and architect Altdorfer lived in Regensburg, approximately sixty miles north of the ducal residence in Munich. Though situated in the middle of Bavaria, Regensburg was a Free Imperial Town, whose allegiances alternated between the Emperor in Vienna and the Wittelsbach dukes. The same might be said for the Regensburg citizen Altdorfer. Altdorfer executed some 200 works for Emperor Maximilian, most of them miniatures and woodcuts, but he created his masterpiece for Duke Wilhelm in Munich.

Altdorfer must have been almost 50 when he received the commission to paint *The Battle of Issus*. His exact age cannot be established, since his date of birth is unknown. It is thought to have been *c.* 1480. However, documentary evidence

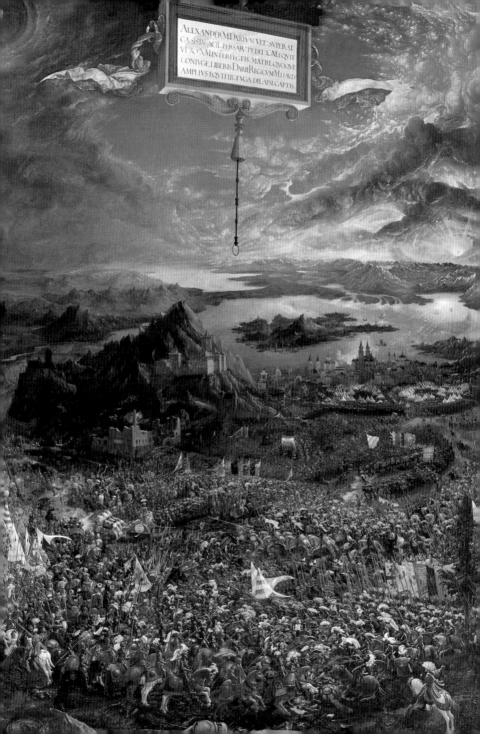

ALEXANDER M·DARIVM·VI·CT·SVPERAT
CÆSIS·IN·ACIE·PERSAR·PEDIT·X·M·EQVIT
VERO·A·M·INTERFECTIS· MATRE·QVOQVE
CONIVGE·LIBERIS·DARII·REGIS·CVM·M·HAVD
AMPLIVS·EQVITIB·FVGA·DILAPSI·CAPTIS·

does reveal that Altdorfer quickly rose to wealth and prestige. In 1513 he bought a house "with a tower and farmstead". In 1517 he became a member of the Outer Town Council, in 1526 a member of the Inner Council, and on 18th September 1528 he was elected Mayor. However, Altdorfer declined this high office. His reason for doing so is mentioned in the annals of the Regensburg Council: "He much desires to execute a special

Women on the battlefield

work in Bavaria for my Serene Highness and gracious Lord, Duke Wilhelm." This "work" was *The Battle of Issus*.

As an artist and member of the town council, Altdorfer became involved in the conflicts of his age. He announced the town's expulsion of its Jewish inhabitants, making a quick sketch of the synagogue before it was destroyed. His connections to the imperial court were such that, when Regensburg fell into disgrace with the Emperor, Altdorfer was entrusted with the mission of apologizing. When the Turkish army threatened Vienna, he was given the task of fortifying the Regensburg defences.

As a member of the town council, Altdorfer had to interrogate Anabaptists and sit in a committee to appoint a Protestant minister. In his will, he declared that he had no desire for "spiritual accessories", which probably meant that he rejected the administration of last rites, or the holding of a mass. By the time of his death in 1538, he was probably no longer a practising Catholic.

The schism within the church and the military threat that sprang from the non-Christian Orient were the two main factors determining life at the time. Insecurity and fear were widespread. It is against this background, too, that we must consider the genesis of the present painting.

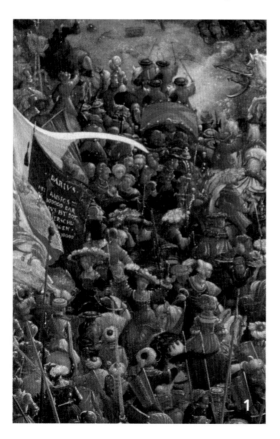

Albrecht Altdorfer

The artist shows an event from the distant past, a battle fought near Issus in 333 B. C. This he sets against a panorama of sky and landscape; the battle in Asia Minor thus assumes the aura of a natural disaster, or a scene from some cosmic Armageddon. In fact, the battle was seen at the time as a turning point in world history: the Greek Occident had defeated the Persian Orient.

The contemporary signifcance of the subject was obvious, and the tablet proclaiming victory at the top of the painting assumed a special significance in the face of the Turkish threat. The tablet appears to descend from the vault of the heavens, and bears a message in Latin: "The defeat of Darius by Alexander the Great, following the deaths of 100,000 Persian foot-soldiers and more than 10,000 Persian horsemen. King Darius' mother, wife and children were taken prisoner, together with about 1,000 fleeing horse-soldiers."

Altdorfer provides details of military strengths and losses not only on the large tablet, but on banners and flags. The painting was probably intended to serve several purposes, one being to keep alive Alexander's strategic fame, which derived from the Macedonian's defeat of an army many times larger than his own. According to figures cited in the painting itself, Darius commanded 300,000 foot-soldiers, while Alexander led only 32,000; the Persian king had a cavalry of 100,000, his opponent a mere 4,000. One of the great general's admirers was Napoleon, who, in 1800, had Altdorfer's painting brought to Paris and hung in his bathroom.

As an artist, however, Altdorfer evidently felt little obligation to illustrate the details he cited. There is nothing in the painting to sugggest the numerical superiority of Darius' army; nor has the artist followed historical accounts of strategic deployment. On top of this, he has clothed the figures in the dress of his own time. The cavalry wear heavy armour; some of Persians are shown in turbans of the kind Turks were seen to wear. The women in feathered toques look like German courtly ladies, dressed for a hunting party.

That Altdorfer painted women at all on a battlefield must probably be attributed to his passion for invention. The 16th century became increasingly preoccupied with western civilisation, but this was not necessarily accompanied by an interest in historic truth. Investigative research into the past had not yet begun; archaeology was a subject of the future.

One of Altdorfer's sources was probably Hartmann Schedel's "World Chronicle". Most of the artist's statistics are identical to

those given by Schedel. The book had appeared in Nuremberg in 1493, 35 years before Altdorfer commenced work on *The Battle of Issus*. Another source may have been an account written by Q. Curtius Rufus, a document probably dating from the first century. However, neither work makes mention of women entering the fray – one of Altdorfer's inventions.

A highly dramatic scene involving women is indeed related in Curtius's account, only this takes place in a camp. According to Curtius, Darius' mother and wife, taken prisoner in their tents, suddenly began to wail: "The reason for this shocking scene was that Darius' mother and wife had broken into loud and woeful lamentations for the king, whom they thought killed. For a captive eunuch … recognizing Darius' tunic, … which he had cast off for fear that his clothing would betray him, in the hands of the soldier who had found it, and imagining the garment to be taken from the king's dead body, had brought false news of his death."

Darius escaped with his life at the battle of Issus. He was certainly not pursued by Alexander to within a length of the latter's lance, as Altdorfer's painting suggests. At least, there is no mention of this in either historical account. The artist was faithful to historical truth only when it suited him, when historical facts were compatible with the demands of his composition.

It is not known what Altorfer's patron wished the painting to show: admiration for Alexander's strategic prowess, the parallel with the Turkish threat, or – since he was himself such an enthusiastic participant in tournaments – a celebration of chivalry? All that can be said for sure is that Altdorfer's painting reflected one of the chief preoccuptions of his age: the reappraisal of Classical antiquity was a characteristic feature of the Renaissance. During the Middle Ages, saints had grown in significance over the legendary figures of ancient Greece and Rome, and more value was attached to relics of Christian martyrs than to antique manuscripts. However, a change in attitude soon began to make itself felt in quattrocento Italy, spreading north across the Alps during the century that followed. The saints began to lose their exemplary status. Of course, this process was linked to the decadence of the Roman Catholic Church. Reappraisal of antiquity and the decline of the Church went hand in hand.

Wilhelm IV commissioned not only *The Battle of Issus*, but a whole series of heroic scenes: Hannibal defeating the Romans at Cannae, Caesar besieging Alesia, the captive Mucius Scaevola burning his hand

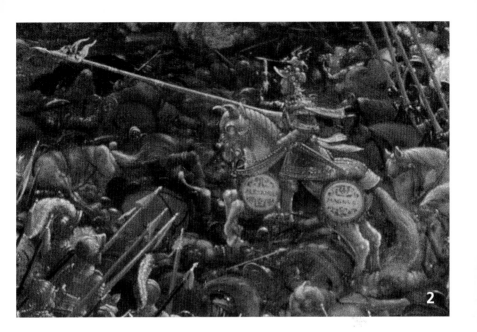

2

to demonstrate to his adversaries the bravery of the young men of Rome; eight paintings (of which Altendorfer painted only one) in an identical, upright format. There is also a second series in horizontal format – possibly commissioned for the Duchess – showing seven famous women, many of them Old Testament figures: Susanna bathing, before defending herself against the advances of two elders who slander her and condemn her to death; Judith cutting off the head of Holofernes, the enemy of her people; and Helen, Troy's ruin.

All of these men and women had distinguished themselves in some way or other. The interest they aroused during the 16th century was not only a sign of the period's rediscovery of antiquity, it was the mark of a new sense of self. During the Renaissance people no longer saw themselves solely as members of a social group, as the citizens of a town, or as sinners before God in whose eyes all were equal. They had become aware of the unique qualities that distinguished one person from another. Unlike the Middle Ages, the Renaissance celebrated the individual. Altdorfer may have painted row after row of apparently identical warriors, but the spectators themselves would identify with Alexander and Darius, figures who had names, whose significance was indicated by the cord which hung down from the tablet above them.

The Battle of Issus, 1529

53

Schedel's *World Chronicle* was a seminal work, treasured not only for its comprehensive survey of the historical knowledge of the age, but for its detailed approach to geography. The book contained illustrations of the more important figures of the Bible and Classical antiquity (naturally wearing 16th-century dress); it also showed the famous woodcut *vedutas* of towns executed in Nuremberg after the sketches of travellers.

The *World Chronicle* thus not only reflected contemporary interest in the history of civilization "from the beginning of the world unto our own time", but also a widespread curiosity about geography. In this sense, it is a typical product of the age of discovery, an epoch marked by Columbus reaching America, Magellan sailing around the world, and attempts by cartographers to find the appropriate visual form in which to present distant parts of the world. Altdorfer attempted something similar. His *Battle of Issus* is set against the imposing panorama of the Eastern Mediterranean.

The inspiration for this was probably provided by a map in Schedel's chronicle. In the detail below, Cyprus is shown as a disproportionately large island, with the Red Sea above it to the left. Above right is the Nile delta, identified by its eight arms and by the lakes

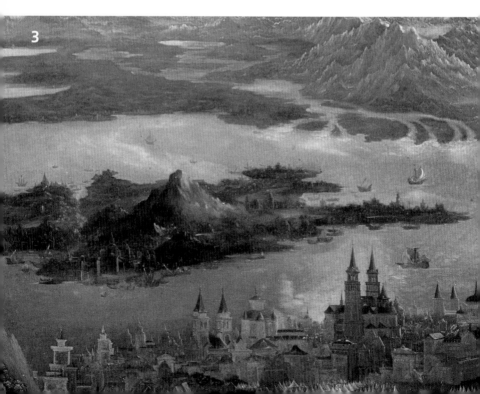

3

thought to be its source. The mountain range beside the Nile has no equivalent in reality, but is featured in Schedel's map.

The town situated on the near Mediterranean shore is probably not intended to be Issus. Issus was an unimportant town in Altdorfer's day, and is not mentioned in Schedel's book. According to the *Chronicle*, the battle took place in 333 B.C. near the town of Tarsus. This, by contrast, was a name to conjure with, associated in many readers' minds with a school of philosophy which, in Roman times, had been as famous as the schools of Athens and Alexandria. First and foremost, however, Tarsus was known as the birthplace of the Apostle Paul, a place of significance in church history. Perhaps this explains why Altdorfer – anachronistically – embellished the townscape with church towers.

For in spite of the Renaissance, the prevalent geographical and historical pictures of the world c. 1500 were still dominated by church doctrine. This, too, is reflected in Schedel's book. The acts of God in creating the world are there presented as no less factual than the number of soldiers who took part in the Battle of Issus. Because God created the world in six days and rested on the seventh, Schedel divided the entire history of mankind into seven "ages": "Now, seven is a perfect number, seven days there

are to a week, seven stars that never sink …" According to Schedel's calculations, the human race c. 1500 had reached the seventh, and final, "age". The end of the world was nigh.

Many of Schedel's and Altdorfer's contemporaries were tormented by the fear that the world was coming to an end. Even Luther believed it. One of Luther's commensals reported: "the following day he again spoke much of the Day of Judgement and of the end of the world, for he has been troubled by many terrible dreams of the Last Judgement this half year past …" On another occasion Luther complained: "Dear Lord, how this world is reduced … It is drawing to a close." Or: "When I slept this afternoon I dreamt the Day of Judgement came on the day of Paul's conversion."

Dreams, premonitions and prophecies of the end of the world were fed not only by calculations based on the "seven days" premise, as in Schedel's work. Calculations of an entirely different order, those of the prophet Daniel, seemed to point in the same direction. He had predicted that four kingdoms would come and go, before the coming of the kingdom of the Lord. The four kingdoms were thought to be Babylon, Persia, Greece and Rome. This was problematic, however, for the Roman Empire had long since passed away.

A route out of the quandary was found by propounding that Rome still existed – in the form of the papacy. By Luther's time, however, the papacy was so much gone to seed that it really did seem on its last legs. Luther: "Daniel saw the world as a series of kingdoms, those of the Babylonians, Persians, Greeks and Romans. These have passed away. The papacy may have preserved the Roman Empire, but that was its parting cup; now that, too, is gone into decline."

This comment, along with other examples of Luther's "table-talk", was recorded in 1532, four years after Altdorfer began work on his painting. Altdorfer was undoubtedly aware of the eschatalogical preoccupations of his contemporaries. As a member of the leading body of the town in which he lived, he was forced constantly to deal with questions relating to the church.

If we take for granted that Altdorfer knew of these things, and that he, too, sensed what it was to live at the end of Time, then the sky over the Battle of Issus assumes a new meaning. In the original work, the sky was bigger; the painting was reduced in size at a later date when strips were cut from all four sides, with the largest section removed from the top. The moon, too, originally stood further from the corner of the painting. Even in its present size, however, the sky covers more than a third of the painting's surface. With its sharply contrasting lights and darks, dynamic congregation of clouds and sun reflected in the sea, it suggests the occurrence of an extraordinary event.

The exact nature of this event was expounded by Daniel: the second of the kingdoms anticipated by God and prophesied by Daniel cedes, near Issus, to the third, as the Greeks defeat the Persians. However, the change of power is, at the same time, a stage further on the world clock, a step closer to the impending end of the world. Viewed in this way, *The Battle of Issus* had a direct bearing upon the present.

It is thought that Wilhelm IV wanted the painting to celebrate the grandeur of the individual. He wanted a Renaissance painting. What he got was a work whose view of the world was dominated in equal parts by new ideas and medieval tradition: even the cleverest and boldest of individuals cannot decide the course of world history – that is the province of God alone.

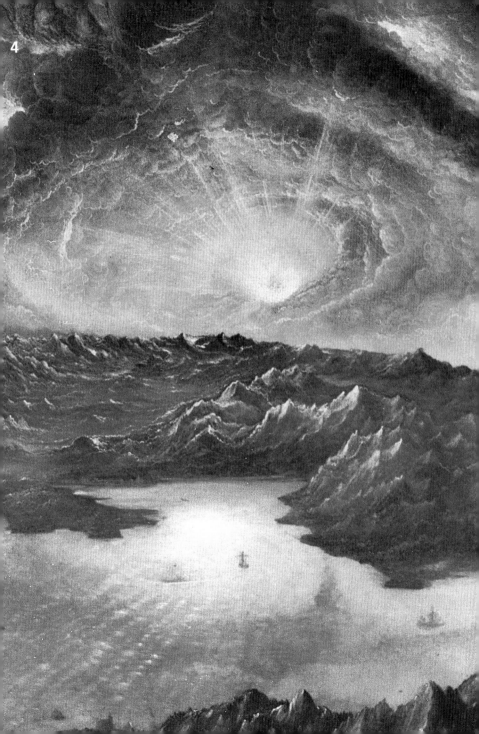

Hans Holbein the Younger: The Ambassadors, 1533
Careers in the king's service

A young French bishop visits a young French diplomat in England. They were friends, and the artist shows us some of the interests they shared: music, mathematics, astronomy. Death, too, is concealed in the painting. The double portrait (207 x 209 cm) is in the National Gallery, London.

An official portrait: two men whose bearing, respectability and earnest mien make them look about 40 years old. But they were both much younger; the man on the left was 29, the man on the right 25. Life expectancy in the 16th century was shorter than today; people tended to enter important posts at an earlier age. One of the men is already a bishop, the other is French ambassador to the English court.

The churchman, himself occasionally entusted with ambassadorial duties by the French king, is visiting his friend, the diplomat. The two represent different sectors within the diplomatic corps, named after their styles of dress: "l'homme de robe courte" and "l'homme de robe longue". Men of the short robe were worldly ambassadors; those with long robes were clergymen.

To be sent on a diplomatic mission by the king was an honour, but seldom a pleasure in the 16th century. Above all, it was expensive. The king granted fiefs, benefices and allowances to both clergy and nobility. In return, these were obliged to perform services, a duty extending to the disposal of their incomes. They were thus expected to pay for their stay in foreign lands out of their own pocket. Once there, they were generally treated with due politeness, but also with suspicion. Diplomats were thought to combine their official duties with spying. In 1482, for example, it was strictly forbidden for Venetians to talk of public affairs to foreign diplomats; and one Swiss ambassador reported from London in 1653 that a member of parliament

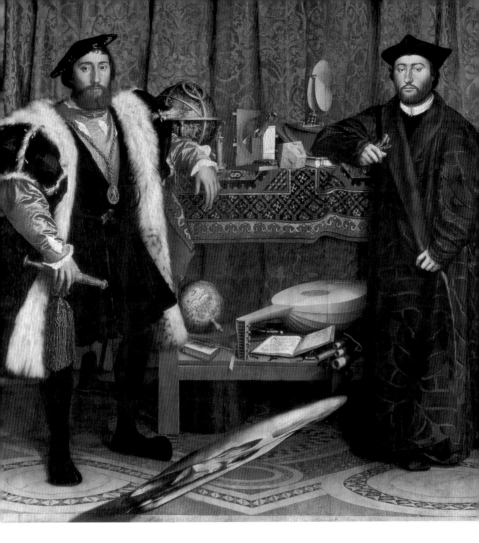

who spoke to a foreign ambassador risked losing his seat. Certainly, it was one of the ambassador's main tasks to collect as much exact information as possible about the country he was visiting. Newspapers did not exist at the time.

Contemporary manuals and memoirs give us some idea of the abilities expected of a diplomat: First of all, he should cut an appropriately representative figure, wearing clothes that were fine enough, and expensive enough, to be worthy of his master. He should be eloquent, have an excellent knowledge

of Latin (the *lingua franca* of the day), and be educated to converse with scientists and artists. His manner should be urbane, charming, never too curious; he must be able to retain full composure while listening to the worst of news, and be skilled in slowing down or speeding up negotiations whenever necessary. His private life should be impeccable, precluding even the slightest hint of a scandal. His wife must stay at home, of course; after all, she might gossip. It was considered of the utmost importance to retain an able cook; good food is often a ticket to the best information.

The 16th century was the cradle of modern diplomacy. Previously, the affairs of European states in the Holy Roman Empire had been regulated centrally by the Emperor. This system had lost much of its authority. Instead, bilateral agreements had grown in significance, and with them the art of diplomacy. However, permanent embassies remained an exception; diplomatic missions lasted only a few weeks or months. It was not yet essential, as it later became, for foreign policy to direct its energy toward establishing relationships of mutual trust over long periods. Short-term success was more important. If a contract no longer served a country's interests, it was simply broken. These were times of great insecurity. The balance of power changed from month to month. There was one means alone of securing an alliance of real duration – marriage.

The changing structure of alliances in the 16th century is reflected in its record of engagements and their dissolution, its history of marriages and their annulment. As a young man, the English king Henry VIII had married Catherine of Aragon. She was an aunt of the powerful Spanish king, Charles V. Henry and Catherine had a daughter, Mary, who herself became engaged to Charles V of Spain. However, while Mary was still a child,

Nobleman on a delicate mission

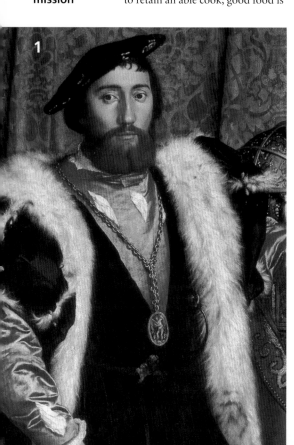

1

Charles V dissolved his engagement to her, for he wished to marry Isabella, the Infanta of Portugal, a match which would directly increase his wealth and sphere of influence. Henry, meanwhile, in whose opinion Charles V was becoming altogether too powerful, sought to ally himself by marriage with France. Before remarrying he needed the pope to declare his marriage to Catherine null and void. But the pope had been dominated by Charles V since 1527. He was therefore unabale to annul Henry's marriage. The matter was made even more complicated by the Privy Council, who wished to see the English noblewoman Anne Boleyn, rather than a French princess, on the throne of England.

It was against this background, in the spring of 1533, that a French ambassador was sent to London. While there, the diplomat had his portrait painted in the company of his friend. Hans Holbein documents execution of the painting on English soil by means of the mosaic on which his subjects are standing; the design is that of the mosaic laid by Italian craftsmen in the sanctuary floor at Westminster Abbey. Today, the floor is heavily worn and covered by a large carpet. Only at the carpet's edge is it possible to see the original ornamental work.

The French ambassador is Jean de Dinteville. Born in 1504, he resided at Polisy in Champagne. As a manorial lord, he had the right of jurisdiction; he was also King's Proxy at the provincial capital of Troyes, an office held by his father before him. Jean de Dinteville did not belong to one of the great noble families of the land, nor was he one of the great historical figures of his time. He was, however, an archetypal Renaissance nobleman: a humanist with an interest in music, painting and the sciences. He was active in the king's service, and dependent on the king's goodwill. His greatest gift to posterity was his decision to have himself portrayed with his friend by Hans Holbein.

The artist portrays the nobleman with the Order of St. Michael hung on a long golden chain around his neck. This was the French equivalent to the Spanish Order of the Golden Fleece or the English Order of the Garter. The 16th-century royal orders had nothing to do with the orders of the late Middle Ages, brotherhoods dedicated to a way of life combining monastic and chivalric ideals. Instead, they were a means of endorsing the allegiance of a loyal subject, awarded to capable men in the hope of ensuring their devoted service to the throne. Their prestige derived partly from their limited membership. There were only 100 holders of the Order of St. Michael at any one time.

Francis I, the French king, had sent Jean de Dinteville to London

for the first time in 1531. In the spring of 1533, he was sent to London again, for in the meantime, the alliance between the two countries had become even more confused. Henry VIII had secretly married the pregnant Anne Boleyn in January, though the pope had not yet annulled his previous marriage.

Francis I offered to use his influence in the Catholic Church on Henry's behalf. A meeting was arranged between Clement VII and Francis I; but Henry procrastinated. He had the Archbishop of Canterbury declare his old marriage null and void, thereby encroaching upon papal rights. He obstructed negotiations between the French king and the pope.

On 23 May 1533, Dinteville informed his master by letter that he had asked Henry VIII "if it should please him to make a secret" of the archbishop's decision, "so that our Holy Father is not informed of this matter before Your Majesty speaks to him of it. He replied that it was impossible to make a secret of this, and that it must be made public even before the coronation."[1]

Anne Boleyn was crowned at Westminster Abbey on 21 June. High honours were conferred upon the French ambassador during the festivities that followed. In the meantime, however, the subject of negotiations between Dinteville's sovereign, Francis I, and the pope had changed: the French king now

sought to marry his son to the pope's niece. His aim was to win over Milan. Henry's interests were forgotten. There was therefore little left for Dinteville to do in London. He left on 18 November 1533.

Dinteville was present in London not only for Anne Boleyn's coronation, but also for her execution. He was entrusted with three further diplomatic missions to England, before his family fell into disgrace. Apparently, his three brothers had plotted against Francis I. Jean de Dinteville died, aged 51, at Polisy. Before his death, he conducted renovations at his castle, employing – like the English kings and Francis I – Italian craftsmen to execute the work. A tiled floor in the Italian style exists at Polisy to this day. Holbein's painting hung at the castle for many years. Today it is in London's National Gallery.

Unlike his worldly friend, the bishop does not hold an ornamental dagger in his right hand, but a pair of gloves. His arm rests on a book, on whose fore-edge part of a sentence may be deciphered: "aetatis suae 25". If we add the word "anno", the sentence, rendered into English, reads: "in the 25th year of his life". Dinteville's age, incidently, is written on his dagger. Facts like this helped identify the figures. The bishop was Georges de Selve.

As can be expected from a representative portrait of this kind, the

subjects' faces are almost expressionless. Without their different styles of beards, the two friends might even look quite similar. Their eyes, on the other hand, are distinctive. Those of the bishop are smaller, with their pupils more heavily shadowed by the lids. Accordingly, the bishop does not appear to concentrate quite so intently on his immediate surroundings as the worldly ambassador. A similar distinction may be made in respect of their dress and bearing. Dinteville's puffed up fur makes his shoulders twice as wide as those of his friend. The diplomat wears his fur coat wide open; the clergyman is holding his coat so that it completely covers his body. The life of one is more outward-going, the other's more introspective. Their different personalities allow Holbein to characterise two castes: *robe longue, robe courte*.

Georges de Selve's father, president of the *Parlement de Paris*, had been rewarded for his many services to the crown by the bestowal of a bishop's fief upon his son. Georges, then aged 20, was made Bishop of Lavaur in the southwest of France. Although the minimum age for this office was 25, a dispensation from the pope rendered exceptions possible. These were frequent enough. Bishops who were too young for office received an income and title, while their clerical duties were performed by priests.

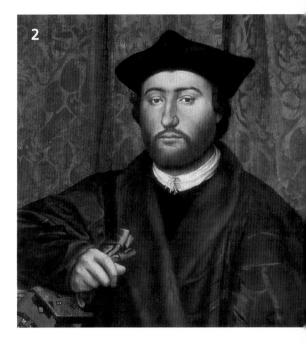

2

Even after Georges de Selve was permitted to take up ecclesiastical office, he spent most of his time outside his diocese. In the autumn of 1533, following a private visit to London, the French king sent him as an ambassador to Venice; later, he was entrusted with a mission to the pope in Rome, and then to Charles V in Madrid. In 1540 de Selve requested to be relieved of his offices for reasons of health. In April of the following year he died, aged 33.

Georges de Selve's writings bear testimony to his piety. He saw the solution to the problems of his time, including those of a worldly nature, in a total regeneration of religious life. He criticised not only

A pious man fears for the Church

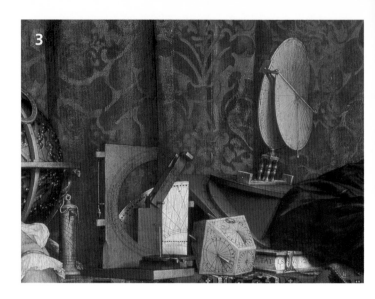

Central role of mathematics

the condition of the Church, but also the selfish machinations of kings and princes. De Selve evidently had some sympathy for Luther's endeavours as a reformer; he nevertheless opposed the division of the Church. In all probability, De Selve was France's delegate at the Diet of Speyer in 1529, holding a great speech there in favour of confessional re-unification.

Holbein refers to the notion of re-unification by means of a hymnal lying open on the lower shelf. The book is neither French nor English, but the German Johann Walther's *Book of Hymns*, printed at Wittenberg in 1524. The book lies open at two of Luther's hymns: the first is a German translation of *"Veni Creator Spiritus"*, the second points to the importance of the Ten Command-

ments. In content and tradition both are good "catholic" texts, emphasizing the common ground between the new Lutheran and old Roman Catholic standpoints.

The figures portrayed in 16th-century double portraits are usually shown close together. Not so Dinteville and De Selve. Holbein sets them as far apart as possible, placing them right at the edges of the painting. Between them, a plain, twostoreyed cupboard displays a large number of books and instruments. It is almost as if Holbein wished to indicate that the bachelors' friendship was based on a common interest in natural science.

All of the instruments are linked in some way or another to applied mathematics. On the left there is a

Hans Holbein the Younger

celestial globe; next to it, a cylindrical sundial, or shepherd's timekeeper. There are several sundials on the faces of the polyhedron; these were used for travel. Then there are two types of quadrant, and on the lower shelf a small, portable globe, a level, and a compass lying under the neck of a lute. Music, too, was considered a mathematical art at the time. The tubes probably contained maps.

It might seem strange to us today that a display of instruments of measurement should be considered fitting attributes for a diplomat and a churchman, but it would not have seemed so at the time. Both men had been to university, where mathematics had become one of the most important academic disciplines of the Renaissance. This contrasted with the Middle Ages, when a religious explanation of the world had been considered more appropriate than the study of natural sciences, and mathematics had consequently fallen into neglect. However, as times changed, scientists began to search once again for laws of mathematics and physics which would make it possible to explain how the world functioned. Even painters occupied themselves with the study of mathematics. In his *Instructions for Measurements taken with the Level and Compass*, Holbein's compatriot Albrecht Dürer had celebrated geometry as the true foundation of all painting. Per-

haps the inclusion of these two instruments in Holbein's painting was a reference to the older artist's work.

The level is inserted between the leaves of a book, which, like the *Hymnal*, has been identified: *A sound instruction in all calculation for merchants, in three volumes, including useful rules and questions.* This was a textbook on the principles of calculation in business, written by Peter Apian, a university teacher at Ingolstadt, and printed in 1527. Apian begins with the fundamental operations of arithmetic and guides his reader via a series of steps to the extraction of square roots. With the aid of practical examples, he shows how silver value equivalents can be converted into gold value, or how to convert currencies. Then come the "useful questions", which are not much different from those used in schools to this day: "A messenger leaves Leipzig and takes 18 days to reach Venice; another messenger leaves Venice at exactly the same hour and takes 24 days to reach Leipzig. The question is: how many days pass before they meet?"[2]

The globe behind Apian's book has been attributed to Johann Schöner of Nuremberg. Holbein himself came from Augsburg, and it may be supposed that the objects from southern Germany which are exhibited in the painting were introduced by the artist rather than the patron. However, Holbein has altered Schöner's globe to suit Din-

Death concealed in a puzzle

teville's wishes. This is evident from a comparison of the names on the painted version with those on the original. They both have about 100 names in common, but there are also 20 names which appear on Holbein's copy only. These names all relate to Dinteville and the members of his family: Burgundy, Avern, or Polisy, for example.

Everything in Holbein's painting, whether persons or things, is represented more or less realistically, with one exception: the skull suspended above the floor. At first

glance it is hardly identifiable. It is only recognizable as a skull when seen from the right or left edge of the painting, and only when it is viewed through a lens which alters its proportions altogether does the image become quite distinct.

Anamorphoses, or distorted images of this kind, were a well-known trick at the time. They were usually applied to portrait drawings, and were achieved by means of a ruler and length gauge, that is by the use of mathematical instruments. First, the artist would draw the contours of a normal portrait, over which he would then draw a grid of lines. On a second sheet of paper he would distort the grid, squashing it flat in one direction, and exending it in the other. He then transferred the portrait to the dimensions of the corresponding grid-squares – a mathematical picture puzzle.

There is yet another skull in the painting: a very small one set in the brooch on Dinteville's beret. The double appearance of the skull can-

Hans Holbein the Younger

not be put down to chance; Holbein's painting is too well thought out, its effect too precisely calculated. Their meaning may become clearer if we consult two paintings by Fra Vincenzo dalle Vacche, painted around 1520 for a church in Padua. The paintings do not contain anamorphoses, nor do they even contain figures; however, like Holbein's painting they show a number of different objects on shelves. One of the paintings, entitled *The Vanity of the Worldly Power of the Church and Laity*, shows a bishop's staff, a crown, an hour-glass and a skull. The other painting, entitled *The Vanity of Science*, shows a celestial globe, a sextant, a mathematical textbook, a sheet of music and a viola with a broken string. Holbein's lute also has a broken string. His arrangement of instruments seems deliberately to combine the effect of the two Italian paintings. The common theme is vanity, or *vanitas*.

The notion of *vanitas* had wider connotations at the time than it does today. It meant blindness towards the most important things in life; also, the futility of human endeavour. The vain easily forget that they must die and believe that science gives worldly knowledge. In a Latin pamphlet of 1529, shortly before Hans Holbein executed his painting, the German writer Cornelius Agrippa complained of the "uncertainty and vanity of all art and science". Art and science, "are nothing but the laws and imaginings of human beings"; the truth, on the other hand, is "so great and free that it cannot be grasped by the musings of science, but by faith alone …"[3]

Holbein's painting is thus not merely a double portrait. At first, its subject seems worldly: the official portrait of two young men surrounded by scientific and mathematical instruments. Even the composition of the painting, with its emphasis on powerful horizontals and verticals, seems arranged according to mathematical principles. Only the anamorphosis, apparently floating diagonally through the picture, contradicts this regime of calculated rectangularity, giving the work an aura of contemplation and suggesting a hidden commentary on human affairs. Compared with Agrippa's text, or with paintings like those by Vincenzo dalle Vacche, it might seem its message was the vanity of art, science and high rank. But for this, Holbein need not have disguised the skull. He therefore seems to be saying: Study of the arts and sciences need not be vain at all. On the contrary, it may lead us to a deeper, more comprehensive appreciation of the world. Indeed, it is sometimes only by scientific means that we can make visible the presence of death behind phenomena, behind the pleasing appearance of things. That, after all, is what the painting achieves.

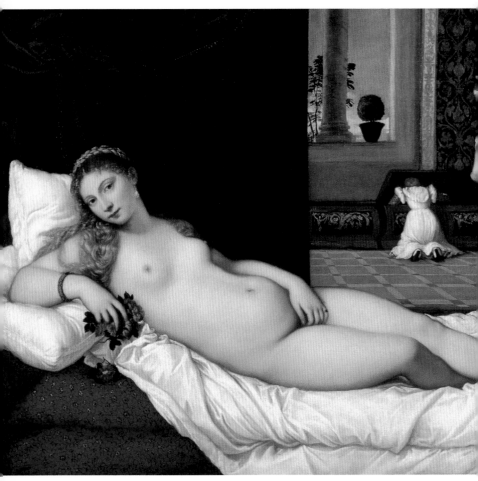

From the canopy of Heaven to a four-poster bed

On 9th March 1538 Guidobaldo della Rovere, son of the Duke of Urbino, wrote a letter to his father's ambassador in Venice. The young man was sending a courier to "bring me two paintings currently in the hands of Titian". The courier was under no circumstances to return without the paintings, even if it meant waiting for two months.

The situation was complicated, for Guidobaldo did not have enough money to pay for the works. The ambassador, so he requested, was to use his good offices to elicit an advance, or a guarantee for the required sum, from his mother, the Duchess. In a later letter Guidobaldo wrote that "if the worst comes to the worst" he should have to "pledge that which is mine". He was determined to have the two Titians. One was his own portrait, the other was "la donna nuda", the "naked woman". Known today as the *Venus of Urbino*, this 119 x 165 cm Renaissance painting can now be seen in the Uffizi, Florence.

In the spring of 1538 Guidobaldo reached the age of 25 years. Titian (probably born between 1488 and 1490) was twice Guidobaldo's age. By that time he was probably the most highly-regarded artist in southern Europe. He had worked for churches and monasteries, for rich merchants and the Republic of Venice, for Italian princes and the Emperor, Charles V. He enjoyed the highest social and artistic esteem. Charles V had named him Count Palatine and Knight of the Golden Spur – an extraordinary honour for a painter.

Guidobaldo may have become acquainted with Titian through his father, Francesco Maria della Rovere, Duke of Urbino since 1508. Francesco, known for his violent temper and prowess in military strategy, had killed a cardinal with his bare hands, defended the papacy and led a Venetian army into battle: in short, he was a typical *condottiere*. The owner of a Venetian palace, he died in October 1538, presumably poisoned by rivals.

This *condottiere* loved paintings and sophisticated company. He was married to the much-admired

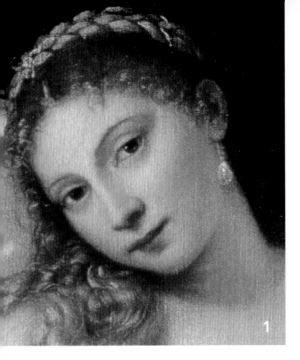

spring 1538 were solved by the death of his father in the autumn of that year. He was now Duke of Urbino. And his mother had paid for her son's portrait, though not for the "naked woman".

It was later claimed that the future Duke of Urbino wished to possess the painting because it portrayed his mistress. Alternatively, it has been suggested that Titian painted his own mistress, for the woman appears in his paintings no fewer than three times. A rumour during the nineteenth century maintained that the painting showed Guidobaldo's mother, Eleonora Gonzaga, for it was difficult to ignore a certain resemblance between her portrait from Titian's hand and the "naked woman". Moreover, both paintings contained the same curled-up lapdog.

There is no evidence for any of these theories. An Italian "lady of quality" was unlikely to have herself portrayed in the nude, for this would have been irreconcilable with her role in society: she was expected to bear children, hold house, prise husband's honour and stand by his side on public occasions. Though the human body was increasingly exalted during the Renaissance, the exhibition of a woman's body unclothed to eyes other than those of her husband would have provoked ugly scenes indeed, had her image

Who was the »donna nuda«?

Eleonora Gonzaga: "If ever knowledge, grace, beauty, intellect, wit, humanity and every other virtue were joined in one body, then in this", enthused the writer Baldassare Castiglione. Francesco began commissioning work by Titian in 1532; a Nativity, a Hannibal, a Christ (for the Duchess) and later a Resurrection. He purchased *Woman in a Blue Dress* and ordered portaits of himself and his wife.

Guidobaldo continued the family tradition, commissioning new paintings more or less regularly until his death in 1574. Like his father, he served as a general in the Venetian army, frequently staying at Venice. His financial problems of

been publically revealed in a painting.

The ideal of uxorial respectability did not include the expression of sexual and sensual pleasure, so evident in the present painting. The church, with its repudiation of the body and disdain for women, did whatever it could to ensure that the respectable ideal became respectable practice. Men were permitted to indulge their sexuality, women were not. It is probable that the opportunities for such gratification within marriage were limited, for marriage – both to the aristocracy and to the bourgeoisie – had less to do with personal inclination than with politics, or finance. Families were expected to afford their members protection; safety was more highly valued than love.

The constraints imposed by men on their wives and daughters drove the former to seek their consolation in mistresses and prostitutes. According to the diary entry of a man called Priuli, there were some 11,000 prostitutes in Venice c. 1500, and, according to another source, there were 6800 in Rome c. 1490. If one relates these figures to the total population of the towns at the time – Rome had 40,000 inhabitants, Venice 120,000 – one arrives at the figure of almost 20 percent of the female population in one case, and over 30 percent in the other. Even if these figures seem too high to sustain credibility, they nonethless suggest that prostitution not was at all a marginal social phenomenon. Countless anecdotes confirm this. Payment for sexual favours was socially acceptable. Priests damned it, but Cardinal de' Medici, during his stay in Venice in 1532, openly lived with a girl called Zeffetta.

Alfonso d'Este, who married Guidobaldo's sister Julia, was even praised for it on one occasion: instead of simply seducing young girls, he at least asked their parents' permission before taking the girls to live with him. Later, he married them off with an excellent dowry. For the poorer strata of the population, giving away one's daughter as the mistress of a wealthy man was practically considered a normal means of securing her existence.

The prerequisite was, of course, that the girl was as appealing as Titian's model. Titian himself lived for many years with a barber's daughter, who bore him two children. Titian then did something quite unusual: he married her.

Titian painted a bouquet of roses in the reclining nude's hand. Roses were an attribute of Venus. Whether mythical figure or "donna nuda", her body reflects the ideals of beauty and erotic predilections of the High Renaissance.

Her high forehead, however, was untypical of the period. Throughout the Middle Ages, women whose circumstances had granted them

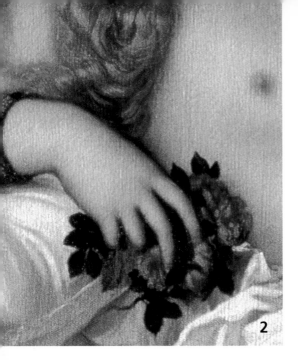

2

Bodies change wih fashions

leisure to indulge in fashion had plucked their hair above the forehead in order to lengthen their faces. The curve of the head between forehead and cranium was considered attractive, and was emphasized for that reason. High foreheads, however, were now a thing of the past. Even married women no longer hid their hair under bonnets, and the locks of unmarried women fell loose about their faces, softening their features.

Although the hair of most Italian women was black by nature, the most fashionable colour at the time was blonde. Almost all mythical figures painted during the Renaissance have fair hair. It was said of

the women of Venice in 1581 that they used "spirits and other remedies to turn their hair, not only golden, but snow-white".

In Gothic art, women generally appear slender and elongate, an effect emphasized by their trains, tapering bonnets and sloping shoulders. The ideal Renaissance female was more solidly built. Broad shoulders, enlarged and embellished by the ploys of dressmakers, were an important characteristic of this type. Titian gives special emphasis to the reclining nude's right shoulder, while a servant in the background wears fashionably puffed sleeves. Breasts were considered beautiful only if small, round and firm, lacking the fullness of maturity, as expressed in an Italian text of 1554 – a view evidently shared by Titian. A narrow waist, the distinguishing feature of 19th-century fashion, was considered undesirable. The latest Spanish fashion was a high corset that flattened the breasts, denied the waist and enclosed the trunk of the body like a tube. However, this puritanical garment, turning the female body into a kind of geometrical figure, gained little acceptance in Italy.

Titian painted his nude with a gently rounded belly. In Gothic art, the stomach tended to protrude further than the breasts. Renaissance painters, on the other hand, hoping to capture a more natural attitude, did away with exaggerated curves.

Nonetheless, the belly, the symbol of fertility and procreation, remained the focal point of the female body.

Titian's "donna nuda" reflected the Renaissance ideal in a number of details, and it was perhaps for this reason – as much as for its quality as a work of art – that Guidobaldo was so desperate to possess it. The artist emphasizes the nudity of the reclining woman by showing two fully-clothed servants in the background. The kneeling woman is seen from behind, an unusual posture. Indeed, Titian may be the only artist of his day to have painted a woman in this attitude.

The interior and furnishings are typical of the period. The kneeling woman is rummaging in a clothes-chest, referred to in Italian as a *cassone*. Clothes-hangers and wardrobes had not yet come into use, and clothes were kept in chests. They formed an integral part of every dowry and, depending on whether their owners were wealthy enough, would often be inlaid with marquetry, or painted. Titian, too, had painted *cassoni* in his youth. They tended to be low, since they

Venus of Urbino, c. 1538

doubled as seats. Some were even fitted with backrests.

The bed was probably a four-poster, supporting a canopy and with crossboards for hanging curtains; neither posts nor crossboards are visible in the present painting, however. With its curtains drawn, a bed was transformed to a room within a room, a realm of privacy. Maids and servants often slept in the master bedroom, since the majority of houses did not have servants' quarters. Titian painted his beauty half-sitting; the pose reflects contemporary sleeping habits.

Titian's interior contains little but a bed and chests, which were the most important, and sometimes the only, pieces of furniture in a house. There were few proper tables; meals were generally eaten at boards laid across trestles and later stowed away. It is difficult to see whether the hangings in the background are tapestry or leather.

Venice, with lively trading relations to the Near East, was one of the main transshipping ports for oriental carpets, and the best, or most famous, gold-printed leather was imported from the Spanish town of Córdoba. Marble floors were found in all the wealthier homes. Artists treasured their regular square patterns, which provided a means of lending mathematical precision to perspective; this had been an important feature in painting since the development, in Florence a century

A chest was part of every dowry

earlier, of artificial perspective.

The windows of domestic interiors were relatively small, and were closed with wooden shutters. The open space shown in Titian's painting may be part of a room used only in summer, perhaps at a country villa. A view of pleasant, surrounding countryside was an essential feature in every Renaissance villa.

While Titian's work contains many details epitomizing life at the time, it was not his intention to paint a realistic picture. This is made abundantly clear by the dark plane dividing the painting into two halves, whose right edge ends just above the reclining nude's hand. Though evidently intended to suggest the curtain of the bed, it is entirely lacking in definition. The plane helps balance the two halves of the picture, as well as providing a background against which the upper half of her body stands out more clearly. The vertical border also emphasizes her *mons veneris*, which the nude coyly conceals.

In c. 1485, Sandro Botticelli painted his *Birth of Venus*, one of the loveliest Venus nudes to emerge from the Florentine Renaissance. She is shown standing upright, almost floating. It was the Venetian Giorgione who devised the first reclining Venus. Against a natural setting, she is asleep with her head resting on one arm. Giorgione died in 1510, before he could finish the

work. Titian, his collaborator, completed it. He returned to the theme more than a quarter of a century later, now replacing the outdoor scene with a domestic interior.

The three paintings show a progression. Botticelli's Venus is a supernatural apparition in human form, untouchable, not of this world. Giorgione's Venus has a realer presence, reclining in an attitude of abandon – to sleep, rather than a man's gaze. She, too, retains something of the aura of a Nature goddess. Titian removes her from natural surroundings, placing her in the man-made setting of a fourposter bed. The goddess is transformed: a young woman meets the spectator's gaze, conscious of her appeal, revealing her body and expecting, if not caresses, then admiration. Titian liberated the nude from the constraints of the mythical stereotype, seeing a real woman in the female figure – probably an exciting development to his contempories. It can hardly be accidental that Guidobaldo, who wanted the painting so badly, spoke only of the "donna nuda".

It was not until later, through the intervention in 1567 of the art historian Vasari, that the nude became known as Venus. Her identity was confirmed in a later inventory. Though the chief attribute of antique Venus, her son Cupid with his bow and arrows, seems to have deserted her in the present picture,

Titian nonetheless paints her with her characteristic flowers: he shows her holding roses, the symbol of pleasure and fidelity in love, and places a pot of myrtle on the window ledge to indicate constancy in marriage. The lapdog is an unusual figure here. It symbolized carnal desire, but also devotion; on the gravestones of many married couples a dog was shown lying at the woman's feet. Perhaps it found its

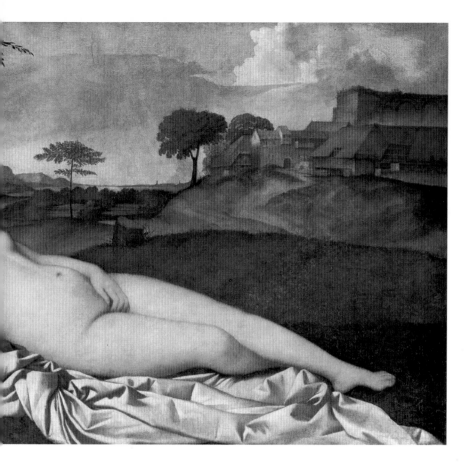

way into the painting quite by accident. Perhaps it belonged to the artist's workshop, and Titian simply enjoyed painting it.

Some scholars have suggested that Guidobaldo commissioned the work to mark the occasion of his wedding in 1534, which would explain his eagerness to possess it. There is no evidence for this. At the same time, however, it is impossible to overlook the symbolic reference

of roses and myrtle to conjugal fidelity. Titian may have wished to show more than Venus' conventional attributes. Perhaps he wanted to show an alternative to the widespread division of the female population into repectable housewives and paid paramours, demonstrating that sensual pleasure could be found in marriage too. Guidobaldo, as his letters testify, was very happily married.

Venus of Urbino, c. 1538 77

Lucas Cranach the Younger: The Stag Hunt, 1544

The utopia of common huntsmanship

Painted in 1544 by Lucas Cranach the Younger, Elector John Frederick of Saxony and the German Emperor Charles V appear the best of hunting companions. But appearances are deceptive: the Protestant prince and Catholic monarch were rivals, soon to wage war. Their hunting expedition never took place. Cranach's painting (117 x 177 cm) is in the Kunsthistorisches Museum, Vienna.

A hunting scene in Saxony in 1544. In the background the river Elbe with Torgau on its banks. In the foreground two of the leading figures of their day: at the left edge of the painting, between two men with white beards, Emperor Charles V; further to the right, wearing a green coat, John Frederick the Magnanimous. As Elector of Saxony, John Frederick was the Emperor's subject; as a Protestant prince, he was the Catholic monarch's enemy.

Big hunting parties were at that time part of the traditional supporting programme at political

Lucas Cranach the Younger

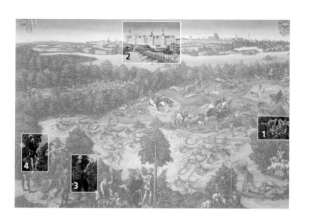

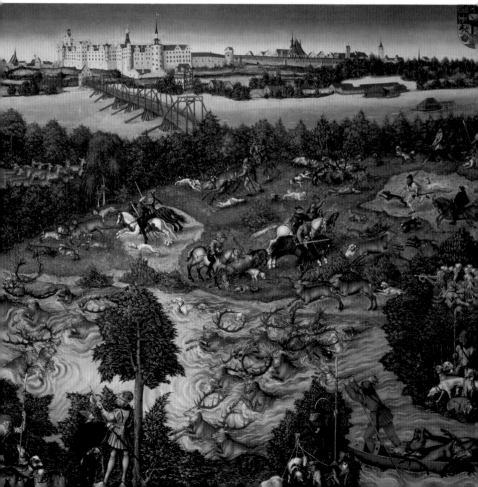

1

A retinue of genteel ladies

meetings; while the deputies at Imperial Diets argued over formalities, their lords went out hunting in the forests. Hunts were organized for entertainment and representative purposes; the names of participants and numbers of head of game were recorded in letters, in written accounts of the chase, and occasionally in paintings.

Lucas Cranach the Elder once received the following advice: "When princes bid you accompany them on the hunt, you take your panel and, with the hunt all around you, show Frederick tracking a stag, or John pursuing a wild boar." For "it is well known", the writer explained, that the finished painting

"affords the princes as much pleasure as the hunt itself".

The stag hunt of 1544 was probably not painted by the elder Cranach, but by his son, Lucas the Younger. The latter began work in his father's studio, which he later took over. Neither Cranach signed paintings with his name, preferring to use the trademark of the workshop, a winged serpent. This is painted on the prow of the boat, beneath the year 1544.

Only in tournaments and the hunt did princes and nobles find opportunity to train for the toils of war. However, the key figures in Cranach's painting would hardly be overstrained by the hunt depict-

ed: they are shooting at driven game.

The lady furthest to the fore is John Frederick's wife, Electress Sybille. Little of the picture space is reserved for her or her retinue; when dogs and stags were present, thus the artist implies, women took a back seat.

The Electress is probably holding a loaded "German spring-bolt", a relatively light crossbow. She woud not draw the bow herself, of course; an attendant would hand her the fully-loaded weapon when she was ready. The heavy crossbows or arbalests of the key huntsmen in the foreground could only be drawn with the help of a special jacking mechanism; the artist has rendered all these instruments – in the hunters' hands or lying at their servants' feet – with great precision. Firearms were still considered "unchivalrous" in the 16th century, at least for the hunt; they were too loud and not especially accurate, and the powder invariably refused to ignite in damp weather.

The variety of game species had shrunk since the Middle Ages. Bison and wild ox were now found only in Eastern Prussia, while bears had withdrawn to the Alps, the Bohemian Forest and further east. What remained – apart from birds – were roe and red deer, wild pigs, hares, foxes and lynx, as well as that most feared of all huntable predators, the wolf.

On the other hand, the populations of these species had increased since 1500, when hunting became the privilege of the ruling class. At the beginning of the century, game laws still allowed peasants to hunt at least small game or huntable predators; later, even this right was removed. Effective protection of crops was thus rendered impossible. The height of fences was strictly limited, while the use of pointed fence-posts was prohibited to prevent injury to crossing deer. Peasants were forced to collar their dogs with wooden bars or clubs to stop them hunting, and they were forbidden to put their pigs to feed in the forests, in case they frightened the game.

At the same time, the villagers were obliged by feudal law to provide labour for the hunt: they set up tents and built fences, drove the animals towards the archers, acted as bearers for killed game. The meat itself rarely came their way. Game was considered the fare of a privileged class. One critically-minded contemporary remarked of the nobility that they "turn up their noses at the sight of a common man or peasant with just a little of it to eat", considering themselves "the victims of grave injustice" unless they were "served game at every mealtime".

The hundreds of peasants who drove the stags for the princes are

not shown in Cranach's painting; they remain behind the scenes, as it were, somewhere in the forest. The extent of the burden on peasants' lives caused by the courtly distraction of hunting is recorded in documents from the Peasants' War, fought almost twenty years before the painting was executed. At the time, peasants from the Black Forest region protested at having to "hang bars from their dogs' collars", while peasants from Stühlingen demanded the right, according to "the divine law of God", to "hunt and shoot" all kinds of game "and to satisfy our hunger". The game laws imposed by the rulers of the land, as well as their rejection of the peasants' demands, were among the factors which provoked peasant uprising.

Cranach probably painted the hunting scene for the building in the background: Castle Hartenfels at Torgau, usually referred to simply as Castle Torgau. It is situated on the river Elbe some 25 miles upstream of Wittenberg: within an easy day's journey. Wittenberg was Elector John Frederick's "capital", Torgau his favourite residence.

Under John Frederick's aegis, the building, already some 500 years old, was redesigned for representational purposes. This was a consequence of the cannon; rendered defenseless by cannonballs, castles had resigned their protective function, a development which led, throughout Europe, to their alteration and conversion. Powerful figures now began to use their residences as a means of demonstrating wealth and good taste: castles were turned into palaces.

Castle Torgau was rebuilt with oriels, bartizans, cornices, countless windows and, outstandingly, a grand spiral staircase. These winding stone steps are, to this day, considered one of the most remarkable examples of German early Renaissance architecture. The outer wall of the staircase resembles the tower on the right in the present work, though in reality it is not situated on the bank of the Elbe. The artist has altered the setting in order to include a famous architectural feature in his painting.

The Elector had employed an architect from Coburg, Cunz Krebs. His interior designer hailed from Wittenberg: Lucas Cranach the Elder. Wherever the latter worked during these years, Lucas the Younger was sure to be found. Their workshop, with countless apprentices, took care of all the necessary painting: they embellished shields, lances and horse-cloths; decorated wardrobes, beds and walls; they painted portraits and altarpieces, as well as antique themes with female nudes, copied and varied ten or twentyfold, according to demand. The Cranachs, like most contemporary artists, thought of themselves first and foremost as

craftsmen; they simply met a demand. The Stag Hunt, too, was commissioned, executed during the final phase of the renovations conducted at Torgau, where the painting presumably also hung. The extent of the work carried out at Castle Hartenfels by the Cranachs can, today, be ascertained only with the help of the prince's account books. The transportable works have been removed; the murals, with the exception of residual islands of the original work, have peeled away or been painted over. Various documents relate that the hares, pheasants, peacocks and partridges these contained were so true to life that visitors would even attempt to remove them from the walls.

During the Reformation, Torgau was a place of some renown, though overshadowed by Wittenberg, the home of Martin Luther and site of a university founded in 1502 by Frederick the Wise. Torgau's historic importance is still felt in the form of two significant concepts: the "Torgau League", an alliance, formed in 1526, among Protestant lands who had sworn to support one another if attacked for their beliefs, and the "Torgau Articles", rules governing the life of the Re-

A castle rebuilt as a palace

formed Church, established in 1530 under the direction of Luther and Philip Melanchthon.

Incidentally, the chapel at Castle Torgau was the first interior to be specifically designed for Protestant services. It was consecrated in 1544 by Martin Luther.

Elector John Frederick was born in Torgau in 1503. His mother died in childbirth, and pigmentation in the form of a cross on the baby boy's skin was immediately interpreteted as a sign of bad luck. In the panorama of the hunt, he is 41 years old, though he appears no older than on earlier paintings. This is hardly surprising, since the portrait was not done from life, but based on already existing likenesses. This was common practice. Charles V did not sit for Cranach, either. It was enough to suggest a few of the person's features; realism was not essential.

This applies to stance, too, for it might have been possible to show one of the two main protagonists in the act of shooting. Yet they appear to have been painted as if with the help of a single stencil. For Cranach the Younger, this evidently constituted the appropriate hunting pose for a sovereign who was not on horseback.

John Frederick grew up under Luther's influence in Weimar and Torgau. Piety and loyalty were writ larger in his character than enthusiasm for humanist learning or political strategy. Early in life he became a zealous supporter of the Reformer, and devotion to his doctrine determined his politics and personal fate. Widely renowned for his physical prowess, he was an excellent horseman and a skilled and powerful combatant at tournaments. He was also a passionate, and frequent, huntsman – indeed he seemed positively possessed by the "fiend" of the chase. An "unholy" devotion to hunting was common enough among the nobility of the day; John Frederick's cousin Maurice, the Duke of the other part of Saxony (a Duchy that included Leipzig and Dresden), confessed on his death bed to deep regrets over his passion for hunting.

With the exception of the common pleasure they took in the chase, John Frederick and his cousin differed in many ways. Though both were Protestant, Maurice had always sought to influence the affairs of state to his own advantage. His loyalties shifted between the Catholic Emperor and the Protestant cause, as suited his interests.

John Frederick would not have been capable of this. He was one of the founding members of the Schmalkaldic League, an association, formed in 1531 on the basis of the Torgau Pact, which united the majority of Protestant cities and lands and, for a short while, facilitated the peaceful spread of the Reformation in Germany.

A prince who stood by his faith

The Stag Hunt, 1544

The Electorate of Saxony, with John Frederick at its head, was the strongest force in the Schmalkaldic League, and – owing to Luther and Wittenberg – also its spiritual and intellectual centre. It therefore grew to become the Catholic Emperor's main German rival. The Emperor's energies, however, were already directed towards dealing with the

The Emperor won in the end

Turks, the Pope and France. In 1544, the year in which the present painting was executed, Charles appealed to the Schmalkaldic forces at the Diet of Speyer, asking them to support him against his enemies. Help was forthcoming when the Emperor gave the Protestants his word that he would do nothing to thwart them.

Charles V and John Frederick may have hunted together during the Diet of Speyer, but they never took part in a hunt at Torgau. Cranach's panorama illustrates the Elector's wishful thinking, his hope that the quarrel between the Catholic Emperor and the Protestants had been settled. The painting is the document of an illusion.

Just as Elector John Frederick was a vehement defender of the Lutheran doctrine, Emperor Charles V was a champion of the one and only redeeming Catholic Church. And he was merely biding his time. In 1547, three years after the Diet of Speyer, his opportunity came: the Turkish threat had receded, peace had been made with the Pope, and his French rival, Francis I, had died. What was more, he had succeeded in forming an alliance with Maurice of Saxony.

By the time the Emperor took to the field, the Schmalkaldic forces had quarrelled and their army split up. John Frederick was stationed with only 6000 men on the bank of the Elbe 20 miles upstream of Tor-

4

Lucas Cranach the Younger

gau, unaware that the imperial army on the opposite bank was four times as large. The Elector had the bridge at Meissen burned, but Maurice, leading Charles' army with the Spanish general Alba, had discovered a ford. The armies engaged in combat at the Battle of Mühlberg. While the imperial troops rallied to "St. George, Burgundy and Spain!", the Protestants' battle-cry was "God's Word is Eternal!"

The Elector's troops were routed on a patch of moorland closely resembling the hunting ground in Cranach's painting; his face bleeding, John Frederick was taken prisoner. According to one member of the imperial army: "Had all done battle as the Elector himself, he would scarcely have been beaten or taken prisoner."

Torgau was forced to surrender, but Wittenberg, with a garrison of 3000 troops under Electress Sybille, held out bravely. Instead of storming the town with great loss to life and limb, Charles called a military court, which, under Alba's presidency, condemned John Frederick to death. This had the desired effect: Wittenberg, the spiritual capital of the Reformation, surrendered to the Emperor.

On arrival at the imperial camp, Sybille kneeled before the Emperor and pleaded for her husband's life. She was permitted to visit him. While inspecting Wittenberg, Charles had Cranach the Elder,

who had painted his portrait as a boy, admitted to his presence. Cranach, too, pleaded for the life of his lord and master, whereupon the Emperor assured him that John Frederick would come to no harm.

However, the title of Elector and much of his land fell to his cousin Maurice. Following long, drawn out negotiations John Frederick was conceded the right to refer to himself as "Elector by birth". He was imprisoned for five years and, though granted several opportunities to escape, stayed his sentence. For three of these years, Cranach the Elder joined his lordship in prison; John Frederick had called, and the painter had come: he, too, a loyal man. In the meantime, work continued at his studio at Wittenberg, under the direction of his son.

Several days after the Battle of Mühlberg, a certain Sastrov von Mohnike rode over the battlefield and recorded what he saw. He wrote of the wounded and half-starving he found lying there. But he also remarked that the Elector had lost the battle on land where he had so often hunted, once a source of great enjoyment to him, and of chagrin to the local population who, "for the sake of the great pleasure he took in the chase, suffered great displeasure, discomfort and damage to limb and livelihood".

The third voyeur stood before the canvas

A young woman, naked, sits at the edge of a pond. She gazes into her mirror, engrossed in the reflection of her body, unaware of watching eyes. Presently, the two old men will approach her. The painting shows the moment before she is startled.

The story upon which this painting is based probably occurred in Babylon, where the Jews were in exile, some 590 years before Christ's birth. One of the "most honoured" of Jews was Joachim, who "was very rich and had a fine garden". He was married to Susanna, "a very beautiful woman and one who feared the Lord", who liked to bathe in the garden on hot days.

According to the Greek version of the Book of Daniel, two Jewish elders who had been appointed judges would often come to the wealthy Joachim's house to discuss law suits. On seeing Susanna, they were "overwhelmed with passion" and decided to wait for an opportune moment when they might find her alone and force her "consent". If she refused them, they would let it be known that they

had found her with a lover. They made their advances and established their conditions, whereupon Susanna cried out: "I am completely trapped", for she knew that witness borne by two highly respected judges would weigh more heavily than her plea of innocence, and that she would be put to death as an adulteress. Should she give in to their blackmail, however, she would not only bring dishonour to her husband, but would break the divine law. Her decision was clear: "I choose not to do it; I will fall into your hands, rather than sin in the sight of the Lord."

During her trial the frustrated elders accused Susanna of adultery with a stranger, but "just as she was being led off to execution, God stirred up the spirit of a young lad named Daniel, and he shouted with a loud voice: I want no part in shedding this woman's blood!" Daniel demanded a return to court, where he subjected the elders to separate examination. Asked under which tree they had seen the lovers intimate, the first elder replied, "under a mastic tree"; the second,

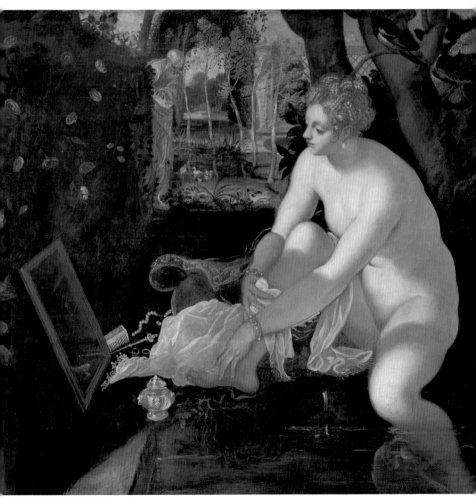

Susanna and the Elders, c. 1555

"under an evergreen oak". This was enough to prove they had given false evidence, and the Jews "did to them, as they had wickedly planned to do to their neighbour. Acting in accordance with the law of Moses, they put them to death."

Different translations of the tale have led to a number of variants. The Greek version of the Book of Daniel, for example, refers to a "mastic tree" (the quotations above, taken from the Revised Standard Version of the Bible, are based on a Greek version attributed to Theodotion), whereas the most famous translation into German, by Martin Luther, refers to an indigenous German tree: the linden.

The original "History of Susanna" was not written in Greek but Hebrew, however, and Bible scholars have suggested the story once served to illustrate one side of the argument during a dispute between two Jewish schools of thought on the value of testimony. Yet other scholars think the story may derive from an older, oriental tale which, in time, was incorporated into the story of the prophet Daniel. Daniel is supposed to have come as a Jewish prisoner to Babylon and, even as a boy, gained a reputation for his wisdom.

Theologians are generally unconvinced by this figure, however. Luther, for example, translated only parts of the Book of Daniel, collecting these in an Apocrypha with various other texts considered less authoratative than the rest of the Old Testament. Luther's Apocrypha opens with the "History of Susanna and Daniel", a theme that enjoyed immense popularity during the Reformation and Counter-Reformation, especially in Italy and Germany. Various adaptations of the material appeared, including some for the stage. Sixt Birck's "History of the Pious and God-fearing Woman Susanna" appeared in 1532,

1

Tintoretto

and in 1535 a "Religious Play Concerning the God-fearing and Chaste Woman Susanna, a Tale Entertaining and Terrifying to Read"; in 1562 the popular Nuremberg cobbler and poet Hans Sachs wrote "Susanna and the Two False Judges".

The dramatized versions invariably centre the action around the trial, with copious reference to the woman's piety and fidelity, as well as to the justice of God. Such features are absent in the work of the Venetian painter Tintoretto (1518–1594). Instead, he portrays a naked woman enjoying the sight of her own body, watched by two voyeurs. Rather than moral instruction, the artist offers aesthetically ingratiating eroticism, together with the thrill of the illicit.

This was not always the case. Scenes from the story in 4th-century frescos in the catacombs, or on sarcophogi, or a 9th-century crystal vase, do not show Susanna bathing, but fully clothed, walking in the garden. One fresco depicts her as a lamb between two wolves. In this context, and at some remove from the original purpose of the tale, Susanna's besieged innocence was intended to illustrate the predicament of Christians, trapped between Jews and pagans.

Interest in Susanna as a female nude grew with the rediscovery by Renaissance artists and philosophers of the human body. In their search for appropriate themes and models, artists were drawn to the myths of pagan antiquity, especially to the figure of Venus, as well as to ecclesiastical and Biblical models. Countless versions were painted of St. Sebastian, whose body, pierced by arrows, was young, male and beautiful. Again and again, artists returned to Adam and Eve, as well as to Susanna bathing.

The artists, mostly men, characteristically played down the cowardly assault on Susanna's chastity by members of their sex, depicting it as little more than a friendly advance. Or they gave a certain frisson to Susanna's fear, flattering the superiority complex of their male spectators. In another *Susanna* by Tintoretto, now in the Prado in Madrid, the hand of one longbeard already rests on the breast of the unprotesting naked woman. The scene, like the versions of several other artists, makes the prospect of an adulterous "passion" seem far from unpleasant to the beautiful woman; on the contrary, she is apparently willing to give it some thought. Thus a paragon of virtue and piety is transformed to the object of male lust.

The Roman painter Artemisia Gentileschi (1593–1651), on the other hand, shows the perspective of a woman in desperate straits. Her Susanna sits on a bench, over whose backrest two men threateningly lean. The relations of power

are exposed in the proportions, with enormous men towering over the slender figure of a woman. Court records reveal that the artist was raped in her youth. She was painting from experience.

Tintoretto's painting in Vienna tells a different story. Certainly, there is something menacing in the appearance of the old man in the foreground. The shapeless red toga and powerful skull on the ground are reminiscent of a gigantic snake. The red cloak itself was seen as a symbol of power by Tintoretto's contemporaries. Only members of the patrician class were entitled to wear such robes during the 16th century, and only patricians attained high state office.

But the appearance of the two old men lays them open to ridicule, too. The behaviour of the one, crawling around on the ground, suggests a toddler rather than the dignity that comes with age, while the man in the background seems too preoccupied with his own feet and the danger of stumbling to remember the object of his desire. They would appear to have very little chance against the large, radiant body of the woman.

The painting (147 x 194 cm), now in the Kunsthistorisches Museum, Vienna, is undated, but most experts think it was executed c. 1555. This is in keeping with the contemporary hair fashion of braided hair.

By contrast, the pale red tint had always been fashionable among Venetian woman, who dyed their hair with special tinctures before letting it bleach in the sunshine while sitting out on the roof gardens of their houses. To this end they would cut out the middle of their straw hats, letting their hair fall over the broad brim.

However, one contemporary gossip claimed that the splendid coiffures of Venetian ladies were usually not theirs at all, but had been "acquired". Hair, he wrote, was sold every day in St. Mark's Square. Despite his long white beard, he had even been offered some himself.

The broad-brimmed hats with centrepieces removed were supposed not only to expose as much as possible of the hair to the sun, but also to protect the face and, by dint of an attached veil, the body too. For skin had to be pale.

White skin – not only in Venice – was considered the ideal of feminine beauty. It was also a class attribute: whereas working women could not afford to cultivate a refined pallor, a lady of the Venetian upper class was unlikely to be seen bathing in the open and exposing her body to the sun.

Tintoretto shows not only the pale skin but the plump figure favoured by contemporary women's fashion. He avoids all reference to pubic hair or nipples,

though it was not uncommon for Venetian women to apply rouge to their nipples and expose them on festive occasions, their breasts well supported by a steel-stiffened bodice.

But other rules applied in art – for aesthetic reasons, or for fear of the Church's watchful eye. The Counter-Reformation was in full swing in Italy, and the Council of Trent (1545–1563) intended to harness the arts to a new propaganda campaign.

Erotically charged religious themes were not in themselves considered offensive, but a line was drawn at the erotic use of sexual imagery. In painting the nude, Tintoretto always toned down, or omitted altogether, the signal colours of the female genitalia.

The identity of the model remains unclear. It is maintained that women were forbidden to sit for artists, and that life painting was restricted to the portrayal of the male body. But this can only have applied to the academies, for in his account-books, Tintoretto's Venetian contemporary Lorenzo Lotto records, "to draw a nude, 3 libri, 10 soldi. For a mere showing, 12 soldi". Lotto noted that his sitters were "courtisans or common women without shameful scruples".

However, circumstances may have made it somewhat easier for Tintoretto. In 1553 he married Faustina, the daughter of a respect-

ed Venetian. His father-in-law was the headmaster of a religious *scuola*, and became a patron of the artist. Venetian women usually married at the age of 15 or 16, so that Faustina, in 1555, was probably still under twenty, while Tintoretto was probably 37. Perhaps Susanna's gaze at her reflection while drying her leg, the contemplative grace of a woman who believes herself alone, was based on the artist's own observations of Faustina. Painters, too, are voyeurs.

Faustina bore him eight surviving children. At his death in 1594 Tintoretto left all he owned to his "carissima mia consorte madonna Faustina Episcopi", his deeply beloved wife.

Beauty in the shade of trees

The Venetians' political and economic power had waned by the time this picture was painted. They had been driven from the eastern Mediterranean by the Turks, and a shifting alliance of forces was now ranged against them in the west. Venice was no longer the point of intersection of important trade routes. Ships now sailed from the Atlantic coast of Europe – around the Cape of Good Hope to Asia, or across the Atlantic to the American colonies.

Venice had lost its status as a world power, but its great wealth was undiminished, as was the zest for luxury displayed by its inhabitants. Jacopo Sansovino and Andrea Palladio, the architects, built the city's magnificent churches, bridges and villas. Tintoretto's con-

A centre of luxury and fashion

temporaries were Titian, Paolo Veronese, Giacomo Bassano and Lorenzo Lotto. Venice was a centre of the arts.

The town was also the manufacturing centre of luxury goods: in 1554 there were 12,000 workers alone employed in the production of silks. Velvet and silk, as well as jewels, silverware and Murano mirrors, were the most important exported goods. Tintoretto includes a small selection of exquisite objects in the form of a still life spread out at Susanna's feet: a pearl necklace, a hairpin, a silk scarf. The comb may be carved from ivory, while the silver vessel with the glass lid would be used to keep creams or perfumes. Mirrors of glass, rather than metal, had not been long in use, and earrings of the type worn by Susanna in the painting had become permissable, and usual, ladies' jewellery only since 1525.

Perhaps it was Faustina who persuaded her husband that beautiful objects were the appropriate accessories for a beautiful woman. She had been born into a wealthy, and more highly respected family than her artist husband. His father had been a silk-dyer, a "tintor". Though his real name was Jacopo Robusti, the artist chose to retain the name given him as a child: Tintoretto, the dyer's little boy. Though the artist's dress habits were generally demure, he is reported, as an older man, to have worn a toga "in order to please

3

his wife". His toga would not have been red, however, but black, as befitted an ordinary citizen.

Venice may have lost power and influence in the 16th century, but it remained sacred in the eyes of its citizens, who were unanimous in their desire to maintain the status quo, including its law and order. This was reflected in the administration of justice in Venice: crimes against the state were punished ruthlessly. One of the threats to public order was calumny: magistrates depended on informants to report crimes, and denunciation was a pillar of justice. A law passed in 1542 therefore demanded that an executioner "cut off the right hand and then the tongue" of anybody who slandered an innocent person or gave false testimony, "to ensure that such persons shall not speak again". If false witness had led to the death of the accused, or to the exoneration of someone deserving the death penalty, "then the offender's head must be cut off".

In Babylon the two old men in the story of Susanna were put to death; in Venice the slanderers would have lost only their right hands and tongues, for adultery no longer carried the death penalty.

Cases of adultery, in any case, were generally settled with extreme discretion out of court during the 16th century. If the accused was a woman of patrician background, she would simply disappear into a nunnery. The crime of rape was equally rarely tried. Sentences were lenient: seldom more than a few months imprisonment and a fine. The judges were all men; and anyway, rape did not seriously undermine the public order.

Despite the unusual density of buildings on the Venetian islands, there were also gardens – though the majority of these were situated at the back of palazzi belonging to patrician families. Those who could afford to do so had a villa built on the mainland, where there was room to spread out.

Landscape gardening was highly fashionable in the 16th century, and Tintoretto's painting records several characteristic features of contemporary design. The ideal was the harmony of nature and art, order and wilderness. Statues were essential, and several are included in the present scene. The trellis fence, wall of roses and deep perspective provide a regular structure. Various authors had demanded that a proper garden include the flora and fauna of the region, and Tintoretto's deer, ducks and bird are a tribute to local variety.

However, the animals are there to remind us of the Garden of Eden, too. Contemporary spectators sought hidden allusions to anything beyond the apparent theme of the painting, and Tintoretto's work – with its cryptic ref-

erence to prelapsarian Eve spied upon by a serpent – is unlikely to have disappointed them. A desexualized female body also permitted associations with the Virgin Mary. Mirrors and water were considered symbols of purity; roses were a Marian attribute.

4

Tintoretto

Besides hidden references and the illustration of horticultural fashion, Susanna's surroundings are primarily the painter's invention and arranged in such a way as to emphasize the radiant purity of the virtuous woman, while simultaneously creating an atmosphere of imminent catastrophe. The wall of roses, for example, is exceedingly dark, its triangular shadow almost black. There is an ominous-looking thicket of impenetrable trees and bushes at Susanna's back. Technically, the dark planes of colour serve to emphasize the brilliance of her body; psychologically, they signal impending doom. A similar effect is achieved by the vista in the background, which draws the eye past the old man and through the arbour to the trees in the distance. Technically, it stabilizes the composition, centering the painting along an axis; psychologically, however, it renders Susanna highly vulnerable, exposing a scene whose intimacy one might expect to find within the seclusion of a private interior.

It is not clear how often Tintoretto actually painted *Susanna and the Elders*. Five versions survive, of which the painting now in Vienna must surely rank as the most beautiful. These paintings, intended for private interiors, were bought by Venetian patricians, many of whom had themselves attained considerable dignity as the subject of one of Tintoretto's over 100 portraits. Several bear a strong resemblance to the old voyeurs in the painting. Whoever commissioned the work evidently was not disturbed to find – besides a beautiful nude – his own image, or those of two of his peers, portrayed in such a shameful role.

Rather than the mass production of portraits, or painting female nudes with Biblical or antique names, Tintoretto's main work, aided by his assistants, lay in the creation of gigantic religious works. On countless square metres of canvas painted for the Doge's palace, for churches and houses owned by religious brotherhoods, Tintoretto extolled the martydom of the saints, or opened the Heavens to view, drawing the spectator's eye, past hosts of angels, into the Beyond. Foreshortening, exemplified in the present work by the figure of the old man lying on the ground, dramatic lighting and surprise vistas, such as that in Susanna's garden, were typical features of his style. Exact perspective was of little interest, realism an alien notion. He painted his visions: and one of the most impressive was this – possibly quite private – view of Susanna in her enchanted garden.

Art and nature, harmony in a garden

Paolo Caliari (Veronese): The Marriage at Cana, 1562/63

The Lord sits at the table of lords

Despite rules forbidding them to raise their eyes from the plate while eating, the Benedictine monks at the monastery of S. Giorgio Maggiore decorated their refectory walls with the painting of a sumptuous feast. Their excuse was that the work illustrated a miracle: Christ's turning of water into wine at the marriage in Cana of Galilee. Napoleon had the painting (6.69 x 9.90 m) removed to Paris, where it now hangs in the Louvre.

With its 6.69 x 9.90 metres, this is one of the largest works ever to be painted on canvas. The contract concluded between the monks of the Venetian monastery of San Giorgio Maggiore and the painter Veronese (1528–1588) on 6 June 1562 specified "a painting as wide and as high as the wall"[1] for the end wall of their new refectory.

During the 16th century, while the rich Venetians built one splendid Renaissance palace after another, the Benedictine monks of Venice added a new dining-hall (refector-

Paolo Veronese

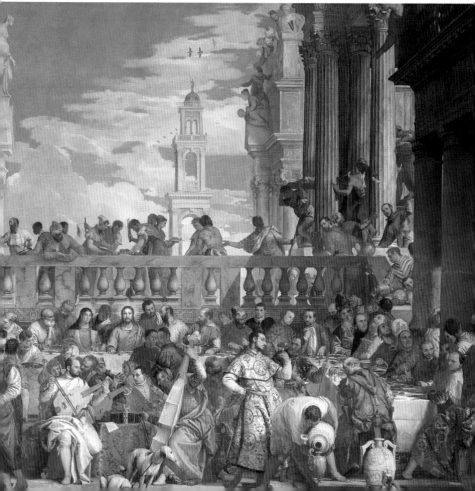

ium), cloister, library and church, thereby greatly embellishing their island opposite St. Mark's. Since many were the younger sons of the lagoon-Republic's ruling families, they had access to wealth and could therefore afford building works on this scale.

The refectory of the Benedictine monastery made its architect Andrea Palladio (1508–1580) famous. Palladio took his inspiration from antique temples, and his cleverly calculated proportions imparted a rare sense of harmony to the large, simply decorated hall. The background of *The Marriage at Cana* is strongly reminiscent of Palladio's architectural style. Veronese draws the spectator's eye through to palaces, a campanile and balconies – in other words into an ideal Renaissance townscape, set against a bright and cloudy sky.

The open square with the marriage feast in progress is framed on either side by columns in antique style. Servants scurry back and forth on a gallery, while the guests sit around the banquet table in the foreground.

Christ presides at the centre of the painting, surrounded by his mother and disciples, while some of Veronese's patrons, the Bendictines of San Giorgio, sit at the right. These elderly gentlemen with their rich robes and well-fed faces do not seem at all disinclined to partake in the feast of life. Nor does it seem

beyond the bounds of credibility that they took great pleasure in Veronese's portrayal of the feast during their own mealtimes – despite a strict rule which forbade Benedictine monks to raise their eyes from the plate while eating.

Large-scale canvases like *The Marriage at Cana* were only possible as the collective work of a studio. According to Veronese's sketches, his brother Benedetto Caliari, a nephew, and a host of nameless assistants and apprentices all worked in his *bottega* at the time.

Benedetto was responsible for the execution of architectonic aspects of the painting, and occasionally sat as model. His striking face with its characteristic Roman nose appears in many of Veronese's paintings. Here, Benedetto is portrayed as a Master of Ceremonies, raising a glass of wine to his expert eye.

This glass is the site of a biblical miracle – the changing of water into wine (St. John 2,1): "This beginning of miracles did Jesus … and manifested forth his glory" at "a marriage in Cana of Galilee". There was no wine left, and "Jesus saith unto them, Fill the waterpots with water … Draw out now, and bear unto the governor of the feast … When the ruler of the feast had tasted the water that was made wine," he was astonished, asking the bridegroom why he had "kept the good wine until now".

Veronese's richly-clothed major-domo does not seem to be asking any questions, however, but to be examining the colour and taste of a wine, an everyday event for a Venetian connoisseur. Consumption of wine in the city in the lagoon was considerable, partly because of the shortage of drinking-water. The Venetian historian Marino Sanudo, writing in 1533, mentions this paradox: "Venice in the water has no water."[2] Although the senate occasionally looked at plans to bring water to Venice by aqueduct, the inhabitants had to make do with rain-water. Collected in a large number of marble cisterns distributed around the town, the water is reputed to have left an unpleasantly muddy, or sandy, aftertaste, so that the Venetians tended to prefer wine.

The biblical miracle of the changing of water into wine does not appear to have found many admirers among the guests of Veronese's *Marriage*. Instead, they seem fully preoccupied with food, music and each other. Certainly, Christ's figure is the focal point of both the banquet and the painting. The cruciate halo shines around his head, while the activity on the gallery immediately above his head is presumably intended to be ambivalent: servants are butchering meat, though they might equally be slaughtering a sacrificial lamb.

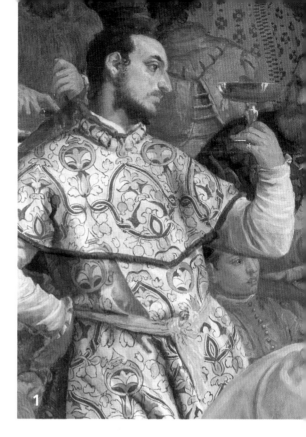

Nonetheless, the significance of the miracle goes unrecognized in the hubbub of the feast, and Jesus is only one of well over 100 figures. Worldly things seem to have displaced the spiritual dimension; the guests are more interested in present enjoyment than in the afterlife. This was hardly an unusual state of affairs in Venice at the time, and one that was frequently described. The Venetians were trying to "turn the world into a pleasure garden", wrote the German pilgrim Felix Faber after visiting Venice in 1480:

Enough wine, but hardly any water

Exotic splendour of the banquet

"The Turks and other infidels who see these gleaming palaces say the Christians who built them cannot esteem the afterlife, nor can they expect to gain very much from it."[3]

Goblets and bowls of finest glass, gold and silver sparkle on the damask table-cloth. The ambassador of the Republic of St. Mark to the Imperial City of Augsburg in 1510 expressed his astonishment that even the rulers of the Empire ate from earthenware dishes, whereas gold and silver dishes had been in widespread use in his own home

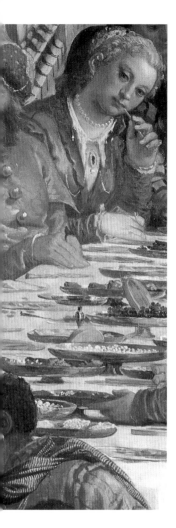

presented them with some highly inventive, and very costly decor: cutlery, crockery and table coverings of pure spun sugar.

The government of the city, whose preferred tone was generally inclined to discretion and understatement, used state functions and feasts as a means of demonstrating that Venice was still the richest and most luxurious city on earth. The more dubious Venice's role as a great power, the greater the need for such demonstrations became.

The patricians gathered around the festive table in the painting evidently still conceived of themselves as rulers of the waves. Almost all of them wear robes of rich and exotic materials. Their services to the Republic will have taken most of them to posts in the Levant as diplomats or colonial administrators. The Venetian Empire itself had included Istria and Dalmatia, and had extended to Constantinople. At its zenith in the beginning of the 15th century, it had held sway over the Adriatic and Aegean, over Crete and Cyprus. Eventually, however, it began to disintegrate. Bit by bit was lost to the Turks. At the same time, the discovery of a sea-route to India in about 1500 broke the Venetian trade monopoly on pepper and spices. By then, the Venetians were no longer in a position to redress such political and economic setbacks. Instead of pumping more and more money into adventurous

town for some time. Even the toothpicks – a lady in the painting is shown raising one to her mouth – are said to have been made of gold. The guests at one noteworthy banquet, held in 1574 in honour of Henry III, were amazed and delighted when their Venetian hosts

3

19 September 1557. Following nine heads of state who were all bachelors, Doge Lorenzo Priuli had at last set a woman beside him on the throne. His reputation for meanness had made him particularly concerned on this occasion to display his magnificence. Perhaps the memory of the feast is reflected in Veronese's painting. According to one contemporary chronicler, nothing like it had been seen for over a hundred years.

The kitchens and other rooms where food was prepared were generally situated in a separate building or cellars, far from the banqueting-hall, or at least out of sight of guests and spectators. Kitchens and those who worked in them therefore rarely appeared in paintings.

Veronese broke with this convention. He painted a third level between the guests seated around the table in the foreground and the spectators looking down at the feast from their balconies in the background: a gallery, joined to the dining area by two staircases at either end, stretches across the entire painting. This is the site of bustling activity: several porters are carrying a roasted ox. A black boy waits on the left with a tray for the roast which a bearded man is holding out between the columns. Those not carrying food or passing it on seem equally busy making sure that everything happens according to plan.

Veronese brings on the servants

trading expeditions, as they had done in the past, they preferred the security of investment in property on the Italian mainland, leaving trade on the high seas to up-and-coming cities like Antwerp and Amsterdam. A Venetian visitor, Tommaso Contarini, saw "neither luxury nor pomp" in these cities, neither silver nor silk robes, noting that "these were unknown in our own town at the time of our forebears".[4]

Shortly before Veronese painted his *Marriage at Cana,* an especially sumptuous feast had been held to celebrate the coronation of the Venetian dogaressa Zilia Priuli on

Paolo Veronese

The Venetians ate an astonishing amount at their feasts. No fewer than 90 different foods would be served to 100 guests at a banquet lasting about four hours. The artist's unconventional look at the trivial world of servants was not to everyone's taste, however. Some years later in 1573, when Veronese had again painted a large-scale picture for the refectory wall of a Venetian monastery, he was summoned before the Inquisition. He was accused of having crowded a biblical scene, *The Last Supper,* with vulgar and irreverent figures such as servants, common mercenaries and even dogs. "If there is room in a painting, I decorate it as I see fit," Veronese answered. "I painted a cook, thinking to myself that he would probably have come out to have some fun and see what was going on."[5] Veronese was aquitted, but instructed to change the title of the painting. The Inquisition demanded it be altered to *A Feast in the House of Levi.*

In *The Marriage at Cana,* too, the servants have come out "to have some fun" and are seen taking part in the general hubbub on the servant's gallery, taking time off to watch the festive goings-on over the balustrade. Their exotic dress and dark faces under turbans and feather-caps identify them as the natives of Venice's traditional trading partners. Saracen, Tartar and Circassian slaves served in almost

every household in Venice. In Veronese's day, slaves were readily available at the public auctions held in the Rialto market.

Attempts by Holy Roman emperors, popes, patriarchs and doges to forbid the slave trade in Venice had always ended in failure. It was simply too lucrative. Countless female slaves worked in Venice as wet-nurses and maids. Without their labour, and without the enormous sums of money gained by trafficking slaves, the Venetians' very pleasant, very lavish life-style would not have been possible.

It is said that Veronese portrayed many of the famous figures of his time, including Francis I of France (died 1547), among the roughly 150 guests depicted in the *Marriage at Cana.* However, we do not owe this notion to the testimony of his contemporaries, but to art historians of the 16th and 17th centuries. Equally unproven, though more enticing, is the art theorist A. H. Zanetti's contention in 1771 that the little orchestra in the middle of the painting was composed of the most well-known painters in Venice. "Titian is playing the double-bass," he wrote, describing the man on the right dressed in red. "Paolo portrayed himself as the figure in the white robe with the cello", he went on, and, of the musician sitting next to him: "It is correct to suppose that this is Jacopo Tintoretto."[6]

4

Painters play for the guests

If this is true – and comparisons with other portraits appear to corroborate the claim – then the unchallenged masters of 16th-century Venetian painting, the three great colourists, were gathered here to make music. All three received major state commissions and worked hard to decorate Venice's churches and government buildings with their paintings. Paolo Caliari was the youngest of the three, born in 1528 at Verona, the reason for his nickname Veronese. His first success at the city on the lagoon had come

when he was commissioned to decorate St. Mark's library. Already an old man in 1557, Titian is said to have rewarded the artist by hanging a gold chain around his neck.

Tintoretto (1518–1594) was an eccentric who, during his lifetime, did not achieve such great public recognition as Titian (c. 1477–1576), who was knighted and celebrated as a "divino", one of the divine.

Perhaps the painters met at Titian's house. He possessed an organ, bartered from an organbuilder in return for the latter's por-

mony must have fascinated painters and sculptors, too: "Just as vocal proportions are harmonious to the ear," explained the learned monk Francesco Giorgi in 1525, "so physical proportions are harmonious to the eye. Such harmonies provide the greatest of pleasure without anyone knowing why, except for One who understands the causal connections between all things."[7] The search for these "causal connections", and for perfect harmonies of tone, proportion and colour, was taken up by composers, architects and painters alike. As a result, 16th-century Venice entered a period of unparalled flowering of music and the arts, at a time when the city was long past its political and economic heyday. This was made possible by the continued wealth of the city, together with the artistic sensibility of its ruling class. Unwilling to risk adventurous journeys on the high seas or to engage in pioneering trading expeditions as they once had, the patricians of the Republic of St. Mark had become a class of highly educated, hedonistic humanists who were fond of spending large sums of money on the arts. The Benedictine monks of San Giorgio, who had their refectory built by Palladio and painted by Paolo Veronese, and who wished to eat to the accompaniment at least of painted music, are themselves an excellent example.

trait. Music was played there just as it was everywhere in Venice in the 16th century. Even in 1506, Dürer had written of the city-state that he had heard people playing violins so sweetly there that the players themselves had been moved to tears.

It is quite possible that the music played at Veronese's feast would have been by Andrea Gabrieli, the organist at St. Mark's and leading composer of his time. His melodies were heard at the time in the salons, theatres and on public squares. Gabrieli's studies in the field of har-

The Antwerp building boom

The unfinished tower warns against arrogance before God. Bruegel set the biblical scene against a contemporary background. For many years, the artist had lived in Antwerp, the new financial capital of Europe. The city was experiencing a building boom. The painting (114 x 155 cm), a testimony to the fears that accompany modernization, is in the Kunsthistorisches Museum, Vienna.

The Old Testament Book of Genesis describes how God created the earth, the animals, the plants and eventually also man. It is a story of disobedience and punishment, revolt and suppression. God punishes man three times. The first punishment is the expulsion of Adam and Eve from Paradise after they have eaten from the Tree of Knowledge of good and evil. They lose eternal life in a world without work or need.

But God is also unhappy with the behaviour of their children and children's children: "God saw that the wickedness of man was great in the earth … And the Lord said, I will destroy man whom I have created from the face of the earth",

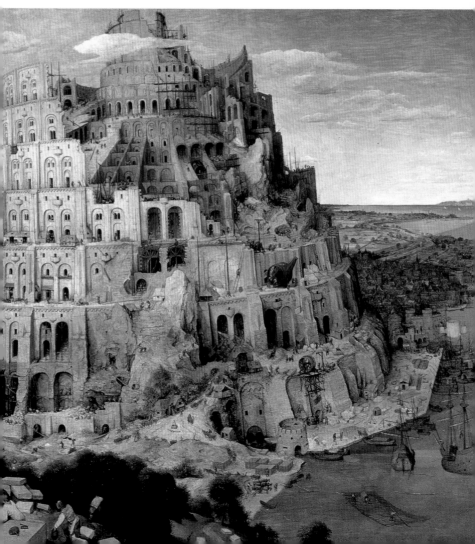

The most crowded town in Europe

and not only man, but the beasts, too. Only Noah finds grace in the eyes of the Lord. God commands him to build an ark in which to rescue himself, his wife, and two of every sort of living thing. God then destroys all other living substance by means of a great flood. When the flood abates, Noah prepares a burnt offering. God smells "a sweet savour" and decides not to destroy man again: "Neither will I again smite any more every thing living, as I have done."

But he certainly made life difficult when He thought man deserved another punishment. For in the meantime, Noah's descendants had decided as follows: "Let us build us a city and a tower, whose top may reach unto heaven; and let us make us a name, lest we be scattered abroad upon the face of the whole earth."[1]

Now, building a tower as a means of self-orientation and as a symbol of community was one thing; building one that reached into heaven was quite another. It was not the sort of challenge God could easily put up with!

Instead of killing them, he took from them their common language. They could no longer understand one another's speech and were scattered over all the earth. Their city and tower remained unfinished. The name of the city was Babel, like the Hebrew verb "balal", meaning "to confound".

Pieter Bruegel the Elder

Two paintings of the Tower of Babel by Pieter Bruegel the Elder have survived, while a third, a small one on ivory, is lost. The theme must have interested him greatly. There are no records to tell us what led the painter to this subject, but life in the town where he worked for at least a decade must have constantly reminded him of Babel.

The town was Antwerp: few other cities were forced to accommodate such an inflow of people and so gigantic a building boom in such a short period of time. There were only two or three cities with over 100,000 inhabitants in 16th-century Europe; Antwerp became one of them. The Italian Ludovico Guicciardini's description of Antwerp in 1566 contains the following comment: "Today there are already about thirteen thousand, five hundred houses in Antwerp." If building work continued unabated, Antwerp would soon be considered "one of the most crowded towns in Europe".[2]

The main reason for the boom which changed a small port into the "most crowded town in Europe" was the reorientation of world trade following the discovery of sea-routes around the Cape to Asia and across the Atlantic to America. As a result, Venice and Genoa lost their leading positions, while ports on the west coast of Europe gained in significance. The Netherlands were favourably placed not only for transatlantic trade, but for traffic between the north and south, for imports of spices from the Orient, and for reloading wood and cereals from the Baltic. In the course of the 16th century Antwerp advanced to become the centre of Western European trade.

Foreign trade naturally brought a great babel of languages to Antwerp – and not merely to the immediate vicinity of its harbour, or to the public houses frequented by sailors. Foreign trading companies sent representatives to establish branch offices in the city. There were Italians, French and English merchants, traders from the Hansa towns and, most numerous of all, the Portuguese. In 1570, the Portuguese community included 102 households.

Foreigners were enticed to Antwerp with various privileges, but they were also treated with suspicion by the town's inhabitants. Though hardly very many in percentage terms, they were conspicuous: they spoke different languages, wore different clothes, had different customs. The majority of people at the time lived in small towns with stable populations, in which everybody knew everybody else. A town growing as fast as Antwerp, with new faces coming in all the time, was unusual enough, and an influx of people who also spoke different languages must have added to the confusion. The population of

Antwerp probably experienced something similar to the inhabitants of Babel: a growing, tightly-knit family of man disintegrating into separate groups.

There was a similar development in Antwerp – and not only there – in the field of religion. For centuries, the Roman Catholic Church had succeeded in preventing attempts at secession and eliminating sects. Its unity was not destroyed until the Reformation, when not only Luther, Calvin and Zwingli, but also the Anabaptists and a host of other, now long-forgotten sects, established reformed Christian Churches. In 1563, the year in which he painted his *Tower of Babel,* Bruegel left Antwerp for Brussels. It has been suggested that one of his reasons for doing so was to escape the grips of a sect called the Schola Caritatis.

Bruegel has painted an enormous crane on one of the ledges of the tower. There are three men in the tread-wheel attached to the near side of the crane, and presumably three others in the drum at the far side. This enabled the builders to lift weights many times heavier than themselves. In this case, they are lifting a stone that has already been cut to shape. A man on a balcony is trying with a rope to prevent the stone from banging against a buttress.

A crane of this type is said to have stood in the market-place at Antwerp to help with the handling of goods. On the ledge below it, Bruegel shows a different, smaller kind of treadwheel crane; he also painted several winches. His technical drawing was very precise; perhaps this explains why he was commissioned to depict the building of the Antwerp-Brussels canal. His death in 1569 prevented him from executing this work.

Transport of materials on the building site was done by low-paid labourers. The stonemasons came at the top of the hierarchy of building workers; Bruegel paints them at work in the foreground, cutting stones to size. Usually, this was not done on the site itself, but at the quarry. Long-distance transport was expensive; superfluous stone meant higher freight costs. At the same time, it was cheaper to carry materials by boat than to have them transported overland on an ox-drawn cart. Bruegel's decision to show building work in progress by the sea is not, therefore, merely reminiscent of the position of Antwerp as a coastal town, it is also a correct observation of economic reality.

Scaffolding on high buildings presented a particular problem. Only wood could be used. The wooden bars and planks were bound together, but they could not be made as high as the wall of a cathedral. The masons therefore

had to attach the scaffolding to the wall as they built it. Bruegel has avoided this problem by painting his imaginary tower with ledges which served as ground-level supports for work on superior levels. His arrangement of the inner passageways, arches and steps is vaguely reminiscent of the Colosseum and Castel Sant'Angelo at Rome, sites which Bruegel had in fact visited.

On the ledges spiralling to the top of the building are a number of huts. This is also concordant with contemporary building practice: each guild had its own hut, or lodge, built as close as possible to the building site. Here the builders took meals and kept their tools. The lodge was also the masons' winter workshop.

These huts were often surrounded with a great aura of mystery, an aura later transferred to the lodges of the freemasons. In fact, there was nothing more mysterious about them than the specialized knowledge of the master builders who convened there. There were no textbooks in those days, no written instructions; building knowledge was imparted orally from one generation to the next.

As far as we know, the mathematics of statics was still in its infancy. The enormous cathedrals of the day were built not on the basis of cleverly worked out calculations, but on tradition and experience. More than one of God's houses collapsed, like the cathedral at Beauvais; or remained unfinished, as in Siena. Architecture had not yet become a fully-fledged profession. Usually, it was the master mason who directed the work on site.

Experience instead of textbooks

It is said that the order to build the Tower of Babel was given by King Nimrod, a grandson of Noah and the first mighty ruler in the post-

diluvian history of mankind. Bruegel depicts him here with sceptre and crown, and the masons before him on bended knee.

At least one of the masons has gone down on both knees, an unusual form of reverence in 16th-century Europe, at least outside the Church. Of course, anyone who wished to present something to Charles V or Philip II, the Spanish Emperors, was required to kneel, but only on one knee. Here, Bruegel demonstrates an Oriental custom.

Archaeologists have proved that the story of Nimrod's tower is based on a real precedent in ancient Sumerian culture, whose civilization reached its zenith in the 4th and 3rd centuries B.C. It is thought that the Sumerians migrated from the mountians to the Mesopotamian plains and wished to take their gods with them. So that the gods would be more inclined to descend from the heavens to the plains, the Sumerians built mountain-like temples for them. The tower was essentially a later development of the high temple.

Alternatively, it has been suggested that the Sumerians thought the home of the gods was a mountain between heaven and earth; their tall temples were therefore imitations of the heavenly mountain, and were built in praise of the gods.

The ancient Akkadians and Assyrians inherited the celestial mountains from the Sumerians. Every town is thought to have had its own. Babylon – or Babel, as it was called in Hebrew – presumably had the greatest of all. Archaeologists discovered its foundations at the beginning of the twentieth century. It was square, and had sides that were 91 metres long. According to ancient scrolls, it had seven floors, each smaller than the one below it, and was about 90 metres high. The Greek writer Herodotus saw the tower (or rather, a later version of it) in 458 B.C. However, it was already a ruin when Alexander the Great visited Babylon some 130 years later.

The building also found its way into the Christian tradition. The oldest surviving illustrations of the Tower of Babel emphasize that the wrath of God was directed against the hubris of those who dared think in such dimensions. God is shown destroying the tower – an event that is not described in the Bible – or scattering its builders over the face of the earth. A mosaic, dating from about 1220, in St. Mark's cathedral in Venice shows two towers. While work is shown still in progress on one of them, the other is already deserted; angels in the sky around it are shown scattering people in every direction.

Whether in mosaics, Bibleillustrations or the illustrated books of hours of the 14th and 15th century,

The gods descend from heaven

the tower is never particularly huge by comparison with the people around it: it is rarely more than three times the size of the builders. The reasons for this are less ideological than practical. If the artists had attempted to make the building appear gigantic by letting it fill the entire space of the work, they would have had to make the human figures tiny by comparison. In practice, however, the figures would then have been too small to depict with mosaic stones, or in miniatures. The situation changed with the advent of panel-painting and, more especially, with the flourishing of 16th-century Netherlandish painting: during Bruegel's lifetime, and in the decades immediately after his death, the theme found its most widespread treatment.

Painting the Tower of Babel became little short of a fashion in the 16th and 17th centuries. This was not merely due to the obvious parallel of Antwerp's rise to international fame, or to the spectacle of Christendom divided by the Reformation; it was also the attraction of painting imaginary architecture in realistic detail, depicting famous biblical edifices as if they were really situated in western Europe: in a Netherlandish port, for example. Realism of this kind was a comparatively new phenomenon and contrasted sharply with the previously dominant Christian world-view.

The work of a German Jesuit, Athanasius Kircher, who attempted to draw up exact calculations for a tower as high as the moon, serves as an illustration of the extremes to which realism could be taken some 100 years after Bruegel's death. Kircher worked out that the building of such a tower would require so much material that the Earth itself would be thrown off balance and dragged from its position at the centre of the cosmos.

Despite its "secularization", the theme retained its moral force. The less familiar motifs in Bruegel's painting emphasize its message. The artist's contemporaries would have recognized everything they saw in it from their own environment, with two exceptions: the tower piercing the clouds and the mason's Oriental gesture of homage to the king. By contrast with other motifs in the painting – landscape, coast, ships, town, builders, construction technique – these point directly to hubris, vainglory and megalomania.

Bruegel also painted other warnings against hubris: fallen angels, the fall of Icarus, the death of King Saul. Few of these themes appear in his graphic work, however. His drawings were moderately priced, his paintings expensive – his warnings must therefore have been directed primarily at the ruling class. Among the representatives of this class were rich merchants such as

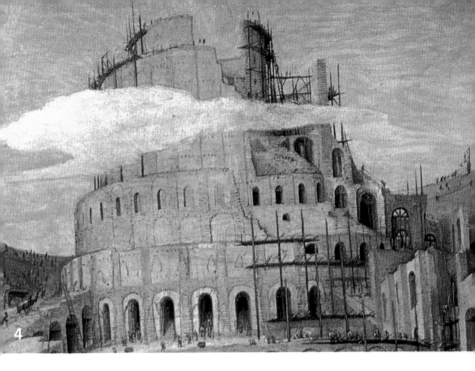

4

Nicolaes Jonghelinck, who is known to have offered his collection of paintings, including many Bruegels, as security against a loan of 16,000 guilders; or representatives of the Spanish government, such as the powerful Cardinal Granvella, who also owned a number of Bruegels. Apparently, the painter considered those with money and power especially vulnerable to hubris.

There may have been a further, quite specific reason for Bruegel to have painted the Tower of Babel in 1563. He had perhaps heard of yet another massive building project, begun in Spain the very year in which his painting was executed:

the Escorial, an enormous, palatial monastery near Madrid. Philip II's motives for building it may have been extremely pious, but his Escorial was also a demonstration of power. Even if Philip could not be accused of throwing down the gauntlet to God, as Nimrod had done, his ideas were a challenge to humanity, and to the Netherlanders in particular, many of whom did not wish to be Catholics. Even if the Escorial itself has survived the passage of centuries, it was under Philip that the power of Imperial Spain began to crumble.

A warning to the mighty

The Tower of Babel, 1563

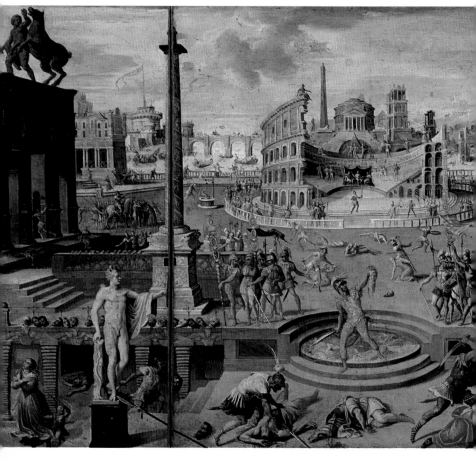

Antoine Caron: The Massacre by the Triumvirate, 1566

For Tiber, read Seine

It was in far-off ancient Rome that the court painter to the French queen chose to set the murderous events taking place in a Paris torn by religious conflict. Caron's elegant portrayals of gruesome atrocities were popular at court and amongst supporters of both camps in the French Wars of Religion, the Hugenots and the Catholics.

One day in 1913, in search of protection from the English drafts, the French Marquis de Jaucourt was rummaging through the London antique shops for a folding screen. He spotted a stand that "was exactly the right height". Only when he got home, did he realize that it was an oil painting, a canvas measuring 116 x 195 cm cut into three pieces.

Cleaning the work brought its bright palette and its content back to light: soldiers in antique military costume are pursuing people across a spacious open square, massacring them and then setting out their heads in a row. The victims attempting to flee up flights of steps and across roofs have no chance of escape. They suffer the most excru-

ciating agonies before finally being left lifeless on the ground by their tormenters. The scene takes place within an imposing decor, between triumphal arches, the Capitol hill, the Colosseum and the Castel Sant'Angelo – the buildings of ancient Rome.

The painting portrays an episode from the history of Rome. In 43 BC, following Caesar's murder, Antony, Octavius and Lepidus formed a tri-umvirate and resolved to dispose of their numerous political opponents in one fell swoop. They put a price upon their heads and had them massacred.

In 1939 Jaucourt donated the painting, still in its three sections, to the Louvre in Paris. Restorers have succeeded in uncovering an inscription on the wall of the steps on the left-hand edge of the composition, behind the stone ball on

Reality behind a classical façade

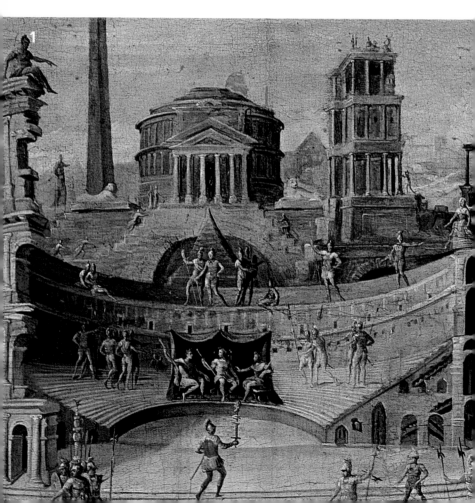

1

the foreground parapet. It reads: "Ant … Caron Pict", and – beneath an illegible line – the year 1566.

Antoine Caron lived from 1521 to 1599 and served Catherine de' Medici as court painter and decorator of lavish feasts. The widow of Henry II reigned for almost 30 years over a France torn by religious wars. Violence, atrocities and murder were the order of the day – just as in ancient Rome.

"All one could hear from every side was screaming, sobbing and wailing … one saw illustrious men fleeing miserably … hiding themselves in wells, cellars and underground places." Thus the Greek historian Appian, writing in the 2nd century AD, described the massacre instituted by the three triumvirs. Caron follows his description right down to letter. For example, he shows a soldier bearing Cicero's head on the tip of his sword to Antony, Cicero's bitter enemy, who "was seated on his tribunal" and who "greatly rejoiced" at the sight. Caron shows the triumvirs sitting beneath a canopy and passing their judgements.

The French translation of Appian's *History of Rome* was published in several editions between 1544 and 1560. Public interest in classical subjects was widespread, but the Roman despots held a particular relevance amongst Caron's contemporaries. On 7 April 1561, three aristocrats founded a French "triumvirate" in Paris to defend the Catholic faith.

The three men who hoped, through the association with ancient Rome, to reflect glory and legality onto their own pact were Anne de Montmorency, France's most senior military commander, Duke François de Guise, the ambitious head of a Lotharingian dynasty, and Marshal Jacques d'Albon de Saint-André, a friend of Henry II. The king's premature death in 1559 had left a power vacuum, since his sons were still too young to succeed to the throne. From 1560 Queen Catherine ruled on behalf of the 10-year-old Charles IX – a welcome opportunity for the feudal lords, who had lost their influence under Henry and his predecessors, to redress the balance. They did not hesitate to exploit the religious conflict to these ends.

France was at that time split into two camps: since the publishing of John Calvin's *Institutio Christianae Religionis* in 1536, many French had professed their faith in the Protestant Church. Although these Huguenots were persecuted by the Catholic majority, around 1559 they numbered about one third of the population. The other two thirds were Catholic.

For Catherine, the banker's daughter from Florence who had come to the French throne through her marriage to Henry II, the welfare of France came second only to

that of her children. She preached tolerance and sought compromises. She would have been happy to allow everyone to worship as they wished. But the power-hungry feudal lords, the many soldiers returning from the Italian campaigns to unemployment and the religious fanaticism in both camps (each backed by support from abroad), conspired to ensure that the latent conflict eventually erupted into the open.

One year after the formation of the triumvirate, France saw its first War of Religion. It was followed by another seven, separated only by brief ceasefires, and lasting till the end of the century.

A few days after the proclamation of the French triumvirate, students from the Paris university gathered to track down Huguenots who dared to sing their psalms in public – something they were only allowed to do outside the city. Persecution of the religious minority started to increase across the whole country.

On 1 March 1562, a Sunday, one of the three Catholic leaders, the Duke de Guise, stopped in the small town of Vassy, where the Protestant community had assembled for a service in a barn next to the church. That was a violation of the rules of religious worship. The Duke's troops stormed the building, killed 74 people and injured

another 104. The Duke took the survivors to Paris to have them punished as insurgents. He was greeted as a hero and the massacre celebrated as a great exploit. Shortly afterwards, the First War of Religion broke out.

French reality was thus not far removed from the scene that Caron portrays in his *Massacre*. A painting of this type is supposed to have hung in the study of the Protestant leader, the Prince of Condé, a permanent reminder to his followers of the persecution they had suffered.

We know from an inventory that the Catholic General Montmorency also owned a Massacre picture. That was nothing unusual. According to a contemporary report, in 1561 "three large pictures, excellently painted", portraying the triumvirate, "were brought to the Court ... dearly purchased by the great rulers".

Representations of such bloodthirsty subjects were evidently in demand – amongst supporters of *both* parties. Over twenty, mostly anonymous versions of the *Massacre by the Triumvirate* survive from this epoch, and the records speak of another two dozen more. A second, unsigned painting of the same subject has been attributed to Caron himself; it hangs in the museum in his native town of Beauvais.

Such pictures were probably also popular for their detailed rendition

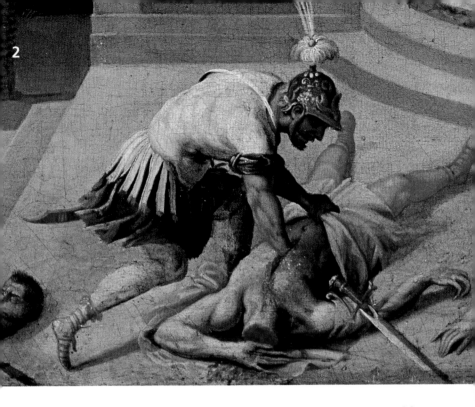

of atrocities – a source of sadistic pleasure to certain viewers. Thirty years of war with Italy had brutalized people's sensitivities, and acts of cruelty were perpetrated by both sides. Thus one Huguenot leader sported a necklace made out of the ears of Catholic priests.

The artist here anticipates events that would take place in real life just a few years later, at the Massacre of St Bartholomew in 1572. Tired of tolerance, Catherine attempted to wipe out the Protestant leaders in one go. The result was a massacre. The Protestant Admiral Coligny was thrown out of a window, tram-pled to death by his enemies, his head cut off and his body dragged through the streets. The bodies of around 4000 killed or drowned were swept down the river Seine.

The victims of Caron's *Massacre* are adrift not in the waters of the Seine in Paris, but in the Tiber, floating past one of Rome's most distinctive landmarks, the mausoleum of Emperor Hadrian, renamed the Castel Sant'Angelo by the popes. Caron distributes an entire collection of well-known Roman monuments across his picture – something which distinguishes it from other

**Atrocities
in art
and life**

Massacre pictures, all of which take place against an ill-defined antique backdrop. Caron shows the Colosseum with the Pantheon rising above it, the triumphal arch of Septimus Severus standing to the left of Trajan's Column and the Arch of Constantine to the right, and in the background the Arch of Titus, surrounded by imaginary ruins. He thereby portrays these monuments not as Antony, Octavius and Lepidus would have seen them, but as they appeared to his own contemporaries, such as the French diplomat and poet Joachim du Bellay, who described Rome's "walls, arches, baths and temples" in the collection of sonnets which he published in 1558 under the title *Les Antiquités de Rome*.

Francis I (1494–1547) had encounted Roman architecture and the Renaissance buildings modelled on the classical style during his military conquests in Italy. When he crossed back over the Alps, he brought a team of architects, painters and craftsmen in his train. They were to build him a "New Rome" in the shape of Fontainebleau, the magnificent palace which was to serve as a shining example to the rest of France. On the king's instructions, the painter Francesco Primaticcio (1505–1570) arranged for 130 crates full of plaster casts of the most famous antique statues to

The artist had never seen Rome

3

be shipped to France. Casts were taken from them in the Fontainebleau workshops in 1545 and erected in the palace grounds. It was there that Caron was able to study replicas of the Belvedere Apollo and Hercules with the child on his arm.

He probably never went to Rome itself, however. Although the buildings he portrays are accurate in their architectural details, they are topographically incorrect – Caron has positioned them at random. It is unlikely, too, that he would have made certain errors of scale (the columns of the Temple of Castor and Pollux above the Forum are too tall, the people in the Colosseum far too large in relation to the building) had he seen it all with his own eyes.

He seems to have based his composition on the engravings of Roman monuments which the French artist Antoine Lafréry executed in Rome and subsequently distributed in Paris in 1562.

With this erudite anthology of classical buildings, the court painter Caron pays tribute to the general passion for architecture shared by the queen herself. Catherine was almost as fanatical about building as her father-in-law Francis I; in 1566 she erected, in the Italian style, the "new Louvre" where Caron's painting is housed today.

Caron learned his trade under the Italian masters at Fontainebleau,

the construction site of the "New Rome". His name appears between 1540 and 1550 on the palace list of salaried staff: he earned the modest sum of 14 pounds a month. A decade later, in 1559, his salary rose to 50 pounds: under the supervision of Primaticcio, Caron was entrusted with the renovation of the royal apartments. Up until then the French art scene had been dominated by the Italians, but by the start of the 1560s most of these guest artists were dead or had returned to their native land. A new emphasis was put upon French qualities: although French poets continued to compose their odes along classical lines, they now wrote in their mother tongue, rather than in Latin or Italian. It was an opportune moment for a French artist, and so Caron entered the service of the king's widow, Catherine.

It is not known for whom he painted the *Massacre by the Triumvirate*. The identity and confession of his client might shed light on the artist's intentions: is he pillorying the outrages committed by the Catholics or by the Protestants, for example, or is he issuing a general warning against the dangers posed to the populace by any dictatorship – something which would have been fully in line with Catherine's thinking? The moral or allegorical meaning of this painting remains locked and barred to us.

In this, his first large-format work, the newly-appointed court painter was probably trying to impress. Hence he chose a broadly popular Roman subject with modern relevance, and portrayed it in an exciting, new style, concentrating upon surprises and contrasts. For a century, art had aspired to ideal beauty and harmony, but Caron's contemporaries had wearied of these Renaissance values. There was nothing harmonious about the world in which they lived: civil war was raging in France, the Reformation had placed a question mark over all that was held most sacred, and Charles V's mercenaries had burnt and plundered the spiritual capital. A new aesthetic was rising to the fore – one art historians call Mannerism.

There is a wide gulf between the form and content of Caron's painting. He paints slain heads and murdered bodies in cheerful, bright colours, while his butchers are grouped in elegant poses under fluttering banners, as if dancing in a courtly ballet. The heads of the actors are small, their gestures exaggerated and mannered. Other than in the details of the architecture, there is no room for realism in Caron's artificial world. The composition is based upon contrasts: the spacious square, teeming with soldiers and their victims, nevertheless gives the impression of being empty. Those fleeing and their pursuers race frantically through a tranquil and timeless decor composed of strictly symmetrical terraces and staircases. The Apollo on the left counterbalances the Hercules on the right, just as the Arch of Septimus Severus finds its counterpart in the Arch of Constantine. Order and confusion permeate each other. An obelisk marks the centre of the canvas, which is divided vertically by two columns into three equal areas – something which probably contributed to its misappropriation as a folding screen.

For almost 300 years Caron's style was dismissed and his works unrecognized or lost. Today, however, his paintings exert a renewed fascination on those visitors who, venturing away from the hordes of *Mona Lisa* tourists, find their way up to the peaceful second floor of the Louvre.

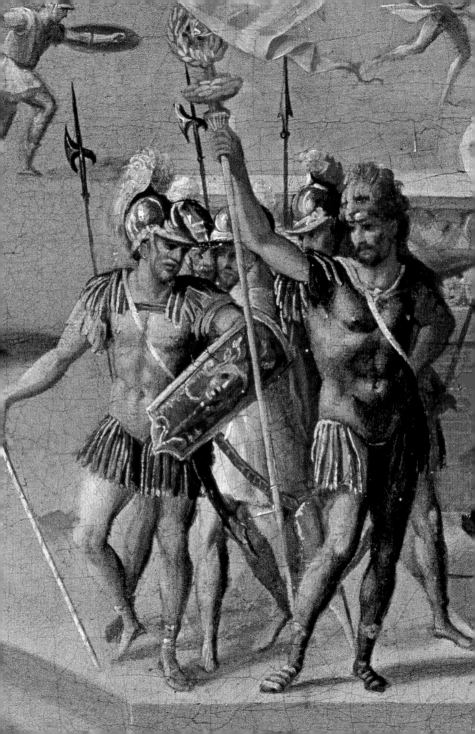

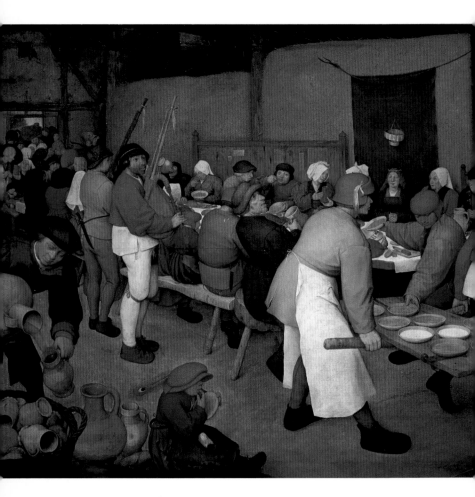

Pieter Bruegel the Elder

Pieter Bruegel the Elder: Peasant Wedding Feast, c. 1567

The barn is full –
time for a wedding!

The painting, now measuring 114 x 163 cm, is in the Kunsthistorisches Museum, Vienna. It is neither signed nor dated. The signature and date were probably on the bottom section of the original oak panel, which was sawn off and replaced at a later date. The craftsmanship of the more recent section is noticeably poorer.

Experts think Bruegel painted the work c. 1567. He married in 1563 and died in 1569, aged about 40. The *Peasant Wedding Feast* was therefore executed during his short marriage, shortly before his death.

The celebration takes place on the threshing floor of a farm. Long tables – not even the rich had proper tables in the 16th century – were put together using wooden planks and trestles. The man in black on the far right is seated on an upturned tub, while most of the other guests sit on roughly hewn benches. The only chair with a backrest has been reserved for an old man: possibly the notary who drew up the contract of marriage. The prints

pinned to the backrest of the long bench resemble those sold during religious festivals or pilgrimages.

In the foreground two men serve bowls of meal, using an unhinged door as a tray. Though merely servants at the feast, the left of the two, the largest figure in the whole painting, is the focal point. The colours, too, make him stand out. Presumably, the artist used the figure to stabilize a complicated composition. The half-diagonals formed by the two rows of eaters in the foreground intersect in the waiter; the edges of the back of his apron mark the central axis.

1

The barn is full

A bunch of ribbons, similar to those tied to the instruments of the two bagpipe players, or peeping out from some men's shirts, hangs from his cap. Usually, these were used to lace up trousers. Worn on the hat, or tied to instruments, they probably indicated membership of a group. Young men at the time lived very much in cliques, a source of fun as well as an opportunity to celebrate with people of their own age.

Scholars often attribute religious or allegorical significance to the work. Some see it as the marriage

at Cana where Christ turned water into wine and vessels were filled over and over again. Others suggest this was Bruegel's version of the Last Supper. Yet another view has it that he was warning his contemporaries against "gula", the deadly sin of gluttony.

None of these hypotheses is especially convincing. However, *The Peasant Wedding Feast* is full of realistic detail, providing a window on 16th-century social reality. In his biographical *Book of Painters*, published in 1604, Carel van Mander describes how Bruegel often went "to visit the peasants, whenever there was a wedding or kermis".

Two sheaves of corn, held together by a rake, whose pole handle is buried in stacked cereal: at first glance the background of straw or unthreshed wheat, almost identical in hue to the trodden clay of the floor, looks like a normal wall. However, the projecting rake and, above the bride's head, the prongs of a fork used to hold up a decorative cloth, together with the blades of corn sticking out on top of the heap, make it clear what Bruegel intended to depict.

The image of a full barn evoked a different response four hundred years ago than in our own age of agricultural surpluses. Cereal was the staple diet; as bread or meal it formed the bulk of every mealtime. To Bruegel's contemporaries, the

sight of a full barn meant the threat of starvation was staved off for the following twelve months.

It was a threat which, as in many developing countries today, recurred annually in Europe. The size of harvests varied enormously, and in the Netherlands, according to historians, losses of as much as 80% had been recorded from one year to the next. Prices were consequently unstable: a yearly increase of 500 percent for a standard measure of oats or wheat was not unknown. A craftsman's apprentice, for example, spent 70% of his income on food, which was mainly cereal. High prices meant insufficient nourishment, which, in turn, led to reduced bodily resistance, illness and early death. Epidemics usually followed in the wake of famine.

Town authorities attempted to compensate by stockpiling and imports. At that time, the Baltic was the breadbasket of Europe, with the Hanse in control of shipment. A sea-journey round the coast of Denmark could take two months. With two months for the order to reach the supplier, and allowance made for winter stoppages, it is obvious that imports could not compensate for bad harvests. What counted was how full your barn was.

There were seasonal fluctuations in price, too. Cereal was cheapest in autumn, directly after the harvest.

Most of the threshing was done between September and January – on the threshing floor, which provides the setting for Bruegel's *Peasant Wedding Feast*. Since weddings usually took place as soon as the harvest was gathered, the cereal here was probably unthreshed.

The Netherlandish peasants were better off in the 16th century than many of their class in other European countries. They had their freedom: serfdom had been abolished, and forced labour for the feudal lords was prohibited by law. In the Netherlands, the peasants' situation made it unnecessary to have a war of the type that raged in Germany. Initially, the Netherlanders found it possible to adapt to the

Peasant Wedding Feast, c. 1567

colonial hegemony of the Spanish Habsburgs. In 1567, however, Philip II sent the Duke of Alba from Madrid to raise taxes and wipe out Protestant "heresy". The last years of Bruegel's life marked the end of an era of prosperity. The long struggle for the liberation of the Netherlands had begun.

There was no more densely populated region north of the Alps than the Netherlands. This was largely due to higher wages. The textiles industry flourished; the Netherlandish ports attracted coastal trade from the Baltic in the north to Lisbon in the south; for several decades Antwerp, the site of the first stock-exchange, was the economic hub of Europe.

The agricultural economy of the densely-populated Netherlands was thought especially progressive and productive. The fact that peasants, as freeholders, worked for their own livelihood, acted as a stimulant – even if the feudal lords owned their houses and land. As money circulation grew and capitalist forms of wage-labour developed, the wealthy bourgeoisie, who had begun to replace the nobles, invested in agriculture as a means of supporting their families in times of crisis.

The man in the dark suit with broad sleeves may have been the landlord. It is impossible to say whether he was a wealthy burgher or a noble, for to wear a sword was no longer deemed an aristocratic privilege.

The aristocracy and clergy each made up approximately one percent of the population. Relations between them were generally excellent. In order to preserve property and power, many sons and daughters of the nobility did not marry, entering various Church institutions instead. In this sense, the Church provided a form of social relief, and, in return, was made the benefactor of countless donations and legacies. For Bruegel's contemporaries it would have been immediately obvious why the monk in the painting converses with the only wedding guest who might be construed as an aristocrat.

The spoon attached to a waiter's hat was a sign of poverty. Since the abolition of serfdom and, its corollary, the obligation of feudal lords to maintain their serfs' welfare, the rural proletariat had greatly increased in number. Peasants with no property or means took whatever work they could find, harvesting, threshing, even assisting on festive occasions. Most lived in huts and were unmarried; wages were not enough to feed a family. Few had a fixed abode, for they spent too long on the road in search of work, a crust of bread or a bowl of meal. This explains the spoon attached to the man's hat, and his bag, of which – in the present work – only the shoulder-strap is visible.

3

The wooden spoon is round. Oval spoons came later, when – following the example of the courts – it was thought bad manners to open one's mouth too wide while eating. To put something into one's mouth with a fork was practically unknown in the 16th century. The alternatives to the spoon were fingers or a knife. Everyone carried their own knife; even the child in the foreground has one dangling from its belt. No instrument features more often in Bruegel's paintings – the knife was the 16th-century all-purpose tool.

The jug being filled in the foreground is a man's drinking vessel. Women drank from smaller jugs. Whether they are serving wine or beer is impossible to say. Wine had been a popular drink in the Netherlands for several centuries and grapes were grown much further north than was later the case. By the 16th century, however, wine-growing was on the decline. The perimeter of the wine-growing regions retreated south, settling more or less where we find it today. Ludovico Guicciardini, reporting on Netherlandish wine in 1563, noted that the "little there was of it generally tasted sour".

Wine was replaced by beer. This was originally imported from Germany, from Hamburg or Bremen. Not until Bruegel's lifetime was beer brewed in large quantities in the Netherlands, where it was not only produced in breweries. The

A spoon in your hat meant poverty

peasants celebrating in this scene may have brewed their own beer. Home-brewing was widespread, and considered a woman's work. Calculations suggest an average daily consumption of one litre per person. According to Guicciardini: "For those used to it, the common beverage of beer, brewed with water, spelt, barley and some wheat, and boiled with hops, is a pleasurable and healthy drink."

Melancholia, a thirsty business

Beer was an important part of the 16th-century diet. It even caused rebellions – for example when the Antwerp city council prohibited the brewing of beer in the Old Town, or its transportation from the surrounding regions. The council "were quick to repeal the beer-law that had so displeased the common people", wrote Guicciardini.

It is to this Italian that we owe the most interesting account of the Netherlands in the 16th century. In his own country, as in Spain, drunkenness was considered disgraceful, and Guicciardini consequently castigates the "vice and abuse of drunkenness". According to his observations, the Netherlanders drank "night and day, and so much that, besides creating disorder and mischief, it does them great harm in more ways than one". As a southerner, unused to the north, he found an excuse for their behaviour: the climate. The air was "damp and melancholy", and "they had found

no better means" of driving away their weather-induced melancholia.

There is no sign of drunkenness in this painting, however. Indeed, the mood seems comparatively sober; an Italian may even have found it melancholy. Nonetheless, the mood would no doubt change as the meal progressed, or during the celebrations, which could last anything up to several days. Bruegel's *Peasant Wedding Dance* (Institute of Arts, Detroit), 1566, a painting of almost identical format, shows the guests in a frenzy of drunken revelry. The two paintings could almost be a pair.

In contrast to the ease with which the bride may be identified, it is difficult to decide which of the celebrants is the bridegroom; he may be the man filling the jugs, whose place, apparently unoccupied, may be at the top of the table on the right – obscured by one of the waiters. He would thus be sitting between two men, just as his bride is seated between two women. Wedding feasts are known to have taken place without the bridegroom being invited, for a wedding day was primarily the day of the bride.

The bride, backed by green fabric, a bridal crown hovering above her head, is easily distinguished. She presents a strange sight: her eyes semi-closed, hands quite still, she is completely motionless. Brides were

expected to do nothing on their wedding days; forbidden to lift a finger, she was thus guaranteed at least one holiday in a lifetime of hard labour. A person who avoided work was sometimes referred to as having "arrived with the bride". The nobleman, or wealthy burgher, at the right of the painting is the only other guest with his hands folded. He, too, was a stranger to physical labour, it seems.

The bride does not lift a finger

The bride is also the only guest not to cover her hair. She is displaying her long hair in public for the last time. Henceforth, like her married cousins at table, she will wear her hair under a bonnet. Here, she wears a circlet, a "bride's coronet". In many parts of the country at the time, this would have a prescribed value. In the same way, the number of guests, the number of courses served at the feast and the value of the wedding presents were all determined in advance according to specific criteria. The authorities justified this measure by claiming that it was necessary to protect families against excessive expenditure, but the more likely explanation is that it provided a means of making social status visible. A feast of this kind would have given Bruegel's contemporaries a fairly exact picture of the financial standing of the newly-weds, or their parents.

The meal was preceded by a wedding ceremony. As far as Luther was concerned this was a purely secular affair, and a priest's presence optional rather than compulsory. This had also been the case among Catholics. In 1563, however, a few years before the painting was executed, the cardinals at the Council of Trent decided that only

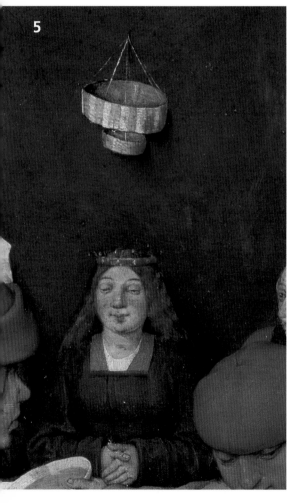

5

priests should join couples in wedlock. It is possible that the Franciscan monk at the table was invited precisely for this purpose. At the time, however, ceremonies were frequently held at the entrance of the church rather than in front of an altar.

Statistics for the period reveal that women raised an average of 2.5 children. There had been a child more in the previous half of the 16th century, but the peasant population was decimated by the wars of liberation which broke out in the wake of Alba's rule of terror, the wholesale pillage, perpetrated especially in unprotected rural areas, by marauding armies, and by ensuing famine and plague.

Bruegel did not live to witness this. His paintings were bought by wealthy burghers or nobles, many finding their way into collections owned by the Austrian Habsburgs. In 1594 the *Peasant Wedding Feast* was purchased in Brussels by Archduke Ernst. It later turned up in Emperor Rudolf II's famous collection at Prague.

There was practically no chance of peasants themselves seeing a painting like this. The only works of art they saw were in churches. If they owned decorative pictures at all, they were most likely to be religious prints of the type pinned to the backrest of the bench in Bruegel's *Wedding Feast*.

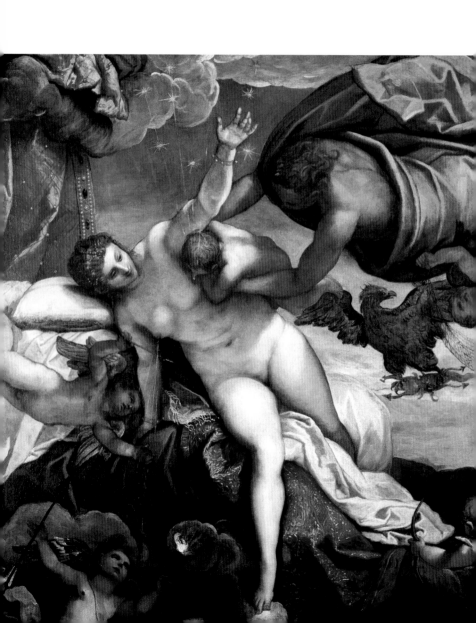

Aspirations to immortality

Jupiter, father of the gods, is known to have loved a number of mortal women. One of these was Alcmene, with whom he begot Hercules. Taking advantage of his wife Juno's slumber, he held the baby boy to her breast, thus letting him drink the milk of immortality. The goddess started up in surprise, sprinkling milk into the firmament. The drops of milk immediately turned into stars. This explanation for the origin of the the Milky Way was given in the first century B.C. by Gaius Julius Hygienus, librarian to Caesar Augustus. Here, the Venetian Jacopo Robusti, known as Tintoretto, an artist of highly refined dramatic sensibilty, has painted the climax of the story, the moment of surprise. Lying on her heavenly bed of clouds, nude Juno starts up from sleep. A skilfully foreshortened Jupiter sweeps down towards her, baby on his arm. Putti and birds surround the two main figures.

Tintoretto's work normally shows angels or saints. He earned his reputation in Venice as a specialist in Christian miracles, rendering spectacular episodes from

the Bible in large format. Erotic scenes from pagan mythology rarely feature in his paintings. Tintoretto was swamped with official commissions when – between 1578 and 1580 – he painted the (undated) *Milky Way*. Although he could not have met the great public demand for his work without the help of his busy studio, it has been established, not only that the *Milky Way* is from Tintoretto's hand, but that he actually painted it twice.

When the London National Gallery restored the 148 by 165 cm oil-painting in 1972, X-rays revealed that a first version of the work had been carefully painted over. The

original version was a treatment of the same subject. However, it was executed in a much less sophisticated manner, in the "rapid and resolute"[1] style characteristic of Tintoretto's work. Art historians have suggested that the potential owner of the *Milky Way* changed before work on the painting reached completion. The new owner was

An ambitious doctor

not just anybody, but a personage entitled to demand the highest standards: Emperor Rudolf II, who had decided to go about establishing a new collection of art.

The painting is not mentioned in an (unreliable) inventory of the collection, compiled during the emperor's lifetime. However, an Italian pamphlet, dated 1648, mentions that Tintoretto executed "four paintings of fables" for the emperor, including "Jupiter holding a little Bacchus to Juno's breast".[2]

If we assume that the writer has mistaken Hercules for Bacchus, then the *Milky Way* probably hung in the Imperial Palace at Prague – although not for very long. For in 1648, shortly before the end of the Thirty Years' War, Prague was taken by the Swedes, whose soldiers looted Rudolf's collection of paintings, taking many away with them when they left Bohemia. In the confusion, about a third of the *Milky Way* canvas was lost.

The original appearance of Tintoretto's painting can be ascertained from a sketch, now kept in the Kupferstichkabinett at Berlin, executed in Prague by the imperial court painter Jakob Hoefnagel. In the sketch, there is a second female nude below the Olympian scene: probably Jupiter's mistress Alcmene, she is lying among long-stalked lilies, which, according to a later version of the legend, are supposed to

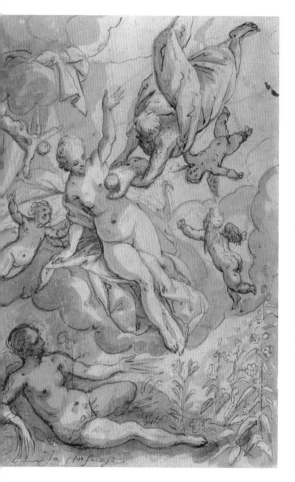

have sprung from drops of Juno's milk which fell to Earth.

This version of the Milky Way legend was published in Venice in a Byzantine tract on botany in 1538, several decades before Tintoretto started work. It was perhaps here that he found the extravagant, and extremely rare iconography of his painting. In any case, there was one person known to the painter who was certainly acquainted with the theme: a medal struck in 1562 in honour of Doctor Tomaso Rangone showed Hercules at Juno's breast, as well as stars and lilies. As documented in a series of receipts, this Venetian doctor commissioned, and paid for, a series of paintings from Tintoretto in honour of St. Mark.

Born at Ravenna as Tomaso Gianotti, he had managed to rise from a poor background, take a doctor's degree and, probably through adoption, acquire the respected Venetian family name Rangone. Perhaps because of its reputation of the Milky Way legend as mythology's first example of an adoption, albeit an involuntary one, Rangone chose it as a motif for his medal and coat-of-arms.

Juno sent two snakes to kill her "adopted" infant, but Hercules, by then already immortal, strangled them. Doctor Rangone also offered his patients a first step to immortality, selling them expensive "magic potions" which, so he promised, would help them live at least 120 years. He became immensely rich in the process. Besides medicine, he had studied physics and astronomy, and, clever charlatan that he was, operated a successful business, exploiting the widespread inability of his customers to distinguish between science and magic.

In order to ensure his own survival, however, Rangone put his trust in art. A spirited patron of the arts, he succeeded in having his bust mounted between a celestial sphere and a globe on a Venetian church façade for which he had donated the money, despite the fact that this form of immortality was officially reserved for nobles and persons born in Venice. Rangone also appears several times in Tintoretto's sequence of paintings on the life of St. Mark. Here, he is shown as a life-sized figure with a central role in the depicted events – much to the displeasure of the public, who demanded that Tintoretto remove the Rangone portraits. However, his striking head has remained a characteristic feature of the paintings to this day. The doctor, vain as he may have been, achieved his aim!

It was for Rangone that Tintoretto probably painted the first, "rapid" version of the *Milky Way.* When the doctor died in 1577, the artist found a new buyer: Emperor Rudolf II, who had been crowned in 1576. However different the Venetian charlatan and the Habs-

burg emperor may have been in
background and social standing,
they did have one thing in common:
both of them used alchemy, astrolo-
gy and art in their attempts to fulfil
their aspirations to immortality.

The Hercules legend was exactly
suited to Emperor Rudolf's taste, for
the ancient hero was already part of
the Habsburg family tradition. At
the beginning of the 16th century,
Rudolf's predecessor Maximilian I
had had himself celebrated as "Her-
cules Germanicus". A demigod who
had strangled the Nemean lion,
exterminated the many-headed
hydra and cleaned out the stables
of Augeas provided the ideal model
for any temporal ruler. Rudolf, too,
liked to have himself portrayed
wearing a lion's skin and carrying
a club, both attributes of Hercules.
This was an indication of the em-
peror's political aims, showing him
committed to following the example
of his ancient model by protecting
his subjects and securing peace and
order in the Empire.

However, Rudolf II found it ex-
ceedingly hard to keep his promise.
Born in 1552 as the son of Maximilian
II, crowned Emperor of the Holy Ro-
man Empire at the age of 24, he in-
herited an empire that was deeply di-
vided, and threatened by the Turks
from without. Ruling was made diffi-
cult for him by religious conflicts, re-
gional disputes and Habsburg family
feuds. During his lifetime, however,

he managed to maintain an unstable
balance of power. It was not until af-
ter his death that the Thirty Years'
War broke out.

The vigorous man of action
chosen by the ruler to symbolize
his power was not in the least like
Rudolf as a person. In 1583, he gave
up Vienna and retreated to Prague.

As a depressive "eccentric in the imperial palace", he did his best to ward off the demands made on him by a chaotic environment. He relaxed from the unpleasant business of ruling by collecting precious objects and works of art. "Whoever wishes to see something new," wrote Karel van Mander, a contemporary biograher of artists, "must seek an opportunity to visit Prague and the greatest living admirer of the art of painting, the Holy Roman Emperor Rudolf II, in his imperial residence".[3]

Tintoretto's completion of the *Milky Way* and Rangone's death in the 1670s were concurrent with

2

Fascination of the enigma

Rudolf's decision to collect paintings in earnest. He was especially interested in works by Dürer. Following a extensive correspondence with the town council of Nuremberg, he was able to purchase Dürer's *All Saints' Altarpiece* in 1585. Rudolf also had a penchant for the Venetian colourists and, over a number of years, bought many works by Titian and Tintoretto. Several works were officially presented to the emperor as gifts by the Venetian Republic; others he bought through his ambassador, or under the guidance of official advisers such as the Mantuan Ottavio Strada, official "antiquary" to the imperial collection.

Ottavio Strada himself sat for Tintoretto in Venice in 1569. It is quite possible that he bought the *Milky Way* for his master ten years later, together with three other works showing the amorous adventures of Hercules. After all, it was not only the subject of these paintings that was suited to Rudolf's taste, but also their erotic qualities; although he steadfastly refused to marry and provide an heir for his

throne, Rudolf was much given to "visual enjoyment".

A work of art was not only there to provide sensuous or aesthetic pleasure, however. To please the emperor it needed an aura of mystery, a hidden meaning which only the initiate could decipher. An elitist predilection for coded messages and arcane reference in art and literature was not unusual at the time. But it was cultivated particularly intensively by the imperial court at Prague, where the emperor, according to one of his contemporaries, "despised common life and loved only what was extraordinary and marvellous".[4]

In the course of his duties, the "antiquary" Ottavio Strada evidently advised the artists in some detail concerning their choice of subject and development of various artistic projects for the emperor. The imperial preference was for "mythologies" which, like the *Milky Way,* intimated to the spectator that the cosmos and human psyche were interrelated at some deep and hidden level.

At first glance, Tintoretto's painting seems easy enough to read; its different elements are derived from a relatively well-known repertoire. Two of the putti playfully circling around the Olympian figures carry erotic symbols: Cupid's bow and arrow and the flaming torch of passion (of Jupiter for Alcmene). The other two bear the chains of marriage (between Jupiter and Juno) and the net of illusion (whose powers so often came to Jupiter's aid). Juno's traditional pair of peacocks are seen at her feet.

Jupiter's eagle accompanies the king of the gods, a figure with whom the Habsburgs were no less inclined to identify than with Hercules, and whose bird they had long included in their coat-of-arms.

The creature held in the talons of Jupiter's eagle provides some grounds for speculation, however. Are its arrow-shaped extremities intended to suggest an embodiment of lightening, Jupiter's traditional weapon? Or does it represent a crab? Cancer was the sign of the zodiac under which Emperor Rudolf had been born on 18 July 1552. The arrangement of figures would seem to confirm this thesis: Cancer comes between Aquarius, represented in the painting by the putto with the net, and Sagittarius, whose incarnation here is the putto with the bow.

It is possible that Tintoretto has integrated into the painting's iconography details of a horoscope cast for Rudolf II by the famous French astrologer Nostradamus. It is said to have been none too favourable – a veritable disaster for a sovereign whose belief in the influence of the stars on human fate was no less powerful than that of his subjects. He was, for example, quite unable to make a decision without consulting his astrologers, and persons seeking

his audience had first to be vetted by having their horoscope cast. In the hope of escaping his ruinous destiny and influencing by magic a reality he could not change, the emperor later decided to move his date of birth so that it fell under the more favourable influence of Taurus, a sign under which the Roman Caesar Augustus was thought to have been born. However, the ruse does not seem to have helped Rudolf much. Lonely, stripped of his power, he died in 1612 in his castle at Prague.

Reaching out to the universe

But Rudolf was also a devotee of yet another occult science: alchemy.

He would spend nights on end in his laboratory, bent over a glass flask in which mysterious substances bubbled over a fire. This met with disapproval in a report sent to Florence by the Tuscan ambassador: the emperor, he wrote, "neglects his duties of state in order to spend time in the laboratories of alchemists and the studios of artists."[5] The ruler, like so many of his contemporaries, was searching for the "philosopher's stone", which not only was a means of transforming base metal into gold, but could make its owner immortal.

Tintoretto's painting, in which

3

everything circles around the subject of immortality, can be interpreted as a study in alchemy. It contains, for example, a number of symbols reminiscent of the vivid language of the "cognoscenti": the *prima materia* which they attempted, in long and difficult operations, to transmute, had first to be bathed in a mysterious substance called "Virgin's milk", also known as *succus lunariae* or "moon-juice". In the course of this process, the more earthy part of the prime material, the "toad", was united with the ethereal element, the "eagle". The arrows held by the putti were symbols of the alchemist's knowledge; they frequently decorate Rudolf's portraits and emblems. The *Milky Way* is so full of references to alchemy that one is inclined to suspect that venetians who referred to Tintoretto, the painter of so many devotional works, as a "necromancer", or sorcerer, did so with some justification.

The original patron of the work, Doctor Rangone, would naturally have been acquainted with alchemy, too, as would most of the imperial physicians. Various scientists and charlatans made their way to Prague in large numbers at that time. Once there, they were safe from persecution by a Church that was determined to prevent the questioning of received dogma. The emperor's protection allowed them to explore nature and investigate its causal sequences. Most of them were searching for the *harmonia mundi*, the correspondence between the human microcosm and divine macrocosm, or universe with its stars and planets. They did so partly by occult means – and prepared the way for modern science.

Two mathematicians, both court astronomers to Rudolf, were largely responsible for the "disenchantment of the universe". The first, the Dane Tycho Brahe, had magic potions sold under his name, but he also set up an observatory near Prague and determined the position of 777 stars. His successor, the German Johannes Kepler, who cast horoscopes and wrote a "Warning to the opponents of astrology", made an important discovery in 1605: "The heavenly machine is more like a clock than a divine being."[6] This turned the traditional view of the universe on its head. It was in Prague, too, that Kepler evolved a theory of the astronomical telescope, an instrument which would, at last, enable scientists to explore the distant Milky Way. Hitherto, all explanation of this heavenly body had been limited to the type of conjecture made by the ancient Greeks, or it had taken the form of a mythological account of its origins.

Rudolf II's patronage of the sciences and arts won him everlasting fame. "The imperial star shines" was a hopeful motto thought up for him by Ottavio Strada: "Astrum fulget Caesareum".

Two saints bury the nunificent donor

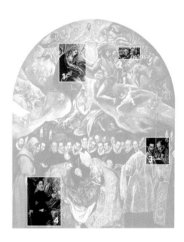

The canvas, 4.8 metres high and 3.6 metres wide, covers the entire wall of a chapel, reaching from the arch of the ceiling almost to the ground. The figures are life-sized, painted in 1586 for the Santo Tomé church in Toledo by the Cretan artist Domenikos Theotokopulos, known in Spain as El Greco, the Greek.

El Greco's painting shows a miracle, said to have occurred in the Santo Tomé church at the burial of Don Gonzalo Ruiz in 1312. According to legend, St Stephan and St Augustine appeared and laid the mortal remains of Gonzalo Ruiz in the grave.

Ruiz, erstwhile Chancellor of Castile and governor of Orgaz, was a man of great wealth and influence, whose benificence had been especially apparent towards institutions of the church. Through his good offices, the Augustinian Order acquired a developable site within the Toledo town walls. He gave financial support to the construction of a monastery, too, and to the building of the church of Santo Tomé. He even made provision that the town of Orgaz should, after his death, make an annual donation to both church and monastery of two lambs, sixteen chickens, two skins of wine, two loads of firewood and 800 coins. According to the testimony of the saints who attended his funeral, their presence there conferred high distinction upon one who had "served his God and saints". On vanishing, they are said to have left a divine fragrance on the air.

El Greco made no attempt to clothe his figures in medieval dress. Social or political change was little understood at the time, and attention to detail of this kind would, in

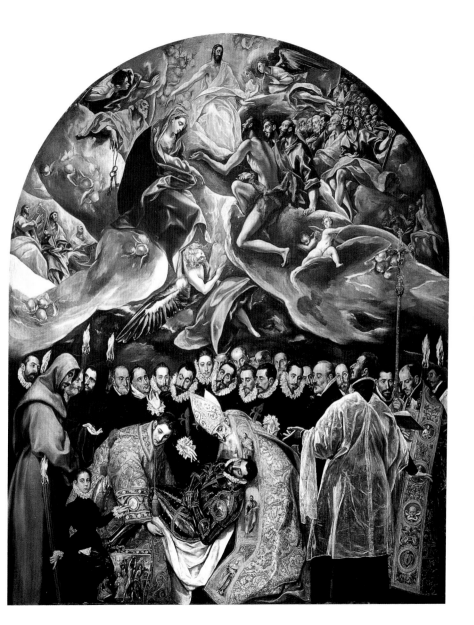

The Burial of Count Orgaz, 1586

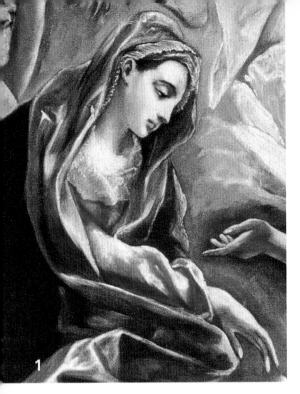

1

Fighting for the Holy Virgin

any case, have conflicted with his patron's wishes: the painting was not intended to recall an historical event, but to encourage contemporary spectators to follow the worthy example it honoured.

Emphasis on the contemporary relevance of the subject probably contributed to the artist's realistic rendering of many details in the lower, more worldly half of the painting: ruffs, lace cuffs, the transparent supplice. Furthermore, the Toledans would have recognized, among the gentlemen in black several of their most well-known citizens.

El Greco gives to the two returned saints the appearance of ordinary persons (showing them without the nimbus which typically surrounded such figures). He portrays Augustine, the great church father, as a venerable greybeard in a bishop's mitre, while Stephan, reputed to be the first Christian martyr, appears as a young man. A further painting is inset in his mantle: the lapidation of St Stephan. Stephan was the patron saint of the monastery to which Gonzalo Ruiz had given his support. The robe of the priest standing at the right edge of the painting carries a series of emblems referring to St Thomas, patron saint of the church and also of architects, whose attribute was usually a builder's square.

It seems the artist chose the theme of the miracle in order to deliver a lesson in hagiology. This may explain why, confronted with such an extraordinary event, the figures maintain their composure: not one is shown throwing up his hands in fright, or sinking in a state of shock to his knees. On the contrary, the monks on the left are engaged in discussion, while others calmly point to the event, as if illustrating a tenet of doctrine.

Indeed, to 16th-century Toledans that was exactly what the painting meant. The legend was part of general religious knowledge, related and reinterpreted each year in a service held on St Stephan's day at

the church of Santo Tomé. The artist's vision conflated past and present, simultaneously showing the miracle and its incorporation into ecclesiastical doctrine.

El Greco's Heaven comes in muted tones; only the Virgin Mary is somewhat brighter in colour. The figure behind her is Peter with his keys; further down are the Old Testament "saints": King David with his harp, Moses and the stone tablets of the decalogue, Noah and his ark. John the Baptist kneels opposite Mary, while Jesus Christ is enthroned on high. El Greco depicts the soul of the dead Gonzalo Ruiz as the transparent figure of a child borne up in the arms of an angel. The soul's progress appears obstructed, however, or restricted to a narrow strait between two converging clouds.

This might seem surprising, given the high distinction conferred upon the pious man at the burial of his mortal remains. An inconsistency perhaps? In fact, the artist had good reason not to take for granted the soul's unimpeded progress to heaven. The reason lay in the political predicament of the church at the close of 16th century.

El Greco painted in the century of the Reformation. Protestant thought had found few followers on the Iberian peninsula, but the Netherlands, where it had spread very quickly, and where Spaniards

and Netherlandish mercenaries fought each other over towns, ports and the true faith, was part of the Spanish empire.

News from their northern province filled pious Spanish souls with terror: church statues of saints had been cast down from their pedestals, paintings of the Virgin pierced by lances – satanic forces were at work. That the events had less to do with the revival of the church than with the work of the Devil was confirmed by reports of iconoclasts tearing the saints to shreds and leaving the demons at their feet intact.

It was the demotion of their most highly venerated Virgin Mary that disturbed the Spaniards most. Luther, so it was reported, had said Mary was no holier than any other Christian believer, while yet another Reformer had said that if Mary had been a purse full of gold before Christ's birth, she was an empty purse afterwards, and that anybody who prayed to the Virgin was committing blasphemy by exalting a woman to the rank of a god.

The great respect commanded by the Holy Virgin south of the Pyrenees stood in peculiar contrast to the disregard shown to women in Spanish society. Their status was far below that of women in Italy, Germany or France. One explanation may lie in the fact that large tracts of Spain, including Toledo itself, had been under Moorish rule for

many centuries. The Moors thought of women as base creatures who, easily tempted, required constant surveillance. Although there were famous nuns in Spain, the mistress of a king, by contrast with her French peer, had no influence whatsoever. Women had no place in the public sphere, as El Greco's painting so ably demonstrates: Mary is the only large-scale female figure among countless men in Heaven and on earth.

In the 16th and 17th centuries the Virgin Mary was the most significant religious and cultural figure in Spanish life: many works by Lope de Vega and Calderón are dedicated to her.

The militant adoration of the Virgin climaxed in the dispute surrounding her Immaculate Conception. This did not, as might be imagined, refer to the begetting of Jesus Christ, but to Mary's own procreation. Her mother was said to have conceived her either without male contribution, or, if a man's presence at the event were conceded, without original sin, for the man was merely God's instrument. Although the pope did not raise the Immaculate Conception to a dogma until the 19th century, it had been tantamount to a dogma in Spain long before. In 1618 the Spanish universities were put under obligation to teach and actively defend the Immaculate Conception.

From a Spanish point of view,

however, the Protestants had not only debased the Holy Virgin, they had also got rid of the saints, who were tremendously important to the Catholic faith. To say that El Greco underlines the integral function of the saints in this painting would be an understatement. Together with the Virgin, it is they who intercede with the distant, enthroned figure of Christ on behalf of the souls of the dead; only through their supplication can the barrier of clouds dissolve and the soul find its way to paradise unhindered. The painting's theological intervention demonstrates the rupture of the vital dynamic suggested in the brightly lit undersides of the clouds: the upward surge through the vortex of light to Jesus Christ is obstructed. Since the Reformation had degraded the Virgin and the saints, it was now the task of the Counter-Reformation to effectively demonstrate their significance.

The painting also contains a portrait of Philip II of Spain, who, in 1586, was still on the throne. He is shown sitting among the saints who, gathered behind John, are interceding for the soul of Ruiz. Philip's empire was the largest of all European states. It not only included the Netherlands and Naples with southern Italy, but colonies in Central and South America, some of which were literally borderless. This was the empire on which – in

the words of the well-known dictum – the sun never set.

Of course, his life was as remote from his many subjects as any god. Furthermore, the court etiquette he had inherited from his father ensured that court and government officials kept their distance. Only a small elite was ever admitted to his presence, and anybody who handed something to him in person was obliged to do so on his knees. However, there was one important element of his father's etiquette which, characteristically, Philip altered: priests were no longer obliged to genuflect before him. He gave to the ambassadors of the kingdom of God, though appointed by himself, a status far greater than that accorded to the representatives of worldly affairs.

This was altogether typical of Philip's rule. He set greater store by defending his faith than his empire. No personal loss could hurt him more deeply, he wrote upon receiving news of the Netherlandish iconoclasts, than the slightest insult or disrespect to the Lord and his effigies. Even "the ruin" of all his lands could not hinder him from "doing what a Christian and God-fearing sovereign must do in the service of God and in testimony to his Catholic faith and the power and honour of the Apostolic See".

Philip II had a powerful instrument at his disposal: the Inquisition. In other countries the authorities who condemned apostates, unbelievers and witches were purely clerical; afterwards, offenders were handed over to the state authorities, who would then enforce the penalty. In Spain even the trial

A king among saints

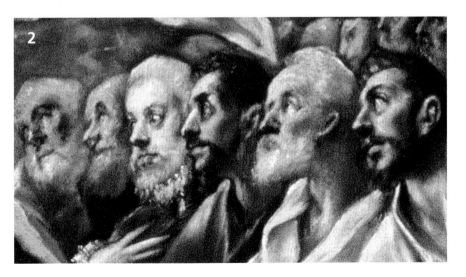

was subordinate to the throne. The king appointed the Grand Inquisitor, and the persecution of non-Catholics served interests of state. For over 700 years the Moors, finally defeated in 1492, had ruled over almost the whole Iberian peninsula. Only families who converted from Islam to Christinity were permitted to remain in Spain. The same applied to Jews. They, too, suffered enforced baptism.

Though hundreds of thousands of Jews and Muslims had left the country, or were in the process of doing so, Philip still saw Catholic Spain threatened by unbelievers who merely paid lip-service to Christ, or by heretics secretly plotting insurrection. The Inquisition acted as a secret police force, defending the status quo and transferring to the state the wealth and property of those it condemned.

Combined religious and racial persecution was one of the chief factors leading to the decline of the Spanish empire. The Jews had been specialists in foreign trade and finance; the country's best physicians were Jews, and they constituted the cream of its university teachers. It was thanks to Jewish scholars and translators that forgotten manuscripts by antique philosophers were translated from Arabic into Latin, thus becoming available to Christian theologians.

For their part, the Muslims had farmed vast areas of the country, and the success of agriculture depended on Moorish irrigation systems. Now that they were gone, the fields were bare, the villages depopulated, and the businesses of the merchants collapsed. For Philip, however, as for the clergy, the Spanish grandees and a large section of the Spanish population, this was less important than defending the faith.

Yet Philip's unrealistic religious zeal was not the only factor that earned him a place among the saints in Heaven in El Greco's painting. Other artists, too, for example Dürer in his *All Saints' Altarpiece* of 1511, gave a place in Heaven to their most prominent contem-

Monument to a priest

El Greco

poraries. In so doing, they enjoyed the support of St Augustine's "City of God", in which the domains of Heaven and earth were interwoven, providing theological justification for the depiction of mortals as the inhabitants of Heaven.

The priest portrayed reading is Andrés Núñez, who, at the time in question, was responsible for the parish of Santo Tomé. It is to him that we owe the existence of this painting. Commissioning El Greco to execute the work was the final act in a campaign Núñez had conducted for decades in an attempt to bring just renown to Gonzalo Ruiz and – lest it be forgot – himself.

His first undertaking of this kind had been the attempt to move Gonzalo's grave. The pious Castilian chancellor had chosen an inconspicuous corner of the church of Santo Tomé as the resting place of his earthly remains – apparently a sign of his modesty. Núñez wanted his bones moved to a more auspicious place, but his superiors rejected the request, for "the hands of sinners" should not touch the body of one who had been "touched by the hands of saints".

Consequently, Núñez decided to build a chapel with a high dome over the immured coffin. Soon after this demonstrative deed in memory of the lord of Orgaz (it was his descendents who received the title of count), the citizens of

Orgaz decided to annul the 250-year-old legacy of two lambs, 16 chickens, two skins of wine, two loads of firewood and 800 coins. Núñez instituted legal proceedings, winning the case in 1569. In order to record his triumph he had a Latin text mounted above the grave, recounting the legend and referring to the rebuttal of the town of Orgaz through "the vigorous efforts of Andrés Núñez".

The smart priest thus created a monument to himself. After applying to the archbishopric in 1584, he was granted permission to commission a painting of the miracle of the interment. El Greco was commissioned in 1586 and delivered the painting the same year. Whatever the work may owe to the personal ambition of a priest, it has to be said that propagation of the miracle of the burial was also fully in keeping with Counter-Reformation church policy. It was seen as important not only to exalt the Virgin and saints, but to defend the need for charitable donations and the worship of relics. According to Catholic belief, the route to Heaven was paved with "good deeds", a view rejected by Reformers, for whom faith and divine mercy were all that counted. The Reformers also vehemently opposed the veneration of relics, a cult of considerable significance in Catholic countries. It was at this time, too, that Gaspar de Quiroga, appointed

archbishop in 1577, brought the bones of St Leocadia and St Ildefonso to Toledo, thereby greatly adding to the status of its cathedral. Santo Tomé's painting of the burial extolled the piety of charitable donations, at the same time defending the worship of relics. For had not two saints touched, and thereby honoured, the mortal frame? Was it not therefore correct to infer that all Christians should honour the mortal remains of the pious, the saints and the martyrs?

The painting's gigantic format complied with Counter-Reformation propaganda in yet another sense: its stunning visual impact. The Protestants, by contrast, wished to see their churches purified of all ornamentation. Places of worship were to be free of graven images, or at least not crowded with visual distractions from God's word. But the Catholics thought otherwise: since the church was God's house, why not use every means possible to decorate it in His honour? The exuberant splendour of Baroque churches was, not least, a reaction against the plain churches of the Reformation.

The boy pointing so meaningfully at the saint was El Greco's son; his year of birth, 1578, can be deciphered on his handkerchief. When his father painted the miracle, he was eight years old. The contract was concluded on 18th March. El Greco finished the work, whose value was estimated by two experts at 1200 ducats, by Christmas. Since the price was too steep for the parish council of Santo Tomé, it appointed two experts of its own, only to find that they arrived at a value of 1600 ducats. It was not until July 1588 that the parties agreed – on the lower sum.

El Greco was dogged by financial problems almost all his life. He was not a prince among painters, like Titian, in whose Venice studio he had trained. "The Greek" was born in 1541 on Crete, which, at that time, was under Venetian rule. He learned icon painting, left for Venice where he became a master of spatial representation and architectonic perspective, then moved to Rome. When Pius V, disturbed by the nudity of some of the figures in Michelangelo's *Last Judgement*, wanted some of the frescos in the Sistine Chapel painted over, El Greco is reputed to have offered to paint an equally good, but more decent, work if the original were destroyed.

It is not known when, or why, El Greco settled in Spain. It is possible he felt ill at ease with the Italian artists' exaltation of corporeal and architectural beauty; perhaps he hoped his celebrations of the afterlife would find greater recognition in Spain. Spanish cardinals, resident in Rome, are likely to have spoken of the Escorial, Philip II's palatial monastery, and El Greco

may have hoped to find work there. Instead he settled in the old religious capital of Toledo, the seat of the archbishop. In 1579 the king commissioned a painting from him – the only order he received from that source. Philip apparently disliked the Greek's paintings.

Spiritually they had much in common. For both, the afterlife was more important than this life. Philip longed to rule from the Escorial in the company of monks, and to be able to see an altar even from his bed. This view meant more to him than his empire: his Armada was defeated in 1588; in 1598, the year of his death, financial pressures forced him to give up his war against France, and the northern provinces of the Netherlands were already as good as lost.

El Greco's whole life's work, and this painting in particular, bears witness to his belief that the kingdom of heaven was more important and more real than the world in which we live. Though he is painstakingly exact in his detailed rendering of the lower, worldly half of the painting, the realistic heads and dress have the effect of drawing the burial scene into the foreground, while the isocephalic arrangement of onlookers' heads gives the appearance of the top of a stage set. It is only here, behind this dividing line, that the true life begins. Only the upper half is dynamic, an effect achieved with the help of lighting

4

and a use of depth and line that draws the eye upward.

It remains to be said that not all Spaniards ceded to the uncritical renunciation of reality. The writer Miguel de Cervantes, for example, a contemporary of El Greco and Philip II, took a different point of view. Though he did not attack the religious zeal of his compatriots, his character Don Quixote, a chivalrous and deluded idealist, illustrates the dangers that may befall a person who inhabits a world of fantasy rather than facts, someone who, in pursuit of ideals, loses sight of the ground beneath his feet.

Reality as a stage set

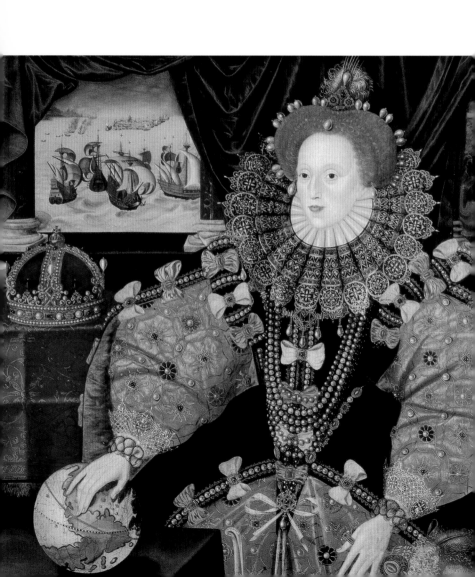

George Gower: Armada Portrait of Elizabeth I, c. 1590

A woman thwarts Spain's pride

In his portrait of Elizabeth I, executed around 1590, the English artist George Gower presents his queen as a self-confident sovereign. He also pays tribute to her greatest triumph: the decisive defeat which Her Majesty's navy had inflicted upon the vast Spanish fleet in the English Channel just a few years earlier, in 1588. The sinking of the Armada marked the beginning of England's rise to major international power. Gower's portrait, which measures 105 x 133 cm, today belongs to Woburn Abbey in Bedfordshire, England.

She was painted many times and had many of her portraits subsequently destroyed; it seems she felt the pictures did not show her to enough advantage. Her red hair needed to shine, proper justice had to be done to her famous pale complexion, and no shadow was to be allowed to darken her face.

When Elizabeth I sat for the present portrait, with its two background views of the sea and ships, she was about 56 years old. Her hair was false and her face plastered with a thick layer of white makeup. But the fiction of youth and beauty had to be maintained, in art as at court. The ageing queen kept young suitors and had been negotiating marriage with a French prince for decades. She enjoyed having many admirers, but had absolutely no intention of wedding any of them. At the mere age of eight she is supposed to have announced: "I will

never get married!" She had good reason to make up her mind so early: that same year her step-mother was beheaded, while her own mother, Anne Boleyn, had already been executed. The cruelty displayed by her father, Henry VIII, towards his wives may thus have shaped her attitude towards marriage; it is more probable, however, that her own thirst for power left no room for a husband to reign at her side.

A battle over trade and trifles

Portraits of this extraordinary woman were fashioned not simply to flatter her vanity, however, but also for reasons of state. Like her carefully stage-managed public appearances, these pictures were also part of a propaganda programme which had no call for realism. Thus the two scenes visible through the windows at the back took place neither at the same time nor in the same place: weeks lay between the first appearance of the Spanish Armada and its eventual defeat off the coast of England. The painting nevertheless makes sense as a glittering tribute to its sitter – it shows the most glorious event in the reign of Elizabeth I that lasted over 40 years. It was painted by George Gower (1540–1596), Serjeant Painter and one of the artists who for many years had the privilege of painting the queen.

The traditional insignia of power – orb and sceptre – are missing from this picture. Instead of a sceptre, the queen holds an ornate fan of ostrich plumes in her left hand, while her right hand rests on a globe. Just as the traditional Roman orb represented the whole world, so the globe offered a modern 16th-century version of the old symbol.

In those days, globes existed only in small numbers. The first had been constructed in Nuremberg barely 100 years earlier. George Gower took no pains to reproduce one of the English models exactly; he was evidently more interested in the queen's hand lying on the

1

globe, which demonstrates in impressive fashion Elizabeth's hegemony beyond the bounds of her small island kingdom.

It was no coincidence that Gower's painted globe should also show ships, for in those days world domination meant sovereignty of the seas. When Elizabeth came to the throne in 1558, the major political and naval powers were still Spain and Portugal, both nations of explorers. In 1580 Philip II of Spain annexed neighbouring Portugal, and from then onwards, declared, "all the Americas, known and unknown" belonged to him.

Elizabeth vied with him on this score. Her subject, Francis Drake, became one the first people to sail round the world and thereby proved that the Spaniards were not the only ones capable of such a pioneering feat. Drake and other English freebooters captured Spanish galleons and diminished the profits which Philip hoped to reap from his American colonies. A small-scale war ensued. Although Elizabeth had not yet officially taken up arms against the number one world power, she permitted her subjects to lay Spanish gold and silver at her feet.

She needed the money, because when she took up office she had inherited a mountain of debts. According to a report by the Venetian ambassador, when Elizabeth paid back the last of the money owing,

she was "hailed by the people as if she were a second Messiah". But the English buccaneers embarked on their perilous voyages not just in search of booty. Philip had a monopoly on trade outside Europe, something which Elizabeth was not prepared to accept. In this she had the backing of the English merchants. The new merchant classes wanted their own slice of the international market, and Elizabeth rightly hoped that they would bring prosperity to her impoverished country.

There was yet another factor, too, in the increasingly bitter conflict with Spain. Philip II was an ardent, fanatical Catholic; Elizabeth, on the other hand, like the majority of her subjects, was a Protestant. Philip appointed himself the battlefield champion of his Church – Elizabeth had no other choice but to fight for her own.

It was a fight she did not want. As far as she was concerned, it was pointless to shed blood for one or the other variation of the faith. Her father, Henry VIII, had renounced Catholicism because he wanted to divorce the first of his many wives and pocket the possessions of the Church. His daughter, "Bloody Mary", had attempted to turn back the tide of the Reformation by torturing people and burning them at the stake. She was followed onto the throne by Elizabeth, who had thus experienced her father's abuse

of religion and her sister's religious fanaticism, and who represented instead – even if she couldn't always act upon it – the law of tolerance: "There is only one Christ Jesus and one faith; the rest is a dispute about trifles."

The view through the left-hand window shows the Spanish Armada in the background as tight-knit as a floating fortress. They possessed more majesty than the English fleet, according to a contemporary report, but advanced only slowly even in full sail, because their hefty superstructures made the ships heavy. They approached in a crescent formation, the two cusps of the crescent at least seven miles apart.

The Armada comprised exactly 130 ships with 30,656 men on board, including over 100 priests and monks. The voyage to England had the character of a Crusade; it was mounted against heretics. The Armada was planned as a transport fleet which would sail to Calais, pick up another 40,000 soldiers from the Spanish Netherlands, and then cross the Channel. Once on land, matters would be settled by force.

Despite adopting a new tactic, the English did not succeed in stopping the floating army on its way to Calais. The English ships were lower and faster than the Spanish "sea elephants", and although their can-

nons did not fire the heavy shot of their opponents, their range was longer. They therefore attempted to manoeuvre themselves close to the Spanish, one behind another in a line, so that they could let off their broadsides while themselves remaining out of firing range.

To appreciate just how new this English style of warfare was, it is necessary to go back 17 years to the last great naval battle, which took place off Lepanto in the Mediterranean in 1571 and which was fought against the Turks by the Venetians and Spanish. In this confrontation, both sides used rowing galleys to board the enemies' ships and overpower their crews. Rowing galleys were not suitable for the rough seas of the Atlantic, however, and the Spaniards had to leave them behind. Boarding nevertheless remained their chief strategy, and they despised the English for not wanting to approach.

In the same view through the window, a number of the English ships are visible in the foreground, recognizable by their traditional St George's flag with its red cross on a white ground. The English fleet was headed by Lord Howard of Effingham, who was intelligent enough to call upon the nautical experience of the former buccaneer Drake. As Sir Francis, ennobled by the queen, he held the position of vice-admiral.

George Gower

Gower shows the famous encounter off Calais. The English had so far failed to halt the Spaniards, and Elizabeth did not possess a standing army; the troops she had hastily rallied together were not nearly so well trained as those of Philip. The danger of England becoming a Catholic province of Spain was great. On 29 July 1588 the English set fire to several of their own ships and let them drift across to the Spanish Armada. The ships burnt out without causing any damage – but their psychological effect was enormous. The Spaniards, sailing so close together, feared nothing more than fire, and they also suspected that the English ships were concealing explosive powder kegs. Panic swept through the fleet, and the ships wildy broke formation and fled individually. A trick had blown the floating fortress apart.

The ships seen here foundering in the waves bear the Spanish national ensign, the diagonal cross of St Andrew. Following the initial dispersal of the Armada on 29 July, the decisive naval battle took place off Gravelines. For the first time, the Spaniards emerged as clearly inferior: they lost eleven ships and counted 600 dead and 800 wounded. According to contemporary reports, when one holed Spanish ship capsized, streams of blood could be seen flowing into the sea.

The trick with the fireships

Armada Portrait of Elizabeth I, c. 1590

163

The English only suffered 60 fatalities. They owed their light losses not just to their speedy ships and long-range artillery, but also to the miserable Spanish command. As in most countries in those days, it was the tradition in both England and Spain to appoint a high-ranking noble to the position of supreme command. But Philip II had thereby chosen a grandee who was prone to sea-sickness and who had previously only fought on land. Nor did he have a Francis Drake as his vice-admiral. The second-in-command in the Spanish fleet had no reputation and no authority.

The battle off Gravelines left the Spanish demoralized. They had considered the Armada invincible and were not prepared for defeat. To avoid being shot apart by the English any further, they had to escape, and took advantage of a strong breeze which carried them north.

The Armada could no longer fulfil its instructions to transport an invasion force to England. Spanish pride, however, and a fear of Philip, meant it could not admit to failure. While the ships held their course northwards, the fleet's commanders decided to return to the English Channel "as soon as conditions permit". They all knew that would not be straightaway. Silently, the captains prepared themselves

Spain's Armada sinks amidst the waves

3

for the long and perilous voyage home, one which would take them over 1500 miles around England, Scotland and Ireland.

The captains were instructed to sail far from the coast. But when their water and food supplies ran out, they had to seek the land, and many thereby ran aground on rocks and sandbanks. Many ships were already damaged even before they started the journey north. These problems were compounded, too, by navigational errors made by sailors who were unfamiliar with the North Sea and the North Atlantic. Altogether, the Armada lost another 59 ships on its voyage home. Only some 10,000 of over 30,000 soldiers and sailors eventually made it back to Spain.

The Armada was ultimately defeated not by the English, but by the forces of nature. The English expressed it differently. They may not have wished to claim victory for themselves, but they did not want to attribute it to Nature either; they announced instead that "this time Christ showed himself to be a Protestant."

The English could have won the day outright had their queen not been so thrifty. Her fleet only had water and provisions for two days, and the gunpowder ran out early. Under these conditions, it would have been impossible to pursue the fleeing Spaniards. In vain, Elizabeth's advisers tried to persuade her that war could only be waged successfully if sufficient means were made available, and in particular if the ships had adequate provisions.

Barely had the immediate danger of an invasion passed than the queen ordered the English fleet to disband. Unlike Philip, Elizabeth possessed almost no ships of her own; those leased from merchants and buccaneers were given back, and the soldiers and sailors dismissed. There was no money with which to pay them off.

More men died of poverty, hunger and typhoid after the war, it is said, than fell in the battle against the Spaniards. No wonder many of the English considered their queen not just thrifty, but mean.

Faced with the magnificent outfits in which she had herself painted, and which she also donned for her public appearances, the tight rein which Elizabeth exercised over her spending seems somewhat contradictory. But the lavish dresses and expensive jewellery cost her little: she had them given to her. On 1 January every year she graciously accepted clothes and jewels from her admirers and courtiers. After his circumnavigation of the globe, Francis Drake presented her with a crown of gold and precious stones which he had plundered from the Spanish. Elizabeth acquired the six strings of pearls which she is wear-

ing in this picture from her sister Mary Stuart, at a price well below their true value.

The many bows, lace trimmings, pearls and diamonds adorning Elizabeth's dress were not merely the attributes of a vain queen, however. They also helped to lend Elizabeth the individual a symbolic stature. The various precious stones carried their own meaning. Pearls, for example – especially predominant in the present Armada portrait – come from the sea: they testify to the fact that, following the defeat of the Spaniards, Elizabeth has become the "queen of the seas". Pearls were also viewed as symbols of virginity. Like the diamonds and topaz on her dress, they are a declaration of purity. What the real state of affairs was, and how far Elizabeth actually went with her lovers, is another question, one often asked at her court and much loved by her biographers. But as the representative of her island, as a symbolic figure, she was emphatically a virgin.

For in order to assert themselves against Spain, the English urgently required a highly stylized, almost mystical figurehead. What was at stake was not money or ships, but religion. Philip had the entire ideological power apparatus of Rome behind him. Elizabeth possessed nothing comparable. She had to appear both as England's regent and the head of its Church. If the others were fighting for the Virgin Mary, the English could at least fight for their Virgin Queen.

A virgin as queen of the seas

George Gower

The princess in the hospital

Princess visits patient – we see the same thing from time to time in our own media, and in the 19th century it was a much-loved motif of Salon painting, whereby the high-ranking visitor was always clearly emphasized. Not so in Adam Elsheimer's picture. Elizabeth, princess and saint, is distinguished from the other figures in the scene neither by her dress nor her pose, but only by the slender halo barely noticeable above her head.

Elsheimer painted Elizabeth as she saw herself, namely in service to those suffering. Born in 1207 as the daughter of the Hungarian king Andreas II, she was married at 14 to the later landgrave Ludwig IV of Thuringia and widowed at 20 with three children. Her husband died while he was in Italy, preparing to go off on a crusade.

To be a widow at 20 was no unusual fate in the Middle Ages. What *was* unusual, however, not to say shocking, was that Elizabeth refused to remarry and renounced all her privileges as a princess and landgrave's widow. She thereby also disassociated herself from her children, left her husband's ancestral seat, the Wartburg, and went to Marburg, where she founded a small hospital. Elsheimer portrays the saint in her hospital – as, 400 years later, he imagined it to look. He painted his picture around 1597/98.

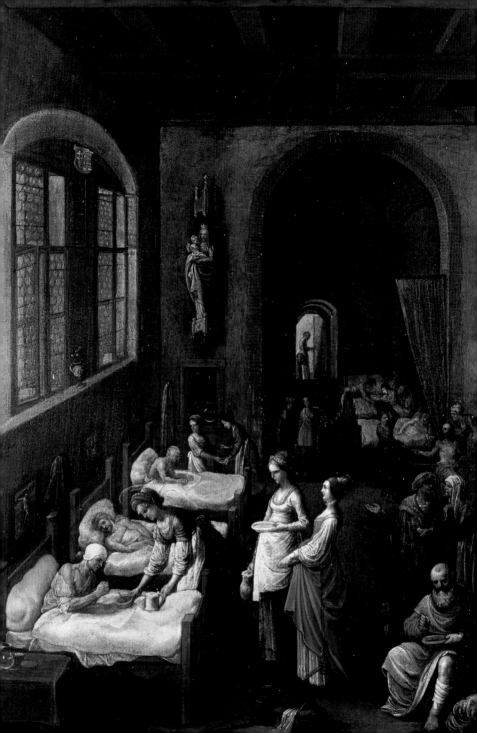

The beds in the foreground are occupied by men, those in the background, as far as can be made out, by women. The leaded glazed windows can be opened. This was common in the 16th century, but not in the 13th: in those days, air was let in through small unglazed windows with wooden shutters.

Above the window, the artist has mounted Elizabeth's Hungarian coat of arms. Had Elsheimer been painting in the saint's own day, he would have portrayed Elizabeth – in line with her elevated status – as larger than the other figures, and the room simply as a shallow backdrop. Nor would he have included the many realistic details such as the slippers and chamber pot under the bed, the rod used to carry the pot of soup and, in the background, the rope which lowered the chandelier whenever the candles needed replacing or lighting.

The case for a person's canonization had to be argued with evidence from contemporary witnesses. Hence we know quite a lot about Elizabeth's life, even if much of the information only serves to stylize her as a saint. "When she was barely five years old", we are told, "she persisted in her prayers in the church for so long that her companions and maids could hardly persuade her to leave". Should she win a children's game, she would break it off saying: "I don't want to carry on

playing, but wish to stop for God's sake."

She developed a radicalism which went far beyond what we perceive as normal – when she renounced her children along with her privileges, for example, and when she laid lepers in her own bed, or kissed their feet. Reading the relevant passages in the documentary accounts of her life, one can't help suspecting that she was engaged on a path not simply of succouring to the sick and infirm, but of conscious self-sacrifice. She died on 17 November 1231 at the age of 24.

A saint is also required to work miracles, and Elizabeth's biographers seem to have felt it important to stress that these were not restricted to Marburg alone. Thus she appeared in a dream to a monk "in the bishopric of Hildesheim" and relieved him of his pain. When her assistance was invoked "in the bishopric of Mainz", she brought a drowned man back to life, and "in the bishopric of Cologne" she helped a hanged man: "And when the grave had been prepared, and he had been taken down, his father and his uncle appealed to Saint Elizabeth to protect the dead man. And lo, the dead man came back to life, so that they were all frightened and astonished."

Her own corpse, too, was the subject of a miracle – if we are to believe the reports. Instead of the smell of decomposition, it gave out

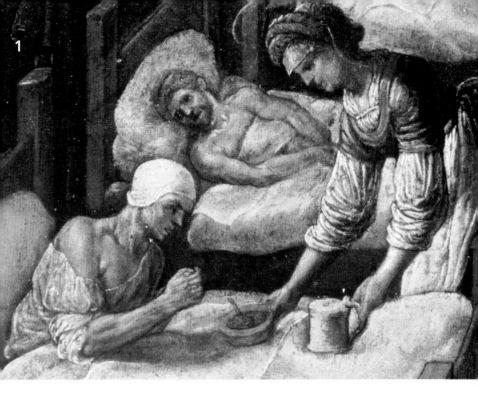

a sweet perfume, for "because her body had been chaste and pure during her lifetime, it issued a sweet perfume after her death". Her corpse also excreted an unctuous fluid, "because in her life she overflowed with acts of mercy".

The staring eyes, protruding tongue and straining muscles of the man sitting up in bed suggest a nervous disorder. It takes great effort for him to control his limbs and organs. His hands are still folded: before he reaches out for the spoon, he wants or has to pray.

The head of the man in the sec-ond bed bears a certain resemblance to traditional portrayals of Christ. A picture of the Crucifixion hangs on the wall beside him. Elsheimer may be making reference here to one of the best-known legends of St Elizabeth. One day while her husband was still alive, so the story goes, Elizabeth tended a leper in her own bed. Her mother-in-law saw this and informed her son. He stormed furiously into Elizabeth's bedroom, but the figure he saw in her bed was Christ nailed to the cross.

It is clear from this legend that tending for the sick was equated

A woman of rank serves the suffering

Leprosy, the deadly disease

tions which cared for needy people of all kinds. Thus pilgrims might seek lodging there, as well as the elderly and homeless. Numbers were nevertheless limited; pilgrims aside, hospitals only considered themselves responsible for those living in the immediate vicinity. Otherwise overcrowding would have soon forced them to close.

Such hospitals were normally funded by churches and monasteries. These in turn lived from alms, donations, legacies, rents and sales of wine. In Elizabeth's day, they ranked amongst the wealthiest landowners. A relatively new source of finance were the orders of knights, most of them founded in Jerusalem, which spread across Europe with the returning Crusaders. They included the Knights Templar and the Knights of St John. After her death, the running of Elizabeth's hospital was handed over to the Teutonic Order.

In these hospitals, treatment primarily took the form of herbal remedies, as prescribed by folk medicine. Conventional medicine, as we understand it, played only a secondary role. The new professional class of academically trained doctors was still too small and its fees too high. During Elizabeth's lifetime, municipal communities occasionally appointed their own doctor, whose duties included visiting hospitals. Perhaps the artist intended the man with the red hat to

with loving service to Jesus Christ. "I assure you, when you did it for one of the least of these my brothers and sisters, you were doing it for me." Thus Matthew 25:40. In the same chapter, St Matthew lists the other acts of mercy which a Christian should practise: feeding the hungry, giving the thirsty something to drink, offering shelter to strangers, clothing the naked and visiting those in prison.

With the exception of visiting prisoners, all these charitable services were offered by hospitals. These were not hospitals in the modern sense, but rather institu-

Adam Elsheimer

represent a trained doctor. But even doctors with a university education were of little help. Most held firm to the ancient theory of the four humours, which in the healthy body were harmoniously balanced. If someone became ill, it meant their humours were upset. In order to establish the extent of this disturbance, doctors observed the urine, and the urine bottle was thus one of their most important pieces of equipment. Elsheimer shows three such bottles, one in the left-hand foreground and two more beneath the Madonna in the niche.

The limited possibilities offered by earthly cures and treatments increased the value of faith. If hospital patients could not hope for a present life that was easier to bear, they could still hope for a better hereafter. For this reason, too – and not just because they were funded by religious institutions – religion played such a prominent role in hospitals. Elsheimer makes its presence clear in the pictures above the beds and the statue of the Virgin high up on the wall. Three of his figures have their hands folded in prayer. Chapel and altar, on the other hand, are not visible, although it was usual for hospital inmates to be able to see an altar from their beds and to take part in services.

Those admitted to a hospital got something to eat. In an epoch when failed harvests and famine were regular occurrences, that alone meant a great deal. It was no coincidence that Elizabeth founded her first hospital beneath the Wartburg during a widespread famine in 1226, when her husband was still alive; and it is no coincidence that most St Elizabeth paintings show her feeding the hungry and giving the thirsty something to drink. According to legend, the apron from which she distributed bread kept miraculously refilling itself, and her jug never emptied. In one story, a sick man asked for fish: when Elizabeth rinsed out a pot at the fountain, it filled with little fish.

A second large category of St Elizabeth paintings shows her tending the sick, in particular lepers. Because of the contagious nature of their disease, lepers were banned from towns and cities. Leprosy is known to have existed in Europe since the 7th century, although it only reached epidemic proportions later, claiming several million victims in the 12th, 13th and 14th centuries. An altar from the workshop of Michael Wolgemut (Albrecht Dürer's teacher) shows Elizabeth washing a leper and cutting another's hair. In an altarpiece by Bernt Notke she is washing the feet of a Christ whose skin exhibits the blemishes typical of leprosy. The first altarpiece was painted around 1480, the second around 1483. Both show men with bandaged calves.

Leg ulcers were another feature of the clinical picture of leprosy.

Elsheimer, too, shows a bandaged calf. It belongs to the bearded man in the right-hand foreground, who thrusts his left leg demonstratively forward. But if we ignore the man's balding head – which could have a variety of causes – he bears no other obvious signs of leprosy. Elsheimer has not portrayed the disease in clearly identifiable way. Perhaps he had never actually seen a leper. Almost 400 years separated his life from that of the saint, and the two altarpieces were executed a good 100 years before his own painting. The epidemic had died out and no longer posed a threat. All that remained was the motif of the bandaged leg, which Elsheimer may have adopted from other paintings of St Elizabeth.

Amongst the most important historical events of those 400 years between Elizabeth and Elsheimer was the Reformation, which had a profound impact upon hospitals in Germany. In the Middle Ages, people's willingness to help the poor and needy was fuelled by the notion of "good works": those who do good in this world can expect to be treated with mercy in the hereafter. Luther vehemently rejected this idea; it was impossible, he argued, for humankind to earn a right to God's mercy. He thereby removed one of the attractions of giving money to good causes. Further-

more, in the wake of the Reformation monasteries were dissolved, robbing hospitals of their sponsors. Sovereigns and cities were more than happy to take over these former monasteries, together with their valuable property holdings, but in doing so also inherited the charitable services they provided for the old and sick. In Hesse, for example, four large monasteries were converted into "regional hospitals". Landgrave Philip I of Hesse, responsible for the founding of these new regional hospitals, also took up Luther's fight against the Catholic cult of saints. In 1539 he had the bones of St Elizabeth forcibly removed from her church and thereby robbed the city of Marburg of its most precious relics.

Elsheimer was 28 when he painted this serious, shadowy self-portrait. Four years later he died. Little is known about his life: born in 1578 in Frankfurt as the son of a tailor, he was probably apprenticed to the painter Philipp Uffenbach. In 1598 he travelled to Venice, and from 1600 he lived in Rome. Here he got married, converted to Catholicism, was considered lazy, and found a patron, who nevertheless had him thrown into a debtors' prison before eventually effecting a reconciliation. Elsheimer died in 1610. His best-known work is the altarpiece *The Discovery and Celebration of the True Cross* (c. 1603/04), today

housed in the Städel Institute in Frankfurt.

He was born into a lean period in German art. The generation which followed on from Albrecht Altdorfer, Lucas Cranach and Albrecht Dürer – the artists who had carried German painting to such great heights in the first half of the 16th century – had produced no painters of similar rank. Elsheimer oriented himself in his youth on these Old Masters; he looked back to the past, studying Dürer's Heller Altar. His portrayal of the sick man with the bandaged calf is clearly reminiscent of saints as painted earlier by Albrecht Dürer.

In contrast to his venerable predecessors, however, he restricted himself to small formats and a very specific carrier. His painting of St Elizabeth measures just 28 x 20 cm (approximately the same size as our reproduction) and is executed on copper. Elsheimer was not the only artist of his day to paint on copper, but most of the others were engravers who were using up old plates. Why Elsheimer limited himself to small formats on copper is unknown. It had certain disadvantages, since it meant he missed out on commissions for large-format works, and only large-scale paintings in churches and palaces brought wide public recognition.

Adam Elsheimer painted little, and he painted small. Perhaps it was this that prompted the accusa-

tion that he was lazy. The smooth surface of the copper allowed him to include miniature-like details which would have been almost impossible on panel or canvas.

Elsheimer's self-portrait is his only (known) painting on canvas and, unusually for him, measures a good 63 x 48 cm. It was probably executed for the San Luca painters' academy in Rome, whose members were all required to supply a self-portrait in a specified format.

With his move to Rome, Elsheimer exchanged a city of 18,000 inhabitants for a metropolis of an

Embracing the Baroque in Rome

**Not in
Frankfurt,
but in
London**

estimated 100,000. Frankfurt enjoyed a certain degree of fame as a centre of commerce, serving as a point of transshipment for goods travelling the trade route between north and south. Rome around 1600, on the other hand, was seen as the centre of the world. The Pope and his Church had recovered from the shock of the Reformation and were spearheading the Counter-Reformation. As part of their battle campaign, they made strategic use of architecture and painting as a means of demonstrating their might and propagating the Catholic faith. Architects and artists flocked to the

holy city from all over Europe. Alongside St Peter's cathedral, there arose a host of churches and palaces, giving Rome the face that it has preserved right up to the present day.

In Rome, Elsheimer's style changed. Static compositions such as his *St Elizabeth* now gave way to scenes of much greater animation. Effects of lighting in the manner of Caravaggio (1571–1610), seven years his senior, added a dramatic dimension. The painter who had formerly looked back to his German past now emerged as a

Adam Elsheimer

Baroque artist eager to explore the latest trends.

His painting *Contentment*, executed around 1607, and thus about a decade after *St Elizabeth Tending the Sick*, makes this transformation clear. Elsheimer takes a motif from earlier Italian literature. Mercury is abducting the female figure of Contentment from the midst of an excited crowd. He is acting upon the instructions of Jupiter, who has been angered by the complacency of the people and their lack of interest in the gods. Jupiter can be seen hovering in front of his temple top left, while in the background people are indulging in various sporting entertainments. Elsheimer's figures are caught up in a line of movement which starts in the front right-hand corner, switches direction by Mercury and Jupiter and bears off into the top right-hand corner. Looking at the illustration reproduced here, one might expect the original to be several metres square; in fact, it measures just 30 x 42 cm – a miniature in comparison to the large formats of Elsheimer's contemporaries Caravaggio and Rubens.

Rubens, one year older than Elsheimer, admired his German colleague, and even copied one section of *Contentment*. Upon hearing of Elsheimer's early death, he wrote: "After such a loss, our entire profession should clad itself in deep mourning. It will not be easy to re-place him, and in my opinion there was none to equal him in the field of smaller figures, landscapes and so many other subjects. He died at the height of his artistic powers."

Elsheimer was similarly praised by Joachim von Sandrart, in his *Teutsche Academie* (German Academy) of 1675. Sandrart describes Elsheimer's inventiveness, his ability to paint landscapes and night scenes, and concludes by reproaching Elsheimer's native city of Frankfurt for possessing not a single one of his works: "In Frankfurt Town Hall there is not a single thing by him to be seen nor any mention of his name."

In 1927 and 1928 Frankfurt had the opportunity to purchase *St Elizabeth Tending the Sick* when it came up twice for auction. At that time, however, Elsheimer had still to be more widely rediscovered; if his works were in demand at all, it was those from his Roman years. The copper plate found its way not into a museum, but into a London collection where it can still be admired today – the Wellcome Institute for the History of Medicine at 183 Euston Road.

Tyrannicide by tender hand

The lovely Jewish widow Judith, who beheaded
an Assyrian leader because he had threatened
the lives of her people, was held up as a shining
example by religious fanatics. Caravaggio's sub-
ject was highly topical at the time of the Counter-
Reformation. Today, the painting (145 x 195 cm)
is in the Roman Galleria Nazionale d'Arte Antica.

"Now when Holofernes was
stretched out on his bed, and
was drunk and asleep … Judith
stood weeping at his bedside and
said in her heart, O Lord, God of
Israel, give me strength and look
in this hour upon the work of my
hands … She … took his sword …
and held him fast by the hair of his
head and prayed again … Then she
struck his neck twice with all her
might and smote off his head …

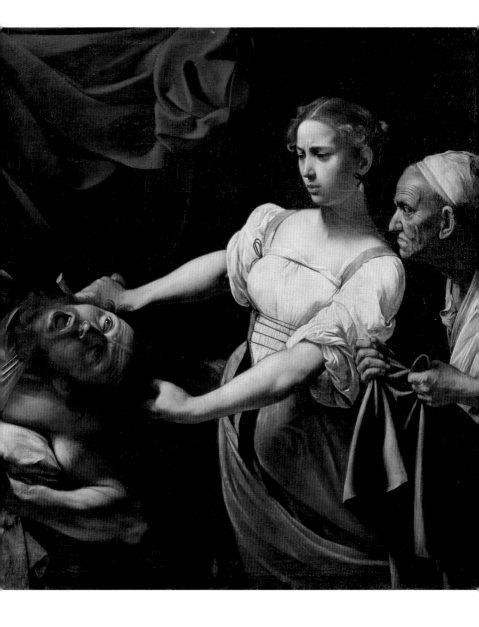

Soon afterward she went out and gave Holofernes' head to her maid, who placed it in her food bag."[1]

This account is taken from the Book of Judith. It recounts an incident in the history of the Jews, but since the original manuscript is lost and the text itself is difficult to date, the Book of Judith is considered apocryphal (not accepted as canonical) by Jews and Protestants. It was, however, included in St. Jerome's Latin translation of the Scriptures, the Vulgate. Caravaggio's painting of the scene, executed in 1599, follows the biblical version, except that the maid does not wait outside but is painted alongside her mistress – her wrinkled skin offering the artist a welcome contrast to the peachy skin of his heroine.

The "very comely" rich widow Judith, "of whom nobody could say ill", had put off her mourning clothes, dressed herself in her finest garments and entered the enemy camp in order to rescue her people. The Assyrian army, led by Holofernes, stood in arms before the city of Bethulia. The Jews had lost heart, were on the point of giving up, and yet this woman set out on her own to seduce the enemy. After her bloody deed, the enemy soldiers fled in panic; Israel was saved and Judith returned "unsullied by sin" from the libertine's tent.

"Thou art the glory of Jerusalem, thou art the great boast of Israel, thou art the great pride of our nation." Such were the high priest's words of praise for the heroine.

A blow against the Protestants

"Exalted thou art in the eyes of the Lord for ever and ever! And all the people said Amen."

This episode has featured in the work of many artists throughout the centuries, many of whom may have been less attracted by the political and religious implications of the tyrannicide than by the violent eroticism which lends the biblical murder story its great narrative tension.

Holofernes had to die because he had attempted to force the Jews to worship the Assyrian king Nebuchadnezzar instead of Jehova. He was a gentile, and Judith's fatal blow was dealt for the greater glory of her – only true – God. This made her deed highly topical when Caravaggio painted the picture in Rome at the end of the 16th century.

The struggle to repress heresy by whatever means possible, including fire and the sword, was the central preoccupation in the capital of the Papal States. It was the time of the Counter-Reformation. The Catholic Church was attempting to recover those dominions that it had lost during the first half of the 16th century. England and Sweden, and parts of the Netherlands, France and Germany, had followed Luther, Calvin or Zwingli. They no longer accepted the authority of the Pope and refused to pay taxes to Rome.

It had taken some time before the Catholic Church and loyalist states (Spain, Italy, Poland and the heartlands of the Habsburg Empire) were capable of taking up the counter-offensive. The Council of Trent had met repeatedly between 1545 and 1563 before finally reaching a consensus on reforms: the removal of the worst forms of abuse leading to the schism, and the establishment of strict rules of faith. The assembled representatives of the Church thus succeeded in laying down the foundations of spiritual renewal, while turning the Church itself into a force to be reckoned with. The hierarchy was tightened up, the Pope's authority strengthened and the organization of the Church in Rome was centralized. Several religious orders grew in power and influence, particularly the Jesuits, who, as defenders of the faith, were organized along military lines and set to work to convert the heretics – or exterminate them.

The most spectacular example of the persecution of heretics was the St. Bartholomew Massacre of thousands of Huguenots on 23/24 August 1572. But at a time when the faith of monarchs automatically determined that of their subjects, it seemed a far more practical business to strike a blow against the Protestant rulers themselves. Thus Pope Gregory XIII publically denounced Elizabeth I of England as "the cause of so much damage to the Catholic faith and of the loss of millions of souls"; he could see "no

doubt, but that he who dispatches her from this world with the holy intention of serving God commits no sin, but is deserving of reward".[2]

At the dawning of the age of absolutism and the divine right of kings, the authority of the royal sovereign was officially unquestionable; if a monarch left the one true faith, however, he was declared a usurper and an outlaw. This was Catholic doctrine in 1600; proclaimed from the pulpit and broadcast by countless pamphlets, it encouraged all kinds of fanatics and madmen who heard voices and thought they were heeding the call of God to take up daggers and firearms.

While Elizabeth I managed to escape countless assassination attempts, finally dying in her bed in 1603, William I of Orange, Stadtholder of Holland, Zealand and Utrecht, was shot in 1584, and Henry IV of France, who had survived a dozen attempts on his life and had even returned to the bosom of the Church in 1593, was stabbed to death by a religious fanatic. Judith was held up as a shining example by many fanatics: in contemporary pamphlets calling for the murder of heretics, Judith was celebrated as a paragon of virtue.

Judith's features betray neither triumph nor passion, but determination and disgust. She slays the defenceless man without using force,

keeping as great a distance as possible between her victim and herself. Nor does this demure heroine appear in a magnificent Baroque gown, like the Judith painted by Christofano Allori just a few years later, but in the best clothes of a woman of the people. Perhaps Caravaggio's model was a woman called Lena who is thought to have been his mistress and, according to a police report of 1605, was usually found "loitering at the Piazza Navona", which was tantamount to saying that she worked as a prostitute.

Travellers to Rome around 1600 generally found the large number of prostitutes worthy of comment: there were many unmarried men among the masses of pilgrims and Church servants who came to the Catholic capital. There were more than a million visitors to the Eternal City during the Holy Year of 1600. The innkeepers and tailors also did a good trade, the latter providing sumptuous robes for ecclesiastical dignitaries. Otherwise, there was neither trade nor industry in Rome; the majority of the city's inhabitants lived in poverty and were dependent on the charity of the Church.

It was at this time, too, that Rome, following its destruction by mercenaries in 1527, was being rebuilt – despite the greatly reduced income of the See – to the magnificent city we know today. The building boom was a product of the Counter-Reformation: it was intended that the

2

capital city of the the Catholic faith should shine out for all to see and that its spiritual hegemony in the world be reflected in its material glory. It was hoped that the magnificence of the Roman architecture would impress the uneducated masses and reinforce their piety.

Pope Sixtus V (1521–1590) commissioned the construction of mag-nificent avenues, had viaducts built and had the huge dome of St Peter's finally completed. Clement VIII (1536–1605) and his cardinals commissioned as many palaces, churches and chapels as they could, attracting architects, masons, sculptors and fresco-painters to Rome from all over Italy.

One of these was Michelangelo

Judith and Holofernes, c.1599

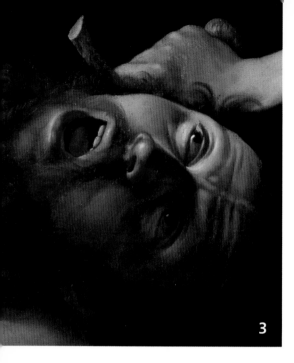

3

Fascinated by decapitation

Merisi, born in 1571 in the Lombardic village of Caravaggio, near Bergamo, a village whose name he later adopted as his own. Arriving in the papal city at the beginning of the nineties, his life had initially been all but easy. A Sicilian art dealer had employed him to produce "three heads every day", and given him only salad at mealtimes. But his talent was discovered in 1596 by Cardinal Francesco Maria del Monte (1549–1626), who offered him food, wine, pocket-money and lodgings at his palace. Caravaggio painted for him in return: semi-nude boys making music; Bacchus with a sensuous mouth, adorned with flowers; gen-

tle angelic figures. Such works appealed to the cardinal, who loved the company of young men.

It was not long before Caravaggio's fame spread abroad. On receiving his first noteworthy commission in 1598/99, the decoration of a chapel, Caravaggio left the homosexual milieu of the cardinal's palace, where he is thought to have lived with another painter.

It was at this time that he painted Judith, his first erotically attractive female figure, although in fact she is modestly dressed – Caravaggio never painted a female nude. Perhaps it was the image of Judith as both a devout heroine and, at the same time, a corrupter of men which so appealed to the artist. Like Delilah, who took Samson's male potency when she shaved off his locks, Judith appears, in the struggle between the sexes, as the incarnation of the male fear of ultimate vulnerability to a woman.

Most artists painting this theme have shown Judith after the deed, holding up the head of the dead Holofernes in her hand. By contrast, Caravaggio has painted the precise moment in which he is beheaded: the victim is still alive, his head only half-severed from his body. His eyes have not yet grown dim in death, but are staring out of his head, full of mortal fear, and his mouth is wrenched open in a scream. Caravaggio sought to cap-

ture the moment of shock and horror, an effect also loved by his English contemporary William Shakespeare. The latter's plays *Macbeth* and *King Lear* with their bloody murders and scenes of torture were performed for the first time in 1606. It was not only on canvas or on the stage that such brutal scenes took place, however; artists were confronted with violence of this kind every day, whether in Elizabethan England or in Rome during the Counter-Reformation. There were said to be more severed heads nailed to the Ponte Sant'Angelo over the Tiber than melons on the Roman market stalls. The "Avvisi", a kind of handwritten newspaper, reported in 1583: "The Papal States are in chaos … The countryside is in the hands of bandits … who murder … rob the couriers, lay waste to towns and houses."[3] These bandits were political outcasts from everywhere in Italy, peasants ruined by papal taxes and bad harvests, monks fled from their monasteries and other social misfits. It was reported that the Papal States were imperilled at times by as many as 27,000 brigands. In Rome they performed the function of armed bodyguards; known as *bravi,* the "daring", they accompanied any citizen or visitor who could afford their services, always ready to defeat their employer's enemies, or to engage in a street battle with the papal police, the *sbirri.*

"Practically no day passes", the Venetian ambassador to Rome reported in 1595, "without our seeing the heads (of dead bandits) they have brought into the city, or of the men they behead at the Castel Sant'Angelo in groups of 4, 6, 10, 20 and sometimes even 30 at a time. It has been calculated that over 5000 persons have died a violent death in the Papal State since the death of Sixtus V (1590), whether condemned to death, or murdered by bandits."[4]

Decapitation – a form of execution reserved for criminal members of the aristocracy – was generally linked to a number of macabre rituals. The severed heads were publically exhibited at the Castel Sant'Angelo, displayed on a black cloth between two burning torches. When the twenty-two year-old Beatrice Cenci was found guilty of patricide and beheaded in 1599, Caravaggio may have attended the execution. A contemporary textbook on art advised painters to accompany the condemned to the scaffold in order to observe their twitching eyelids and rolling eyes. It was at this time that Caravaggio was working on *Judith.*

Decapitation must have fascinated the artist. In 1603 he painted the *Sacrifice of Isaac* by Abraham; his *Beheading of St John the Baptist,* painted in 1608 and now in Valetta Cathedral, Malta, bears Caravaggio's sole extant signature. The words "F Michel A" can still be read on the

badly damaged painting; they are written in the paint he had used for the blood dripping to the ground from the martyr's neck. The head of the Baptist in Salome's hands reappears in a work executed in 1610, while another, later painting shows a young David holding up Goliath's head. Contemporary spectators noticed the similarity in looks between Goliath and Caravaggio himself, who was said to be "dark-skinned, with grave eyes and thick black eyebrows and hair".[5]

Holofernes' screaming, suffering face may also have been a self-portrait, letting Caravaggio act out a masochistic fantasy of himself as the victim of brutal violence.

Caravaggio, whose fame had grown so quickly, was patronized by Monsignori and cardinals. He found it difficult to adapt his work to their taste, however. In decorating churches he frequently departed from the conventions laid down by the Council of Trent, which had stipulated that while paintings of the Scriptures were to be used to educate the ignorant masses, the artwork itself must remain dignified and aloof. Caravaggio's work offended against this "decorum" by showing saints with dirty feet and a drowned Virgin Mary whose corpse had swollen in the water.

At the same time, his style broke with the Renaissance ideal of beauty. His vision and aesthetic were novel and realistic, and his works, treasured by a small circle of supporters who paid high prices for them, shocked many of his contemporaries. Instead of copying conventional models, Caravaggio painted directly from life. Thus, he suppressed neither the furrows and lines on a face nor the wrinkles produced by a life of toil on the hands of an old woman. "Too natural", was all the artist Annibale Carracci could say about his contemporary's painting of Judith.

It was here that Caravaggio first used a device that was to become characteristic of his work: figures, accentuated by artificial, almost subterranean lighting effects, standing out against a dark, nocturnal background.

The fact that darkness and violence were themes to which the artist continually returned may possibly derive from his character. Various incidents show Caravaggio to have been a rowdy and a thug. On 28 May 1606, he mortally wounded a certain Ranuccio Tomassoni in a brawl over a wager on a tennis match. This was by no means his first brush with the law, however, as the numerous demands for sentences recorded in the Roman archives show. On one occasion, the painter threw a plate of artichokes at an impolite waiter at the Osteria del Moro; on another, he insulted a policeman who had asked to see his licence to carry a weapon.

Caravaggio led the adventurous life of a Roman *bravo*. Although he delivered his paintings on time, his biographers say that he rarely stuck it out at work for very long before setting out with his gang of toughs, attending one tennis match after the other, "always ready to fight a duel or engage in a brawl".[6] The sword he carried at his side on these occasions is said to have been conspicuous for its size.

Swords, daggers and knives may be seen in almost all Caravaggio's paintings. Like blood and decapitation, they constitute a kind of sadistic leitmotiv in his work. In the artist's everyday life, they were not only the means of self-assertion, but status symbols. The offence taken by Caravaggio at the policeman's demand to see his licence to carry such a weapon is explicable: wearing a sword was considered a nobleman's privilege, and, despite the torn and dirty clothes he usually wore, it was as a nobleman that Caravaggio wished to be seen. He was a social climber, and his aggression was most likely a means of compensating for a social inferiority complex.

Parallel to the refusal of several of his best works on grounds of theological incorrectness and the consequent reduction in the number of his official commissions, Caravaggio's aggressive behaviour increased, climaxing in the murder of 1606, which forced him to flee Rome. He spent the rest of his life tormented by a persecution complex, driven from one place to another, leaving behind him a trail of masterpieces that were to have a lasting influence on 17th century European art. He died, a lonely man, in exile in 1610 – "as miserably as he lived", as one contemporary noted.[7]

Undaunted by reality

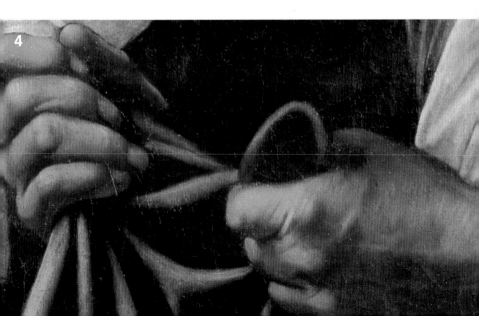

Appendix

**Hieronymus Bosch
(c. 1450 - c. 1516)**
The Ship of Fools, between
1480 and 1516
56 x 32 cm
Paris, Musée du Louvre
Photo: AKG Berlin

Lit.: Adhémar, Hélène: Le Musée
National du Louvre. Vol. 1, Les Pri-
mitifs Flamands, Brussels 1962. –
Brant, Sebastian: Narrenschiff, edited
by Friedrich Zarncke, Darmstadt
1973. – Dörner, Klaus: Bürger und
Irre, Frankfurt 1969. – Foucault,
Michel: Wahnsinn und Gesellschaft,
Frankfurt 1973. – Kirchhoff, Theodor:
Grundriß einer Geschichte der
deutschen Irrenpflege, Berlin 1890. –
Lefebre, Joel: Les fols et la folie,
Paris 1968. – Lurker, Manfred: Der
Baum in Glauben und Kunst, Baden-
Baden 1960. – Tolnay, Charles de:
Hieronymus Bosch, Baden-Baden
1973.
Notes:
1 Kirchhoff, p. 18
2 Brant, p. 90, 75, 84

**Hans Baldung
(c. 1485–1545)** (alias Grien)
The Three Stages of Life,
with Death, c. 1510

48 x 33 cm
Vienna, Kunsthistorisches
Museum
Photo: AKG Berlin

Lit.: Boll, Franz: Die Lebensalter, Ein
Beitrag zur antiken Ethologie und
zur Geschichte der Zahlen, Leipzig,
Berlin 1913. – Herter, Hans: Das un-
schuldige Kind, in: Jahrbuch für An-
tike und Christentum, Jahrgang 4,
Münster 1961. – Von der Osten, Gert:
Hans Baldung Grien, Gemälde und
Dokumente, Berlin 1983. – Wirth,
Jean: La jeune fille et la mort, Geneva
1979.

**Raphael (1483–1520)
(Raffaelo Sanzio)**
The Fire in the Borgo,
1514–1517
Fresco base 6.97 m
Vatican, Stanze di Raffaello
Photo: AKG Berlin

Lit.: Gregorovius, Ferdinand:
Geschichte der Stadt Rom im Mit-
telalter. Dresden 1930. – Heers,
Jacques: La vie quotidienne à la
cour pontificale au temps des
Borgiaet des Médicis. Paris 1986. –
Jones, Roger & Penny, Nicholas:
Raffael. New Haven/Munich 1983. –

Larivaille, Paul: La vie quotidienne
en Italie au temps de Machiavel.
Paris 1978. – Ullmann, Ernst: Raffael.
Leipzig/Gütersloh 1983.
Notes:
1 Letters by Raphael, cited by
Warnke, Martin: Hofkünstler,
zur Vorgeschichte des moder-
nen Künstlers. Cologne 1985,
p. 295
2 Letter by Bembo to Bibbiena,
July 1517, cited by Jones, p. 147
3 Gregorovius. pp. 1179, 1091, 1185
4 Memo by Leo, 1514, in Ullmann,
p. 253
5 Letter by Raphael to his uncle
Simone Ciarla, in Ullmann,
p. 171
6 Ullmann, pp. 259; Jones, p. 199
7 Heers, p. 225; Jones, p. 199
8 Epigram by Calcagnini, 1519, in:
Jones, p. 199
9 Paolo Giovio, in: Jones, p. 151
10 Letter by Raphael to Castiglione,
in: Jones, p. 96

**Niklaus Manuel
(c. 1484–1530)**
The Execution of John the
Baptist, c. 1517
34 x 26 cm
Basle, Kunstmuseum
Photo: Öffentliche Kunstsammlung
Basel, Kunstmuseum, Martin Bühler

Lit.: Beerli, Conrad André: Le peintre poète Niklaus Manuel Deutsch et l'évolution sociale des son temps, Geneva 1953. – Daffner, Hugo: Salome in Kunst und Musik, Munich 1912. – Catalogue of the Berne Kunstmuseum: Niklaus Manuel Deutsch, Maler, Dichter, Staatsmann, Berne 1979. – Merkel, Kerstin: Salome, Ikonographie im Wandel, dissertation, Frankfurt 1990. – Metzsch, Friedrich-August von: Johannes der Täufer, Seine Geschichte und Darstellung in der Kunst, Munich 1989.

Albrecht Altdorfer
(c. 1480–1538)
The Battle of Issus, 1529
158.4 x 120.3 cm
Munich, Alte Pinakothek
Photo: Artothek, Peissenberg

Lit.: Buchner, Ernst: Die Alexanderschlacht, Stuttgart 1956. – Krichbaum, Jörg: Albrecht Altdorfer, Meister der Alexanderschlacht, Cologne 1978. – Winzinger, Franz: Albrecht Altdorfer, die Gemälde. Munich, Zurich 1975.

Hans Holbein the Younger
(1497/98–1543)
The Ambassadors, 1533
207 x 209 cm
London, The National Gallery, reproduced by courtesy of the Trustees
Photo: Artothek Peissenberg

Lit.: Hervey, Mary S.: Holbein's Ambassadors. The picture and the men. A historical study. London 1900. – Jacobs, Eberhard/de Vitray; Eva: Heinrich VIII. von England in Augenzeugenberichten. Düsseldorf 1969. – Pinder, Wilhelm: Holbein der Jüngere und das Ende der altdeutschen Kunst.

Cologne 1951. – Salvini, Robert/ Grohn, Hans Werner: Das gemalte Gesamtwerk von Hans Holbein d. J. Milan, Lucerne 1971. – Samuel, Edgar R.: "Death in the glass – A new view of Holbein's Ambassadors". In: The Burlington Magazine, vol. CV, pp. 718–729, London 1963.

Notes:
1 Dinteville's letter to François I, 23 May 1533, in: Jacobs/de Vitray, p. 137
2 Petrus Apianus: "Eyn Newe unnd wolgegründte underweysung …", Ingolstadt 1527. The copy provided by the British Museum has no page numbers.
3 Henrici Cornellii Agrippae: Ungewissheit und Eitelkeit aller Künste und Wissenschaften, in: Bibliothek der Philosophen, Volume 5, Munich 1913, pp. 19, 22

Titian (1488/1490–1576)
(Tiziano Vecellio)
Venus of Urbino, c. 1538
119 x 165 cm
Florence, Uffizi
Photo: AKG Berlin

Giorgione
(Giorgio da Castelfranco)
Sleeping Venus, 1510
Dresden, Staatliche Kunstsammlung
Photo: Artothek, Peissenberg

Lit.: Gronau, Georg: Die Kunstbestrebungen der Herzöge von Urbino, in: Jahrbuch der Königlich-Preußischen Kunstsammlungen, Berlin 1904. – Hollander, Anne: Seeing through clothes, New York 1975. – Hope, Charles: Titian, London 1980. – Rostand, David: Titian, New York 1978. – Valcanover, Francesco: Das Gesamtwerk von Tizian, German edition: Lucerne nd; Italian edition 1969.

Lucas Cranach the Younger
(1515–1586)
The Stag Hunt, 1544
117 x 177 cm
Vienna, Kunsthistorisches Museum
Photo: Kunsthistorisches Museum, Vienna

Lit.: Friedländer, Max J. and Rosenberg, Jakob: Die Gemälde von Lucas Cranach, Basle, Boston, Stuttgart 1979. – Grimm, Claus, Brockhoff, Evamaria and Erichsen, Johannes, (eds.): Lucas Cranach, Ein Maler-Unternehmer aus Franken, Augsburg 1994. – Kunsthistorisches Museum, Vienna: Lucas Cranach der Ältere und seine Werkstatt, Katalog zur Jubiläumsausstellung museumseigener Werke, Vienna 1972. – Schade, Werner: Die Malerfamilie Cranach, Vienna and Munich 1977.

Tintoretto (1518–1594)
(Jacopo Robusti)
Susanna and the Elders,
c. 1555
147 x 194 cm
Vienna, Kunsthistorisches Museum
Photo: AKG Berlin

Lit.: Holy Bible: New Revised Standard Version, Oxford 1989. – Molmenti, Pompeo: La Storia di Venezia nella vita privata, Bergamo 1905–08, Reprint, Triest 1973. – Pallucchini, Rodolfo and Rossi, Paola: Tintoretto, Florenz 1982. – Ruggiero, Guido: Violence in Early Renaissance Venice, New Brunswick, New Jersey 1989. – Valcanover, Franceso and Pignatti, Terisio: Tintoretto, New York 1985. – Zorzi, Alvise: La vita quotidiana a Venezia nel secolo di Tiziano, Milan 1990.

Paolo Veronese (1528–1588)
(Paolo Caliari)
The Marriage at Cana,
1562/63
6.69 x 9.90 m
Paris, Musée du Louvre

Photo: Artothek, Peissenberg

Lit.: Lebe, Reinhard: Als Markus nach Venedig kam. Frankfurt 1980. – Lenz, Christian: Veroneses Bildarchitektur. Thesis, University of Munich 1969. – Molmenti, Pompeo: La Storia di Venezia nella Vita Privata. Bergamo 1905–1908, Reprint Triest 1973, vol. 2. – Pignati, Terisio: Veronese, catalogue raisonné. Venezia 1976. – Piovene, Guido: L'Opera completa di Veronese. Milan 1968.

Notes:
1 Lenz, p. 94
2 Molmenti II, p. 44
3 Lebe, p. 206
4 -Contarini, cited in: Civiltà veneziana del Rinascimento – atti del congresso, Venice 1958, p. 99
5 Piovene, p. 84
6 Zanetti, cited by Pignatti, p. 74
7 Honour, Hugh: Venedig. Munich 1966, p. 73

Pieter Bruegel the Elder
(c. 1525/30–1569)
The Tower of Babel, 1563
114 x 155 cm
Vienna, Kunsthistorisches Museum

Photo: Artothek, Peissenberg

Lit.: Claessens, Bob/Rousseau, Jeanne: Unser Bruegel. Antwerp 1969. – Eisele, Petra: Babylon. Berne/Munich 1980. – Guicciardin, Ludwig (Luigi Guicciardin): Beschreibung dess Niderlands ursprung, auffnemen und herkommens. Frankfurt 1582. – Grossmann, Fritz: Bruegel, Die Gemälde, Complete catalogue.

Cologne 1566. – Klamt, Johann-Christian: Anmerkungen zu Pieter Bruegels Babel-Darstellungen, in: Pieter Bruegel und seine Welt. Eds. Otto von Simson/Matthias Winner, Berlin 1979. – Seidel, M./Marijnissen, R. H.: Bruegel, Stuttgart 1979.

Notes:
1 Genesis, Chaps. 6, 8 and 11
2 Guicciardin, p. 64

Antoine Caron (1521–1599)
The Massacre by the Triumvirate, 1566
116 x 195 cm
Paris, Musée du Louvre

Photo: Réunion des Musées Nationaux, Paris

Lit.: Béguin, Sylvie: L'Ecole de Fontainebleau, le maniérisme à la cour de France, Paris 1960. – Cloulas, Ivan: Catherine de Médicis, Paris 1978. – Ehrmann, Jean: A. Caron, peitre des fêtes et des massacres, Paris 1986. – Erlanger, Philippe: Le Massacre de la Saint-Barthélémy, Paris 1965.

Pieter Bruegel the Elder
(c. 1525/30–1569)
Peasant Wedding Feast,
c. 1567
114 x163 cm
Vienna, Kunsthistorisches Museum

Photo: AKG Berlin

Lit.: Alpers, Svetlana: Bruegel's festive peasants, in: Simiolis, 1972/3. – Claessens, Bob and Rousseau, Jeanne: Unser Bruegel, Antwerp 1969. – Hagen, Rose-Marie and Hagen, Rainer: Pieter Bruegel der Ältere, Cologne 1994. – Simson, Otto von and Winner, Matthias, (eds.): Pieter Bruegel und seine Welt, Berlin 1979. – Stechow,

Wolfgang: Bruegel the Elder, New York 1980. – Stridbeck, Carl Gustav: Bruegelstudien, Stockholm 1956. – Wied, Alexander: Bruegel, Milan 1979.

Tintoretto (1518–1594)
(Jacopo Robusti)
The Origin of the Milky Way,
c. 1580
148 x 165 cm
London, National Gallery, reproduced by courtesy of the Trustees

Photo: The National Gallery, London

Jakob Hoefnagel
Origin of the Milky Way, sketch after Tintoretto,
c. 1620
Berlin, Staatliche Museen zu Berlin – Preußischer Kulturbesitz, Kupferstichkabinett

Lit.: Evans, Robert John Weston: Rudolf II and his World. A Study in intellectual history. Oxford 1973/84. – Garas. Clara: Le tableau du Tintoret du Musée de Budapest et le cycle peint pour l'Empereur Rodolphe II, in: Bulletin du Musée hongrois des Beaux-Arts no 30, 1967. – Gould, Cecil: An X-ray of Tintoretto's Milky Way, in: Arte Veneta XXXII 1975. – Exhibition Catalogue: Prag um 1600, Kunst und Kultur am Hofe Rudolfs II., 2 vols., Essen/Vienna 1988.

Notes:
1 Gould, p. 212
2 Ridolfi, cited by Garas, pp. 31, 32, 38
3 Catalogue I, p. 39
4 Melchior Goldast, cited in: Erlanger, Philippe: L'Empereur

insolite, Rodolphe II de Habsbourg. Paris 1980, p. 354
5 Catalogue. p. 39
6 Erlanger, p. 222

El Greco (1541–1614) (Domenikos Theotokopulos)

The Burial of Count Orgaz,
1586
480 x 360 cm
Toledo, Santo Tomé
Photo: Artothek, Peissenberg

Lit.: Gudiol José: El Greco, Geneva 1973. – Mâle, Émile: L'art religieux de la fin du XVIe siècle, du XVIIe siècle et du XVIIIe siècle, étude sur l'iconographie après le Concile de Trente (Italie, France, Espagne, Flandres), Paris 1951. – Schroth, Sarah: Burial of the Count of Orgaz, in: Studies in the History of Art, Vol. II, National Gallery of Art, Washington, D. C. 1982.

George Gower (1540–1596)

Armada Portrait of
Elizabeth I, c. 1590
105 x 133 cm
Woburn Abbey
Photo: Woburn Abbey, Bedfordshire, By kind permission of Marquess of Travistock and Trustees of Bedfor Estate

Lit.: Jenkins, Elisabeth: Gloriana, Queen of England, London 1959. – Levey, Michael: Painting at court, London 1971. – Lewis, Michael: The Spanish Armada, London 1960. – Strong, Roy: The cult of Elizabeth, London 1977. – Yates, Frances A.: Astraea, The imperial theme in the 16th century, London 1975.

Adam Elsheimer (1578–1610)

St Elizabeth Tending the Sick,
c. 1597
28 x 20 cm
London, Wellcome Institute
for the History of Medicine
Photo: The Wellcome Institute for Medical Science, Wellcome Institute Library, London

Related works:
Adam Elsheimer
Self-portrait, c. 1606
Florence, Galleria degli Uffizi

Adam Elsheimer
Contentment, c. 1607
Edinburgh, National Gallery of Scotland

Lit.: Andrews, Keith: Adam Elsheimer, Werkverzeichnis der Gemälde, Zeichnungen und Radierungen, Munich 1985. – Krämer, Gode: Ein wiedergefundenes Bild aus der Frühzeit Elsheimers, in: Pantheon, Internationale Zeitschrift für Kunst, vol. XXXVI, no. IV, Munich 1978. – Murken, A. H./Hofmann, B.: Die heilige Elisabeth als Krankenpflegerin, in: Historia Hospitalium, no. 13, without place of publication 1979/80. – Rechberg, Brigitte: Die heilige Elisabeth in der Kunst – Abbild, Vorbild, Wunschbild, Marburg 1983.

Caravaggio (1571–1610) (Michelangelo Merisi)

Judith and Holofernes,
c. 1599
145 x 195 cm
Rome, Galleria Nazionale d'Arte Antica
Photo: Scala, Florence

Lit.: Delumeau, Jean: Vie économique et sociale de Rome dans la seconde moitié du XVI s. Paris 1957. – Hibbard, Howard: Caravaggio. New York 1983. – Hinks, Roger: Michelangelo Merisi da Caravaggio, his life, his legends, his works. London 1953. – Röttgen, Herwarth: Il Caravaggio, ricerche e interpretazioni, Rome 1974.

Notes:
1 Book of Judith, from the Apocrypha of the Lutheran Bible. Ed. Stuttgart 1971, vol. 5, pp. 1178/9; Judith, pp. 16 ff. In: The Holy Bible, New Revised Standard Version with Apocrypha. New York/ Oxford 1989.
2 Lavater Sloman, Mary: Elisabeth I. Zurich 1957, p. 359/360
3 Delumeau, p. 561
4 Paolo Paruta, 1595, in: Delumeau, p. 563
5 Bellori, cited by Röttgen, p. 153 Floris van Dyck, in: Röttgen, p. 152
7 Giovanni Baglione, cited by Hibbard, p. 356

"Buy them all and add some pleasure to your life."

Art Now
Eds. Burkhard Riemschneider,
Uta Grosenick

15th Century Paintings
Rose-Marie and Rainer Hagen

16th Century Paintings
Rose-Marie and Rainer Hagen

Atget's Paris
Ed. Hans Christian Adam

Best of Bizarre
Ed. Eric Kroll

Karl Blossfeldt
Ed. Hans Christian Adam

Chairs
Charlotte & Peter Fiell

Classic Rock Covers
Michael Ochs

Description of Egypt
Ed. Gilles Néret

Design of the 20th Century
Charlotte & Peter Fiell

Dessous
Lingerie as Erotic Weapon
Gilles Néret

Encyclopaedia Anatomica
Museo La Specola
Florence

Erotica 17th–18th Century
From Rembrandt to Fragonard
Gilles Néret

Erotica 19th Century
From Courbet to Gauguin
Gilles Néret

Erotica 20th Century, Vol. I
From Rodin to Picasso
Gilles Néret

Erotica 20th Century, Vol. II
From Dalí to Crumb
Gilles Néret

The Garden at Eichstätt
Basilius Besler

Indian Style
Ed. Angelika Taschen

London Style
Ed. Angelika Taschen

Male Nudes
David Leddick

Man Ray
Ed. Manfred Heiting

Native Americans
Edward S. Curtis
Ed. Hans Christian Adam

Paris-Hollywood.
Serge Jacques
Ed. Gilles Néret

20th Century Photography
Museum Ludwig Cologne

Pin-Ups
Ed. Burkhard Riemschneider

Giovanni Battista Piranesi
Luigi Ficacci

Redouté's Roses
Pierre-Joseph Redouté

Robots and Spaceships
Ed. Teruhisa Kitahara

Eric Stanton
Reunion in Ropes & Other Stories
Ed. Burkhard Riemschneider

Eric Stanton
She Dominates All & Other
Stories
Ed. Burkhard Riemschneider

Tattoos
Ed. Henk Schiffmacher

Edward Weston
Ed. Manfred Heiting

ICONS